SHOOT

Photography of the Moment

By Ken Miller

RIZZOLI
NEW YORK

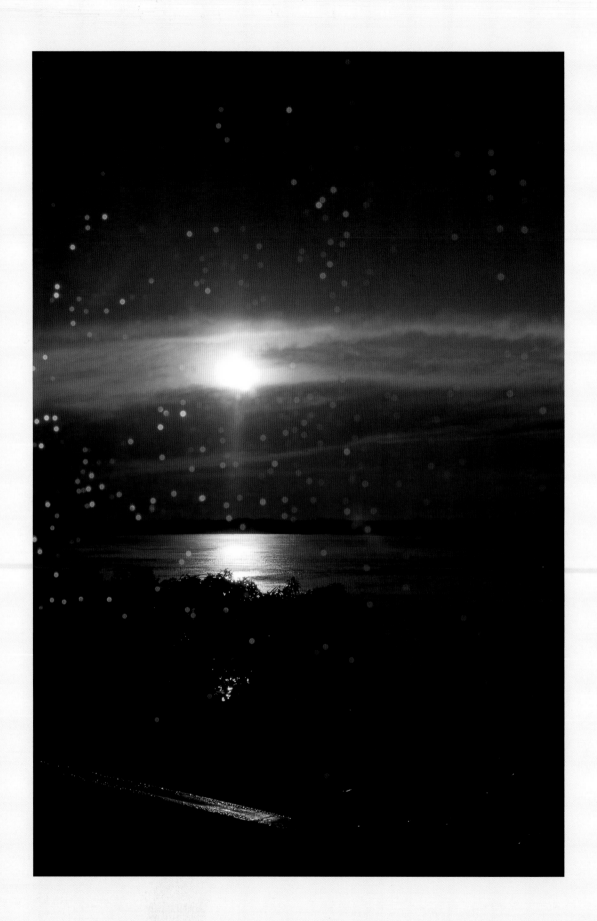

CONTENT

SNAPSHOTS
By Stephen Shore
005

SHOOT
By Penny Martin
009

THE MOMENT
By Ken Miller
029

STEPHEN SHORE
004

NAN GOLDIN
008

WALTER PFEIFFER
012

BORIS MIKHAILOV
016

WOLFGANG TILLMANS
018

JUERGEN TELLER
022

MARK BORTHWICK
026

ARI MARCOPOULOS
030

HIROMIX
032

GLYNNIS MCDARIS
036

LINUS BILL
046

JASON NOCITO
056

YURIE NAGASHIMA
072

TIM BARBER
086

PETER SUTHERLAND
096

JH ENGSTRÖM
108

DASH SNOW
118

KENNETH CAPPELLO
124

LOUISE ENHÖRNING
132

MICHAEL SCHMELLING
142

NACHO ALEGRE
152

OLA RINDAL
158

PAUL SCHIEK
166

MADI JU
176

JAIMIE WARREN
184

THOMAS JEPPE
194

STEPHEN SHORE
Bush (Mick-O-Matic)
1971

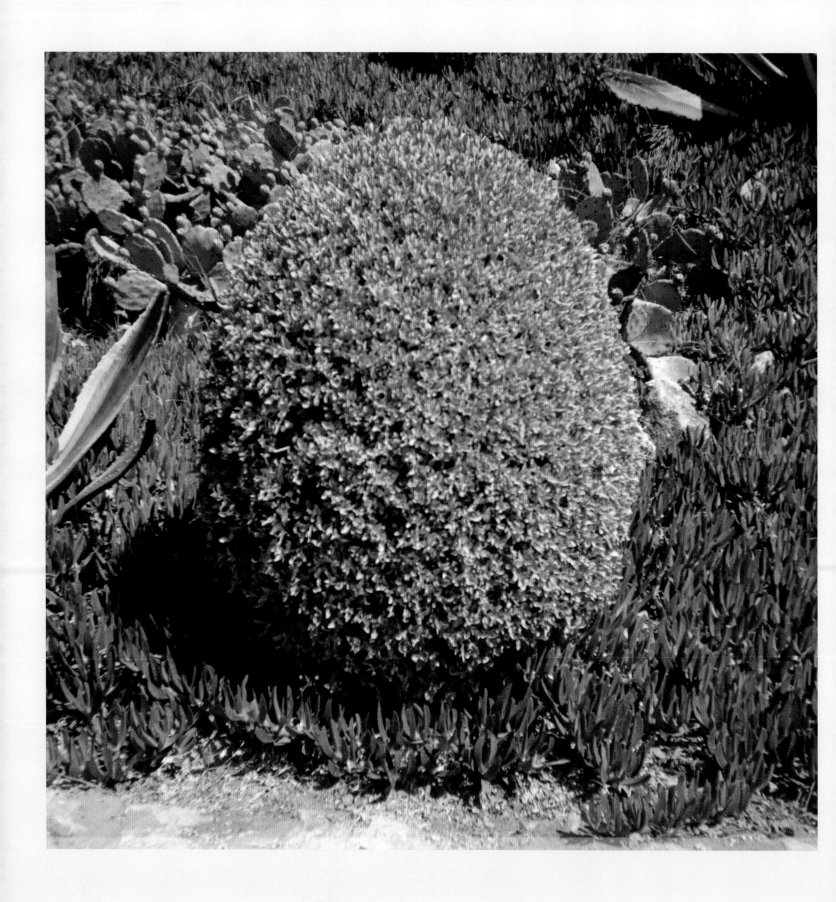

SNAPSHOTS
By Stephen Shore

"To be natural is such a very difficult pose to keep up."
—Oscar Wilde, *An Ideal Husband*

Just as I could take a screenshot of my computer monitor while I write these words, what if you could take a screenshot of your whole field of vision right now? What is surrounding this page? Does your mental screenshot have a frame, as a photograph does?

My interest in snapshot photography began because, every now and then, I would come across a picture that was startling in its directness. Made without pretense to art, these images were without artifice, and their simplicity gave them a special vitality. While there are certainly visual conventions among snapshots, at their best they are seemingly unmediated and unconditioned, the result of an accident or chance. This immediacy has become rarer and rarer as people are more and more exposed to images, and it indicates a path toward understanding, by contrast, what part of a typical photograph is the overlay of visual convention.

We inevitably bring to every picture-making situation our visual conditioning: what to photograph (content) and how to photograph it (structure). Snapshots, at times, can offer a glimpse into a less conditioned visual world. But a photograph, because of its inherent formal and technical qualities, inevitably differs from how we see. Accidents such as unexpected juxtapositions, exposures, and croppings, provide information about how a camera "sees" before the imposition of conditioned structure. Still, some photographs seem more natural, closer to experience than others.

The snapshot made by an untrained amateur and the ephemeral image made by an artist *referencing* the visual style and the personal vision of the snapshot are made with radically different degrees of intentionality. The form of the snapshot affects our expectations: As with a sketch, we welcome its simple notation. A Michelangelo drawing of the turn of a wrist may not have the complexity of one of his frescos, but it communicates the spontaneity of his hand. The photographer adopting the snapshot vernacular recognizes the energy, rawness, and emotion this form can communicate and employs visual devices that reference it. The ephemeral image's energy, like that of the snapshot, comes from its incompleteness—its notational quality. And like notation, it grows by accumulation.

STEPHEN SHORE
Meat (Mick-O-Matic)
1971 (left)

Suitcase (Mick-O-Matic)
1971 (right)

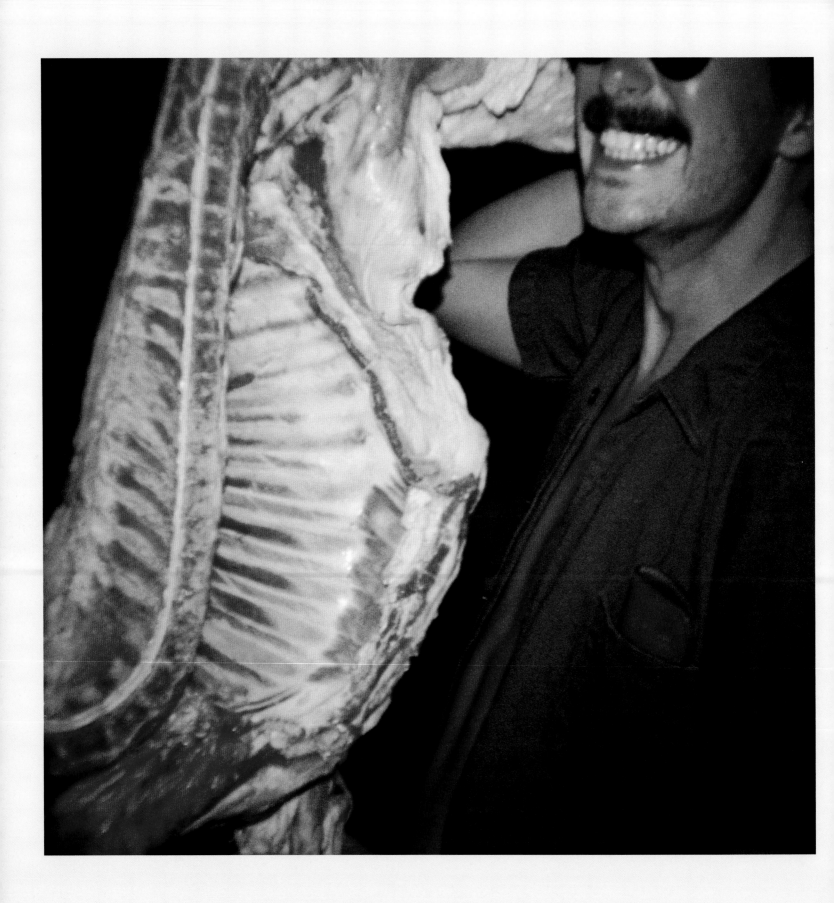

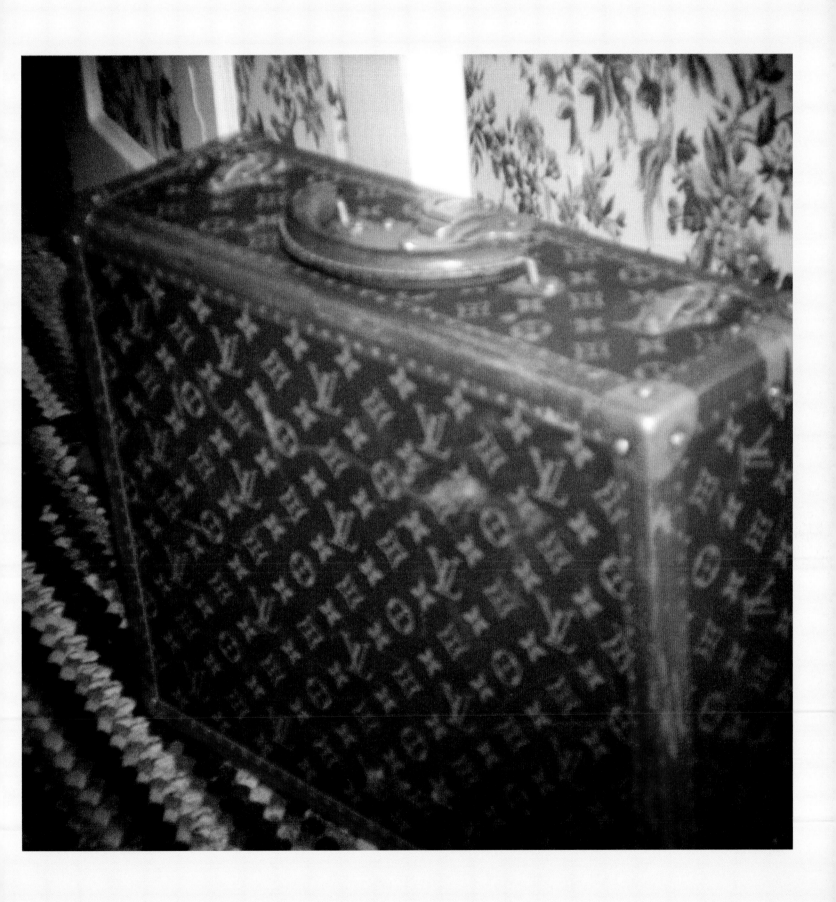

NAN GOLDIN
My Father Under His Blanket
Peabody, MA
2007

Brushstroke Blue Horizon
Malibu, CA
2006 (next page)

SHOOT
By Penny Martin

A mysterious figure, captured at night, its identity concealed by the bleaching effect of a glowing white camera flash. A blood-smeared, freshly born baby resting between its mother's breasts, with the scissors still dangling from the umbilical cord that had connected them only seconds before the shot was taken. A pair of disembodied feet, in electric turquoise socks and sturdy brown oxfords, seem to float above a grid of quarry tiles.

Obscure in content and begging some kind of anecdotal explanation, these images could be the kind of random personal photograph owned by every one of us. Whether archived in a shoebox at the bottom of a closet, languishing on an obsolete cell phone, edited into a gallery on a social networking website, or framed on a mantelpiece, such informal shots of memorable nights out with friends, momentous rites of passage, or amusing camera tricks are the staples of any domestic photography collection. And what helps us recognize them as informal photography are the hallmarks of amateur production—the stark, frontal flash of a compact camera; the saturated color balance created by drugstore processing; the off-center composition; classic technical mistakes such as lens flare, a visible time and date stamp, red-eye, and even missing heads or feet.

Leafing through the pages of this book, you will find these same amateur qualities in work by some of the most celebrated art and commercial photographers of the past three decades. During this period, the seemingly simple snapshot has undergone a profound transformation in its application and cultural import, transporting it from modest domestic record to potent ideological artifact. Informal photography has been adopted into the canon of art and proposed as a career choice for young practitioners. It has become a craze among collectors, and over the last ten years, has been a popular subject of museum retrospectives. Despite the increased tendency to think about snapshot photography retrospectively, however, this period has also coincided with a reinvigoration of the medium by a new generation of image-makers who find the expediency and fluidity of informal imagery ideally suited to the pace and tone of the online portfolios and blogs that have become central to the culture and promotion of their work. Informal photography remains as current and vital as ever.

WALTER PFEIFFER
Untitled
No date

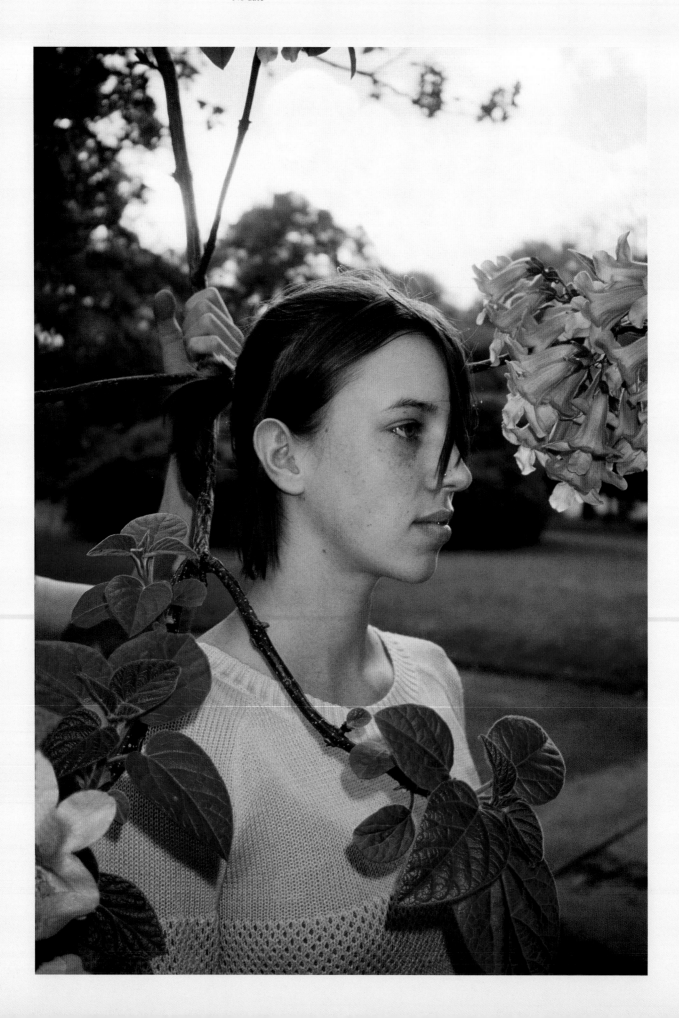

The genre existed arguably as early as the 1850s, with the introduction of wet plate negatives that reduced extensive exposure times to mere seconds—long before George Eastman's much-trumpeted introduction of the iconic Kodak box camera in 1888, preloaded with its 100-exposure roll film. The fact that the application of snapshot photography has remained much the same since then is a testament to the universal pleasure that can be found in making unselfconscious pictures with a simple point-and-shoot tool. As such, writing on snapshot imagery has centered principally on the act of creating it—the photographic intent the medium inspires.

Social and historical accounts of snapshot photography's implementation can be divided into those focusing on the technological developments achieved by specific equipment manufacturers (such as Kodak) and those that detail the visual achievements of key producers (the glorious street photography captured by Thomas Annan, John Thomson, Weegee, Roger Mayne, Helen Levitt, and Gary Winogrand, for example).

In the context of art and art theory, however, the snapshot's history is more complex. Photography's status as passive aide-mémoire to painters dates back to the 1840s when Hill and Adamson created 150 portraits using the newfangled calotype technology to help construct a time-consuming history painting that was in danger of being abandoned uncompleted. But it was the use of everyday kinds of imagery, such as news photography, by artists such as Édouard Manet in the 1860s and, particularly, the fascination with mundane visual culture such as advertisements, archive material, and amateur snapshots by 1960s pop and conceptual painters, including Michelangelo Pistoletto, Gerhard Richter, and Andy Warhol, that gradually demonstrated the photographic reference's power to query pictorial representation. Appropriating the snapshot for its apparent meaninglessness, these artists elevated it to powerful critical entity, ultimately using its cool, disinterested stance to question reality.

An upsurge in Continental philosophy during the late '60s stimulated an agenda among cultural theorists and writers to unpack so-called found imagery and reassert the photograph as inherently meaningful and politicized. This laid fertile ground for projects like Larry Sultan and Mike Mandel's book *Evidence* (1977), which sought to contest photography's ostensibly truthful, objective nature in photographic as well as theoretical terms.

It was less for snapshot imagery's contextual resonance than for its apparently artless appearance that it began to enjoy attention from a new group of contemporary image-makers during the late 1960s and early 1970s—crucially, the point when photography was being adopted into the art market. The storm of controversy surrounding William Eggleston's 1976 MOMA show of color photography cannot be underestimated; it convinced a generation of young photographers that the aesthetic of vernacular imagery presented in a gallery could be provocative and exciting. Stephen Shore's "All the Meat You Can Eat," an exhibition that he co-curated at 98 Greene Street Loft in 1971—for which he displayed a variety of photographic (mass) culture, from press photos and pornography, to tear sheets, family

WALTER PFEIFFER
Untitled
No date (left)

Untitled
No date (right)

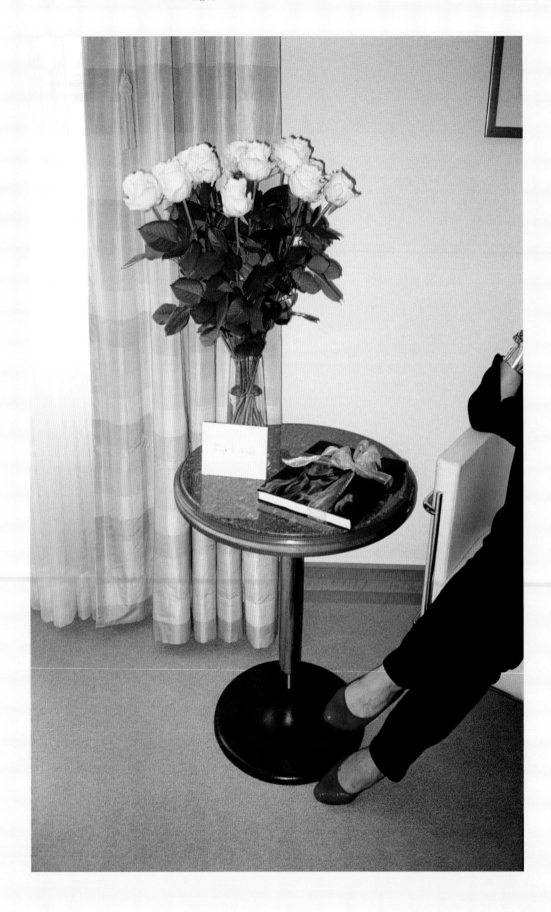

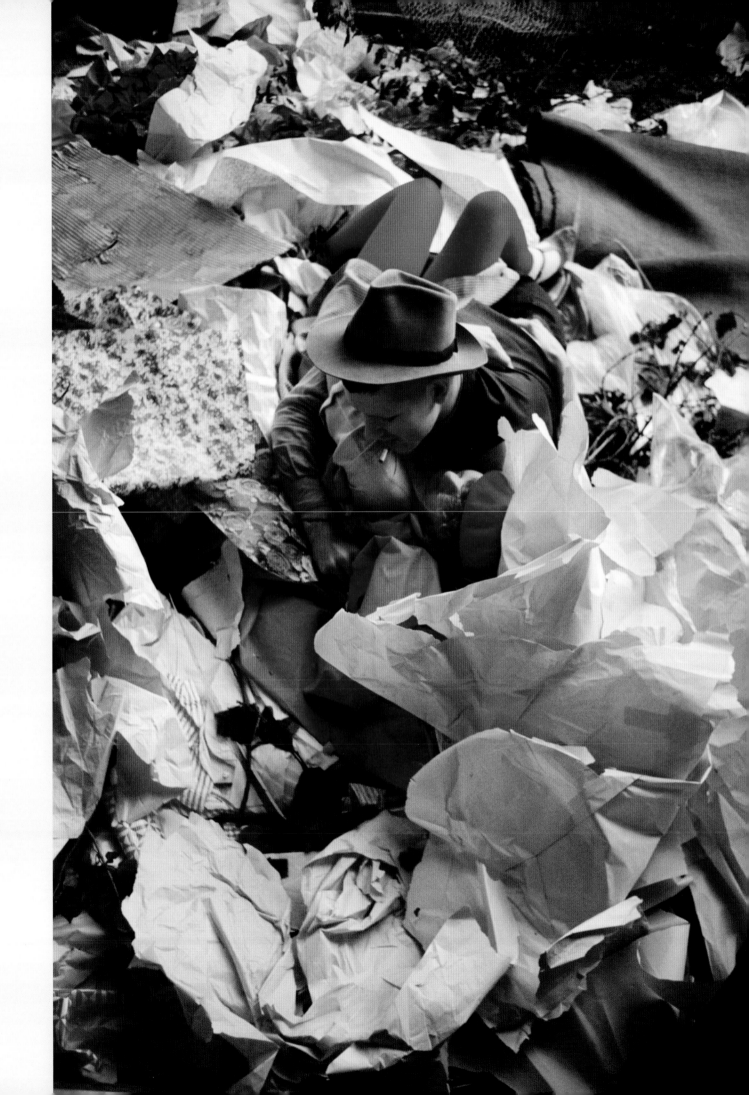

BORIS MIKHAILOV
Untitled
2007 (top)

Untitled
2007 (bottom)

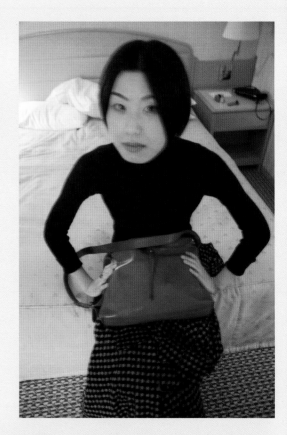

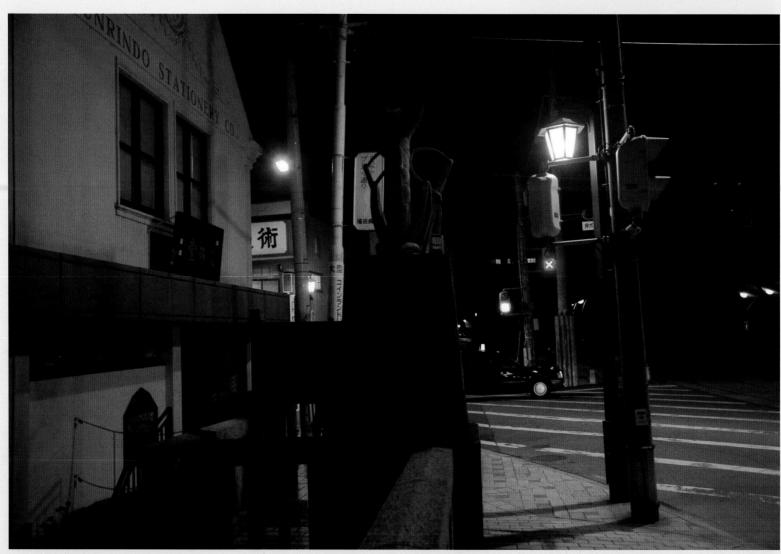

snapshots, and postcards—set the precedent for the inclusion of humdrum photography in such a context. But it was the publication of Shore's *Uncommon Places* in 1982, with its virtuoso, large-format color landscapes of Americana that presented a new generation of photographers with a paradigm of how the vernacular might be expressed in art photography.

Hobbyist photographer Boris Mikhailov—dismissed from the Ukrainian engineering works where he was employed for misusing the company's darkroom—would eventually come to learn of the growing taste for such techniques as color shift and grainy resolution that he employed in the soft porn snaps and street shots he was making in his home town of Kharkov in the '70s and '80s. For Mikhailov, this realization occurred decades before his breakthrough project "Case Study" (1998) was recognized as art. And how could Walter Pfeiffer have known that his early '70s black-and-white Polaroids and extreme close-up snaps of boys—inspired by an autodidactic desire to create a visual vocabulary for the life he led—would in time represent a facet of art practice? The activities of self-taught photographers, as well as the appearance of their amateur photography, were about to enter the mainstream as a vital new visual currency.

Where Nan Goldin (who, by contrast, was academy trained) went further was in her commitment to the *subject* of domestic photography —or rather to depicting an alternative to family life as it is normally portrayed in snapshots. Her ongoing project to document the intimate lives of her friends and lovers was driven by a personal necessity to use pictures to make sense of her own emotional chaos. Flying in the face of contemporary postmodern theory, her essentially modernist belief in the intrinsic candor, intimacy, and evidential nature of snapshot imagery was expressed in an autobiographical, diaristic form. Working in the traditions of Lee Friedlander, Harry Callahan, Larry Clark, and Nobuyoshi Araki and centering herself as both author and subject, Goldin set the standard for a sort of photographic confessional memoir in which it was impossible to separate the artist's own life from her work.

Not only has this provided Goldin with a shield from criticism (to attack her work is to attack her lifestyle choices), it also introduced a rich visual vocabulary for fashion photographers wishing to invest their work with truth and emotional resonance[1]. Furthermore, her example suggested a legitimate working methodology for younger photographers desiring a shift from commercial photography to the art world. From the beginning, Wolfgang Tillmans, Juergen Teller, and Hiromix would have been aware of the potential career to be made in creating personal, informal imagery.

The shared snapshot aesthetic of these photographers makes them tempting to group together. Yet each has positioned their work and career differently, and in doing so has established further dimensions for the field. The photo-diary structure of Hiromix's early project *Seventeen Girl Days* (1995) paid homage to Goldin's "Ballad of Sexual Depencency" (1986) whilst the youthful energy and lightness of the images communicated the informal and spontaneous circumstances of their capture. The inclusion of classic snapshot mistakes and the fluidity of its sequencing presaged the contemporary mania for self-documentation manifested in Flickr and social networking sites, while also

WOLFGANG TILLMANS
Still Life, Tel Aviv
1999

WOLFGANG TILLMANS
Lutz & Alex, Climbing Tree
1992

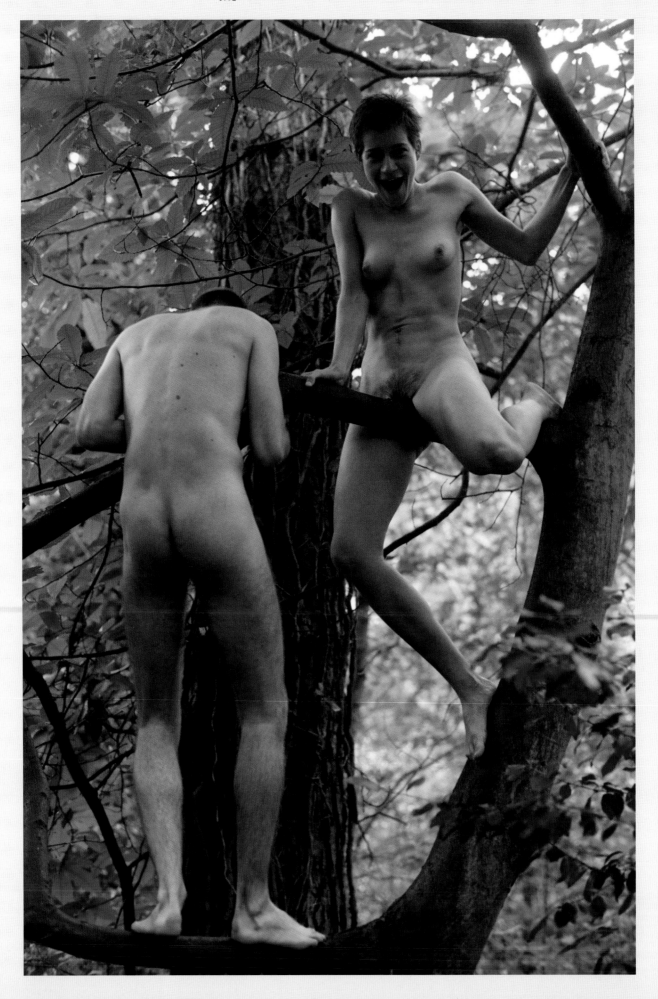

placing her work firmly in the tradition of Japanese artist Nobuyoshi Araki, who judged her the grand winner of Canon's New Cosmos of Photography competition that year. The reflexivity of Hiromix's work has gradually become more metaphorical, however, shifting from her initial erotically charged self-portraits and vivacious shots of the lives of her friends toward an outer view of the world, which is manifest in her contemplative landscape shots and observational views.

Juergen Teller has also enjoyed success in multiple contexts, shifting the emphasis of his imagery onto his authorship, which has become its unifying factor. Imagery originally conceived as part of his editorial commissions is often sold through art galleries, and projects originally published as advertising imagery for Marc Jacobs and Vivienne Westwood have also been turned into art books. When not engaging with fashion portraiture, however, his imagery touches upon traditional domestic snapshot themes: self-portraiture, family imagery, nature studies, and personally significant locations.

In marked contrast, it is important to Wolfgang Tillmans that his imagery is understood as art and not fashion. In 2004, the photographer wrote to *Artforum* to correct their misconception, as he saw it, that he was a fashion photographer[2]. Though he had published editorial work in style magazines such as *i-D* and *Interview*, he argued, his agenda was always as an "exhibiting artist" and he never accepted advertising commissions. Certainly, Tillmans' work is most affecting and powerful in book and particularly exhibition form, where his signature installation schemes, with their maverick rhythms and internal codes, echo the language of a domestic display of photographs. In this way, Tillmans has used not only the content but also the traditions of arranging vernacular photography to assert informal imagery as art.

Away from the art world and back to the everyday— where most informal photography takes place, after all— we are being told the analogue snapshot is swiftly becoming a memorial not just to the subjects it depicts, but also to itself[3]. The discontinuation of beloved film and paper formats promises a diminishing range of pictorial effects and prints, while the presence of 'delete' buttons on digital cameras gives the photographer unprecedented opportunity to prevent those happy accidents that are so central to the snapshot's visual vocabulary.

The threat of material photography's obsolescence or rarity is of course a clarion call to collectors. Since the end of the 1990s, an increase in collectors acquiring vintage amateur snapshots has been supported by a burgeoning academic interest in vernacular photography, resulting in major survey exhibitions at the San Francisco Museum of Modern Art, the Metropolitan Museum of Art, and the National Gallery of Art in Washington, DC[4]. And yet, rather than sounding the death knell for snapshot photography, such endorsement only reflects that the enthusiasm for this resilient medium can coexist in museological, art world, and populist circles simultaneously.

The art exhibition and the photographic book may no longer be the youngest generation of contemporary photographers' favorite modes of dissemination—they can communicate more spontaneously, effectively, and farther via the Web. Many amateur practitioners have progressed

JUERGEN TELLER
*Untitled (from the series
Ed In Japan)*
2006 (left and right)

JUERGEN TELLER
Untitled (from the series Ed In Japan)
2006

MARK BORTHWICK
Day Breaks In
2002 (left)

Love Will
2000 (right)

beyond the notion of the diary and are now self-publishers, as concerned with creating personal websites as they are with honing their photographic craft. For these image-makers, creating an online editorial platform has become as important a means of expressing their authorship and identity as the actual taking of images. It also offers photographers ultimate control: They can simultaneously act as commissioning editor, art director, picture editor, and graphic designer. As the ubiquity and expediency of digital camera technologies increasingly erodes the photographer's exclusivity, editing and curating imagery offers alternative means of asserting taste, connoisseurship, and photographic intent. In creating new contexts to show informal imagery, photographers are constantly preventing the snapshot's museum-ification, guaranteeing its new futures.

1. Charlotte Cotton, *The Photograph as Contemporary Art* (London: Thames & Hudson, 2005), pp. 137–165.

2. Wolfgang Tillmans, "Corrective Lens," *Artforum*, Vol. XLVII, No. 5, (January 2004), p. 18.

3. Joel Smith, "Roll Over: the Snapshot Museum's Afterlife," *Afterimage*, Vol. 29, (September–October 2001), pp. 8–11.

4. "Snapshots: The Photography of Everyday Life from 1888 to the Present," (1998), the San Francisco Museum of Modern Art and "The Art of the American Snapshot 1888-1978," (2007, the National Gallery of Art, Washington, DC.)

MARK BORTHWICK
Skips
1999 (left)

Together
2007 (right)

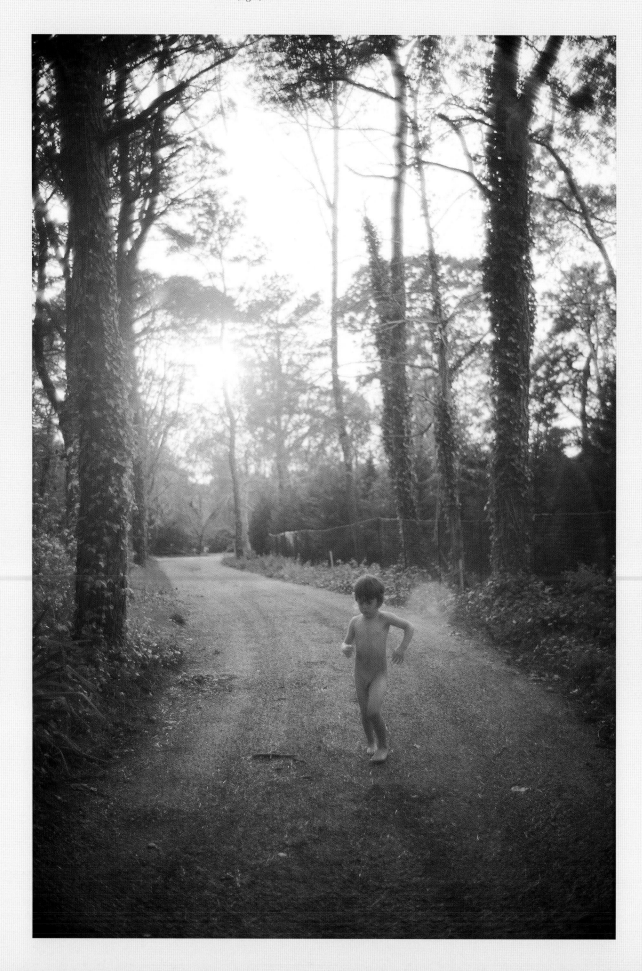

THE MOMENT
By Ken Miller

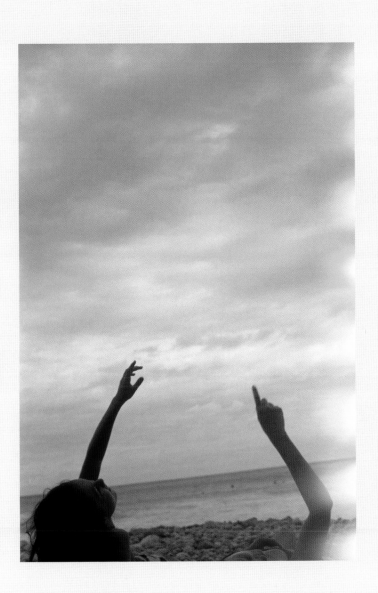

If we all take photographs does that make us all photographers? The answer is both yes and no. There is a clear difference between painting a house and painting a portrait, or between writing a contract and a book. Anyone who puts brush to canvas or who has the diligence to attempt to write a novel is choosing to engage in a deliberate aesthetic act. At the outset, it doesn't matter whether the work produced is good or not, since we can consider the ambition independently from its result.

The intentions behind most photographs are unclear: We aim to document—to capture a moment, a landscape, or a person. Hopefully the photograph looks good or at least conveys the proper sentiment, but the act of taking the picture is not necessarily a declaration of aesthetics. When the casual photographer creates a beautiful image, more often than not it's a happy accident. Those images are saved while the vast majority of photographs are discarded. The distinction between a person who takes a photograph and a professional photographer is that the professional shoots pictures for a living, or at least attempts to make a living from his or her photographs. This implies a deliberate engagement in aesthetics and the ability to produce on demand the desired image—which makes it confusing when a professional photographer deliberately takes photographs that look like those of an amateur.

Photography of the ordinary has a long lineage, beginning in the earliest days of the medium and flourishing with the iconic '60s and '70s color work of, among others, William Eggleston, William Christenberry, Joel Sternfeld, and Stephen Shore. To oversimplify somewhat, these photographers began with the language of documentary street photography but were influenced by Pop Art, photographing the brightly colored bric-a-brac of an ascendant consumerist culture. Parallel to the growth of mass-market media, they engaged with the aesthetics of the increasingly dominant consumer economy. Their images captured the new American vernacular with a heroic flatness, and their coolly observational approach has influenced contemporary photographers whose work manufactures a staged distance that provides its own discomfiting emotional resonance. We share in the photographer's gaze, but we are removed from their experience. It is not *ours*.

So what happens when a photographer not only engages

ARI MARCOPOULOS
A.168
2008 (left)

3.62
2008 (right)

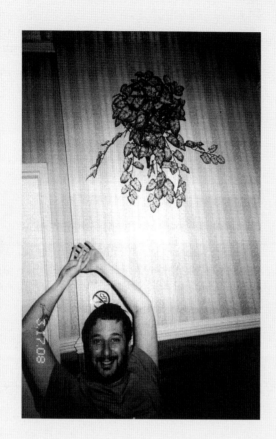

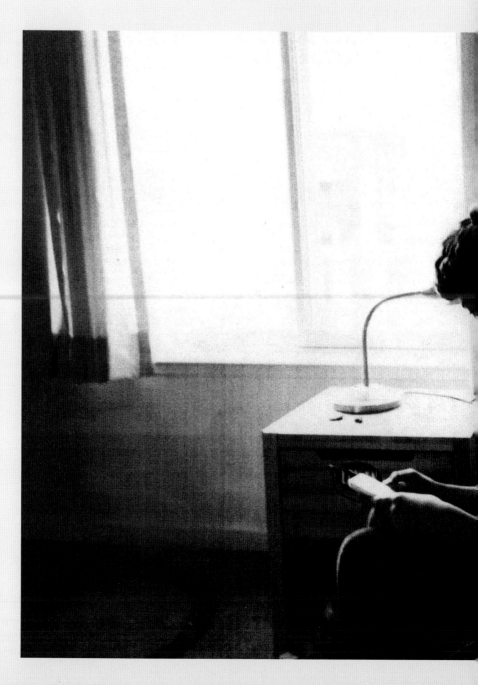

4.23.08

with the subject matter of everyday life, but also adopts the appearance of amateur photography? We are invited to be participants in the photographer's experience, and this enforced intimacy further blurs the line between amateur and professional. This is, to some degree, the point: We are being shown our own images, in both subject and form. And in so doing, the photographer is engaging a visual culture that has progressed beyond a simple (and slow-to-evolve) two-way interaction between artist and subject. To use contemporary digital vernacular, these photographers are searching for image capture through the most immediate means possible, a process of involvement and documentation that speaks to the ways we increasingly define our lives through images, to the point where the creation of an image can provide both definition of self and creation of memory.

We now live in an era where the notion of a passive subject is increasingly obsolete, as we are more often than not deliberately manufacturing our own images. As the consumer economy has become all encompassing, consumer media has become a dominant form. The intention behind a photograph posted on the Internet can be unclear—is the person behind the camera an amateur or a professional and is that self-distinction relevant to our appreciation of the image? One result of living in an increasingly image-saturated culture is that, just as we increasingly use images to define our identities, our appreciation of a photograph is often defined by its context. Just one photo-sharing site (Flickr) contains well over two billion images—and that number is a tiny fraction of the photographs being reproduced on the Internet and in other media, not to mention the innumerable photographs being taken for personal documentation. A photographer who chooses to deliberately present us with a seemingly off-hand, disposable image in a fine art or editorial context is also offering a significant commentary on the evolving meaning of the photographic image. These photographers are not just documenting the mundane. They are creating mundane documents.

I should say here that what would seem at first glance to be the simplest, most casual pictures are often the most difficult to take. Generally, when we shoot a photograph, it is because we are invested in the moment. And what better captures the emotion of a moment, the stilted arrangement of a staged portrait or the fluid vocabulary of a snapshot? Yet it is extremely difficult for a photographer to re-create that perfectly imperfect image—one that does not seem deliberate, yet responds to the moment with deftness and flexibility in order to successfully convey the dynamism of an inadvertent gesture. Or, as any comedian from Charlie Chaplain to Chevy Chase will tell you: It's hard to fall correctly all of the time. The more fluid the situation, the more transient the window of success and the greater intuition and reflexive skill required in creating an effective image.

The work presented in *SHOOT* is varied, and the photographers can hardly be called a cohesive school, hailing as they do from Europe, the Americas, Australia, and Asia. They are part of a global network of media-makers, a community that can generously be said to include anyone with a digital camera, computer, and access to the Internet (a democratization of image-making tools that began with single lens reflex cameras and drugstore processing). Beyond observing and

HIROMIX
Paris Airport
No date

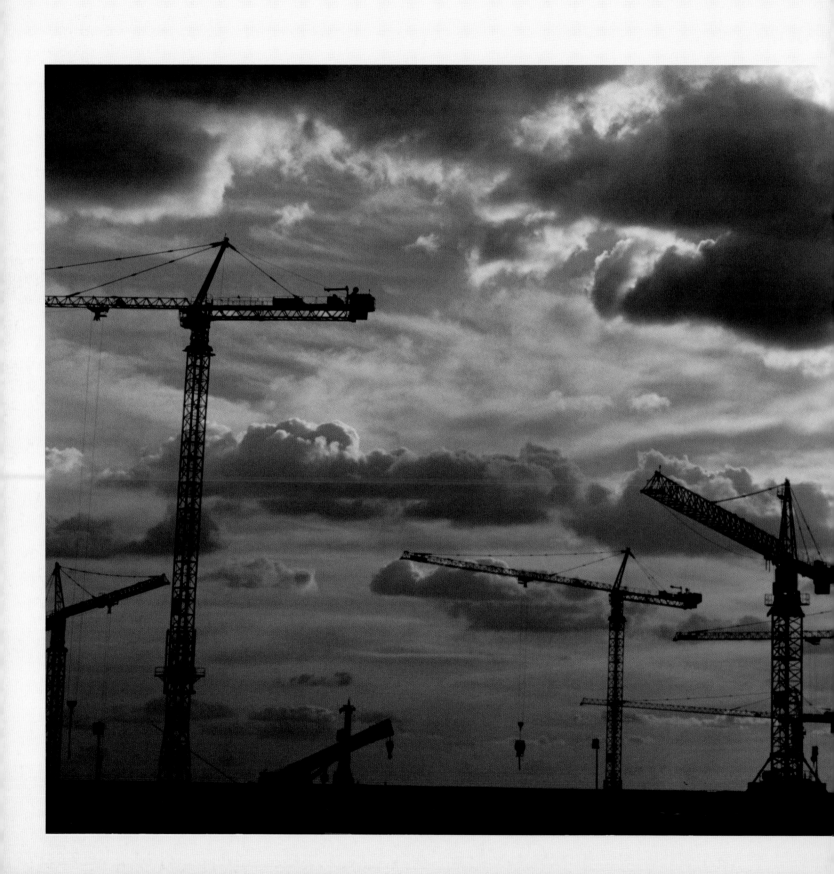

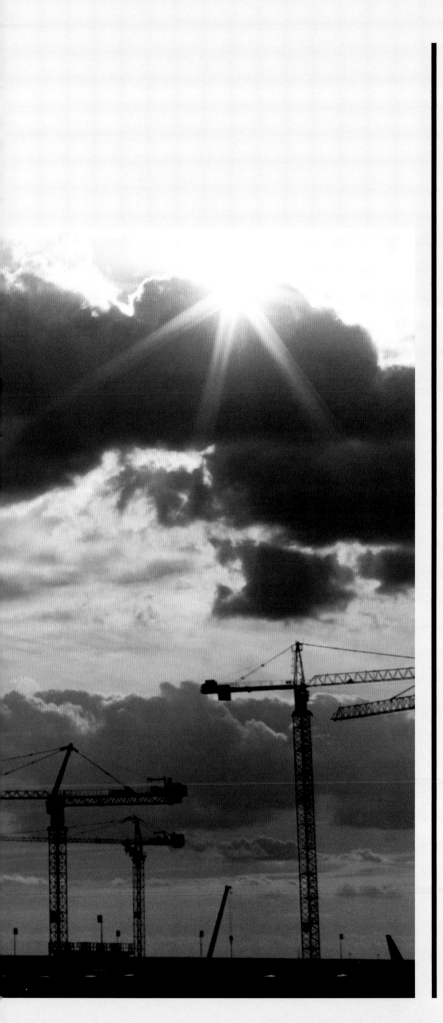

commenting on consumer media, they are actively involved in it, using tools readily available to any consumer. What these images all share is a sensation of engagement: The photograph is 'of the moment' and thus draws you into the photographer's experience. All of these photographers are seeking something simple by using the simplest tools available. That simple thing—a fleeting moment in life or the shifting quality of light—is the ephemeral. It's a nearly impossible quality to describe. You know it when you see it, and when you see it you need to be able to photograph it instantaneously.

But what if the image that best captures the subject and the moment is an image that most photographers would discard? The reasons for dismissal would be obvious. (The focus is blurry; the subject has her head turned away; the landscape is not resonant.) With the delete button on digital cameras, we make these aesthetic choices constantly and, generally, without much deliberation. By choosing to keep photographs most would discard—and by specifically selecting these pictures for display—a photographer is making a very deliberate choice; they are announcing that they see qualities in the image beyond the technical concerns of 'correct' photography. They are using the photograph to capture a feeling as much as a subject, and the process of selecting an image for display only heightens that subjectivity. The photographer is now the subject as much as whatever is shown in the photograph. We look backward through the camera's lens, interacting with the photographer's experience. Through movement, dynamism, forced closeness, deliberate awkwardness, or personal intervention, we are invited or forced to participate in the moment of the photograph.

The photographers collected in *SHOOT* all reflect some of the dominant tendencies in our interactive usage of images. JH Engström, Yurie Nagashima, and Linus Bill photograph their families and homes, following in the footsteps of Nan Goldin by choosing to present intimate details of their own lives. Tim Barber, Thomas Jeppe, or Madi Ju, reflect the influence of Stephen Shore by engaging in a mildly obsessive documentation of their daily surroundings. Michael Schmelling and Paul Schiek's engagement with the mysterious intensity found in 'wrong' photographs, and Jason Nocito's creation of personal archival images that look like commercial clip art, follow in the tradition of the German photographers Wolfgang Tillmans and Juergen Teller by taking a more formalist approach to consumer photography. Hiromix, Dash Snow, and Jaimie Warren, are manufacturing (arguably false) narratives using the language of personal documentation. And Mark Borthwick, Glynnis McDaris, Peter Sutherland, and Louise Enhörning, manifest an urge to heighten and intensify the familiar. What they all also share is a romantic engagement with the everyday and a conviction that there is no wrong subject for a photograph. There are no wrong photographs at all—just the moments we choose to photograph and photographs we choose to save.

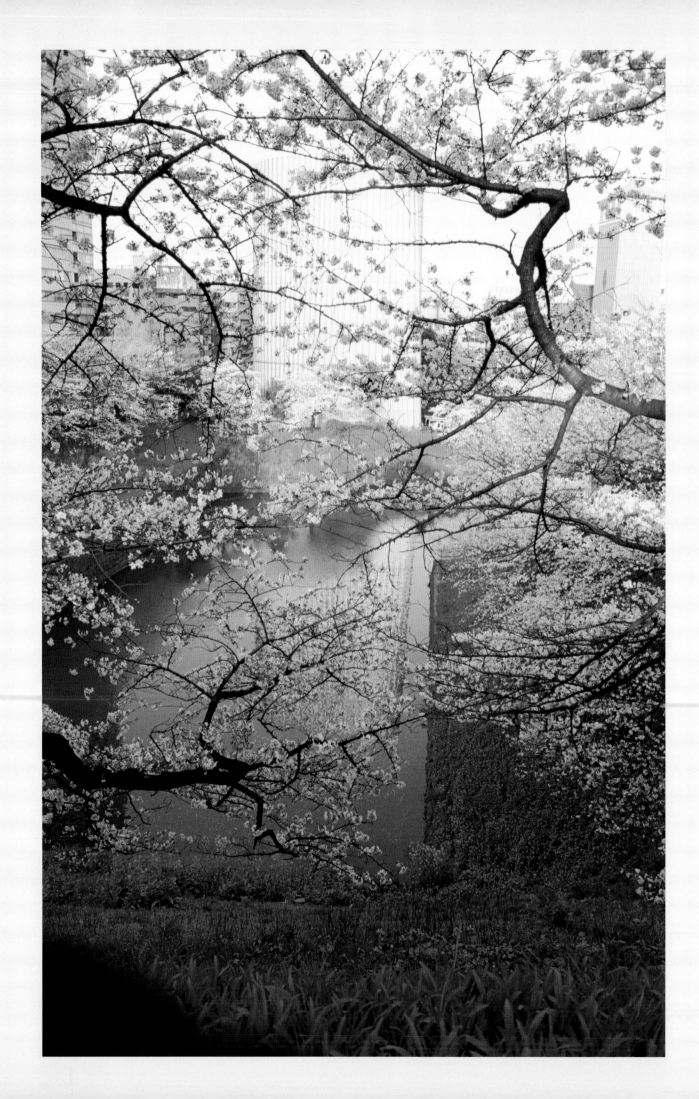

Fountain at Dawn
Jackson, TN
2008

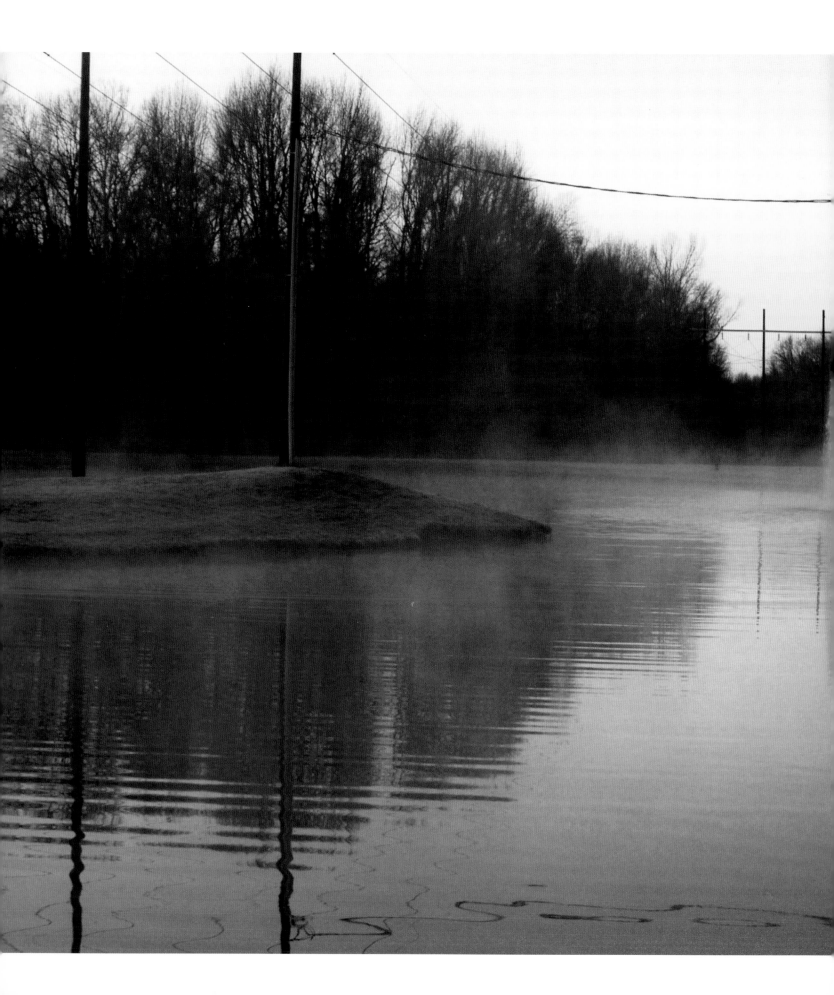

GLYNNIS McDARIS

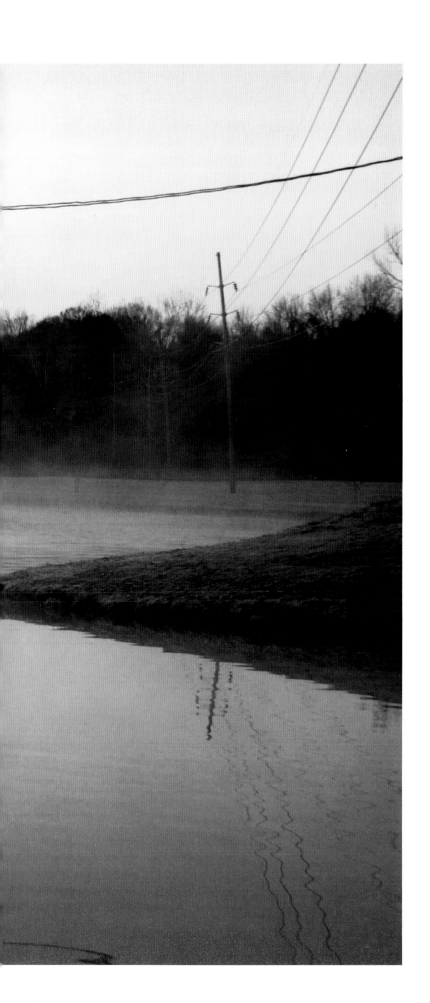

Born in Memphis, Tennessee, Glynnis McDaris lives and works in New York City. The American South (and her second home in rural New York state) still informs her work, which exhibits a dreamy quality of tranquil contemplation. "I like things that are calming yet charged," she says. "It's about the energy that's conveyed first and then the formality of the image... Lately, the more abstract the better." In addition to publishing photographs in *The Vice Photo Book* and numerous magazines, McDaris was curator for *Catholic*, with an exhibition and accompanying book published by D.A.P./Evil Twin Publications. "Ultimately, I react to an energy or feeling" in a photograph, she says. "I have a desire to translate an atmosphere I know well into an image. I find that images made with this intention tend to be stronger, regardless of what the viewer imagines to be happening, because there's a sort of universal language of atmosphere, experience, and memory."

Mitch with Gates, Memphis
2004 (top)

Zipper with Blue Stocking
2002 (bottom)

Fountain, New York
2007 (right)

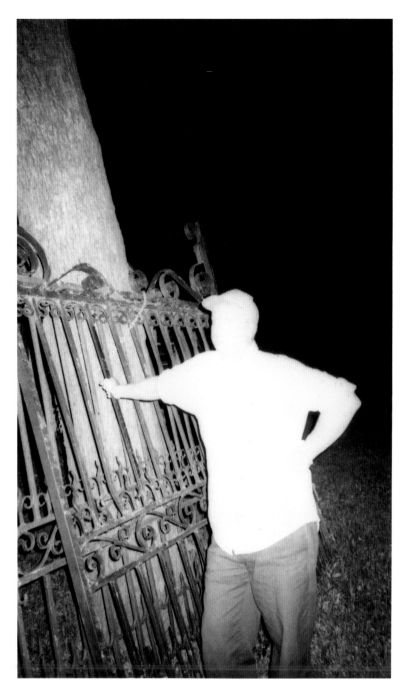

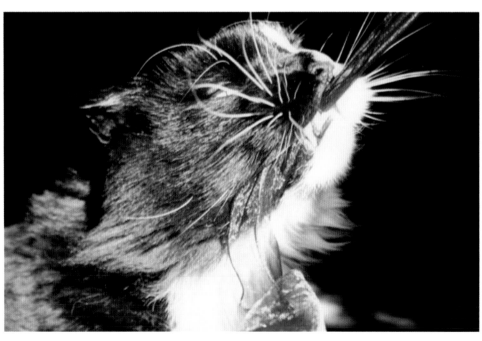

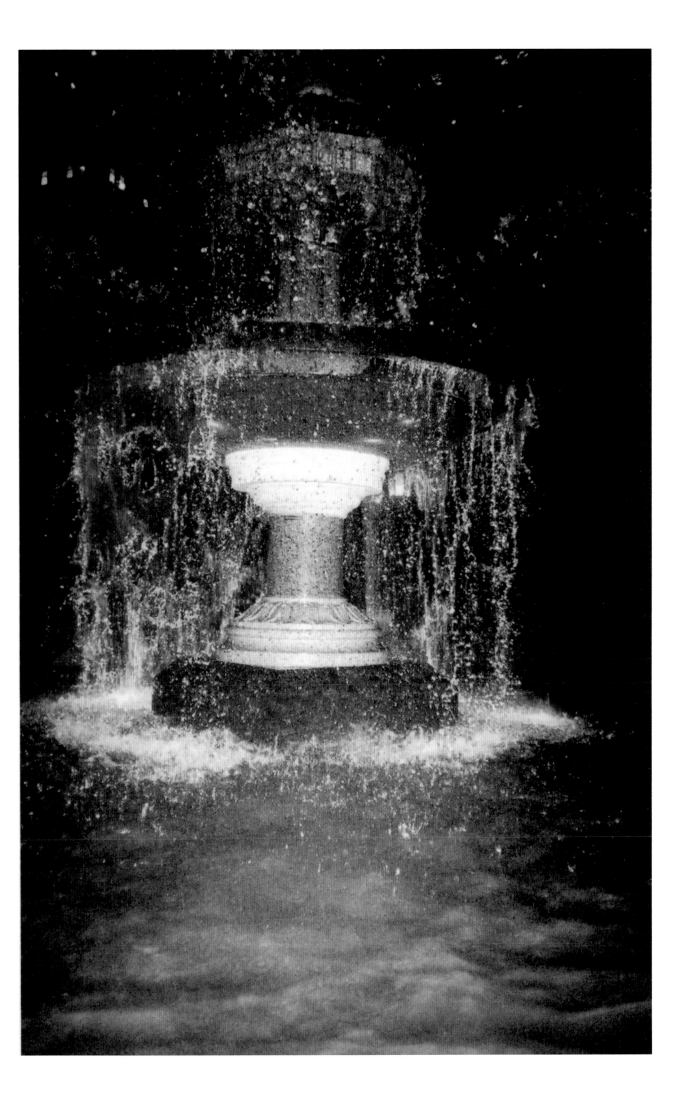

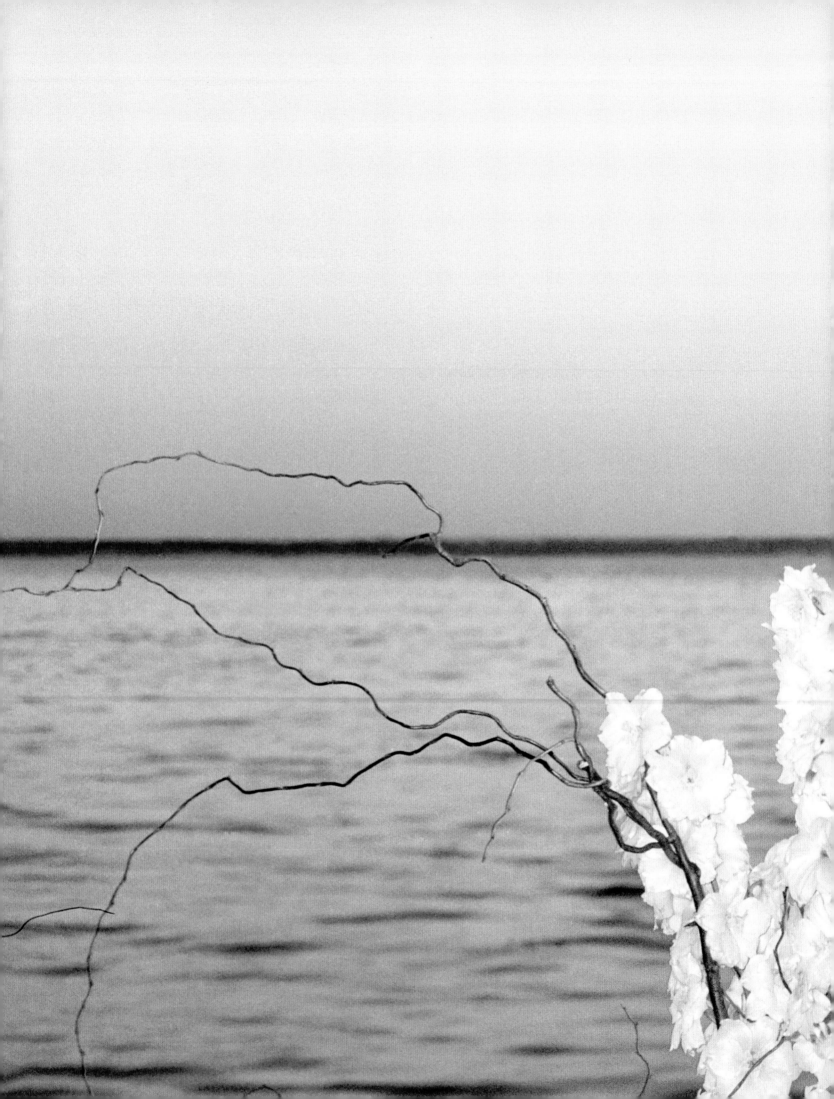

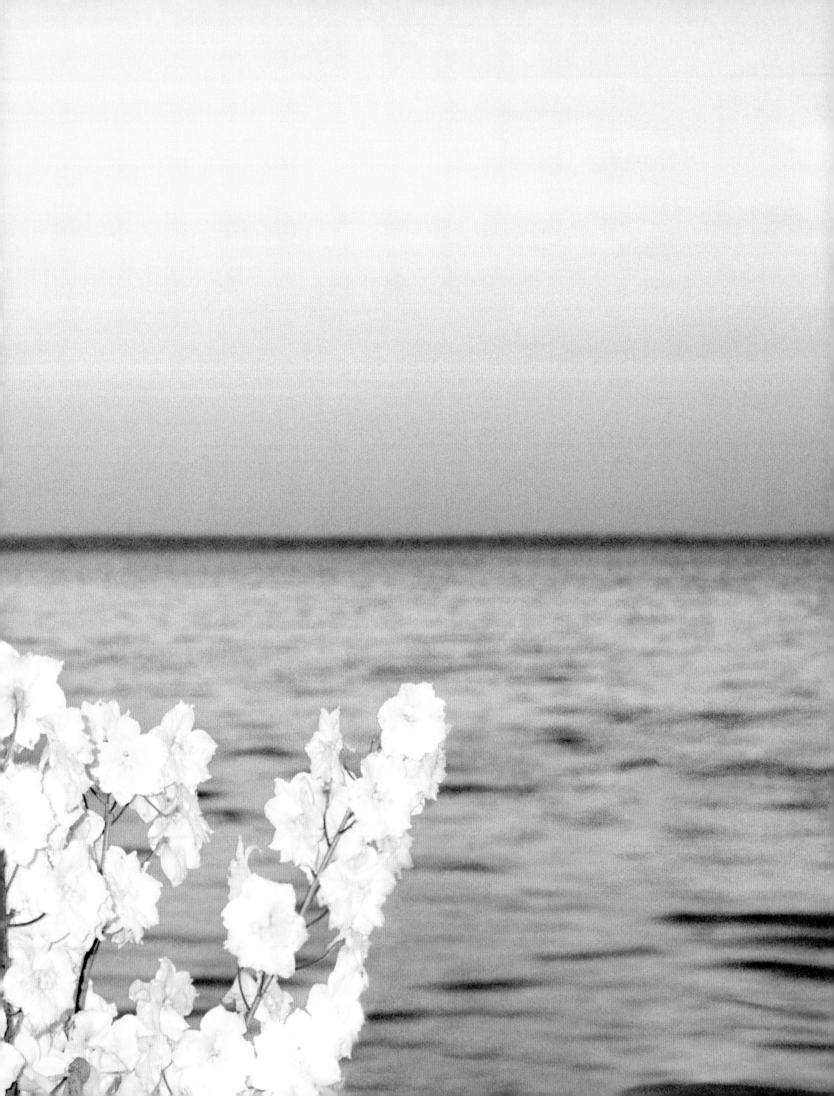

Provincetown Seascape
2003 (previous page)

Self-portrait
2005 (top)

Magenta Wetland
2007 (bottom)

Hot Tub, Mississippi
2004 (right)

The Tracks, Claverack, NY
2006 (next page)

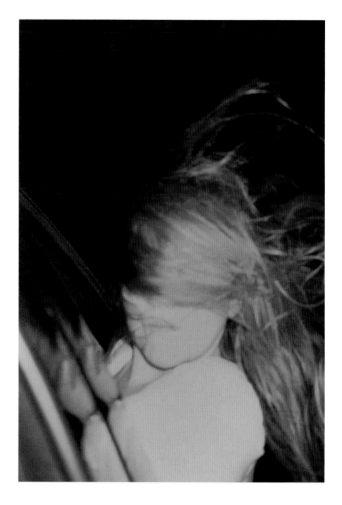

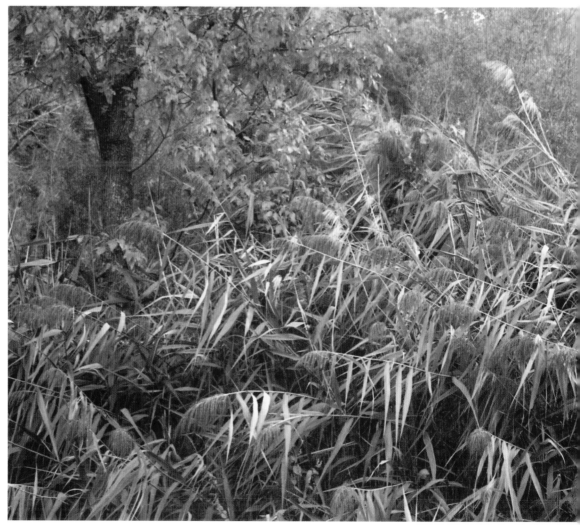

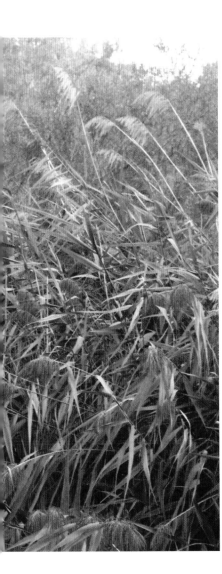

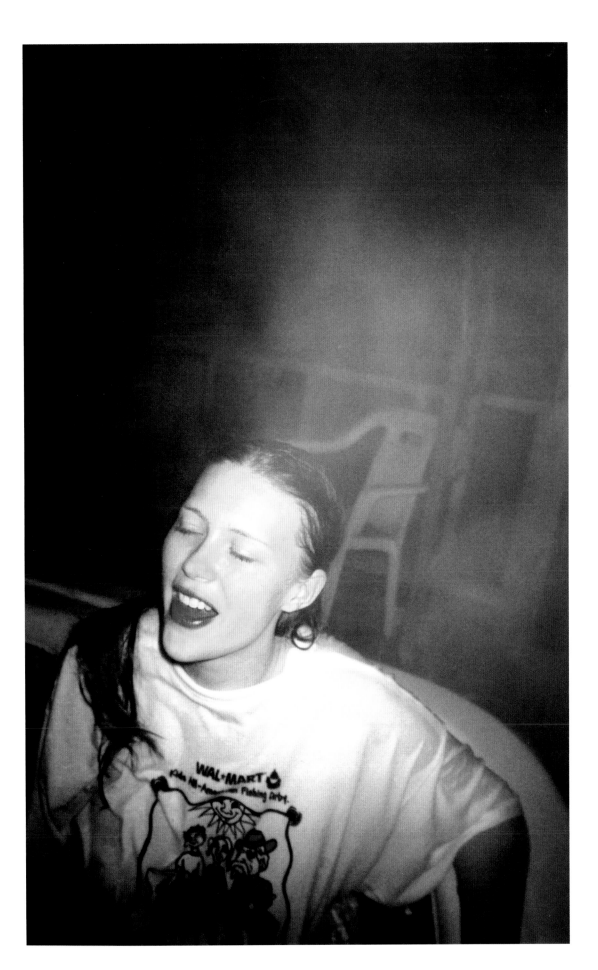

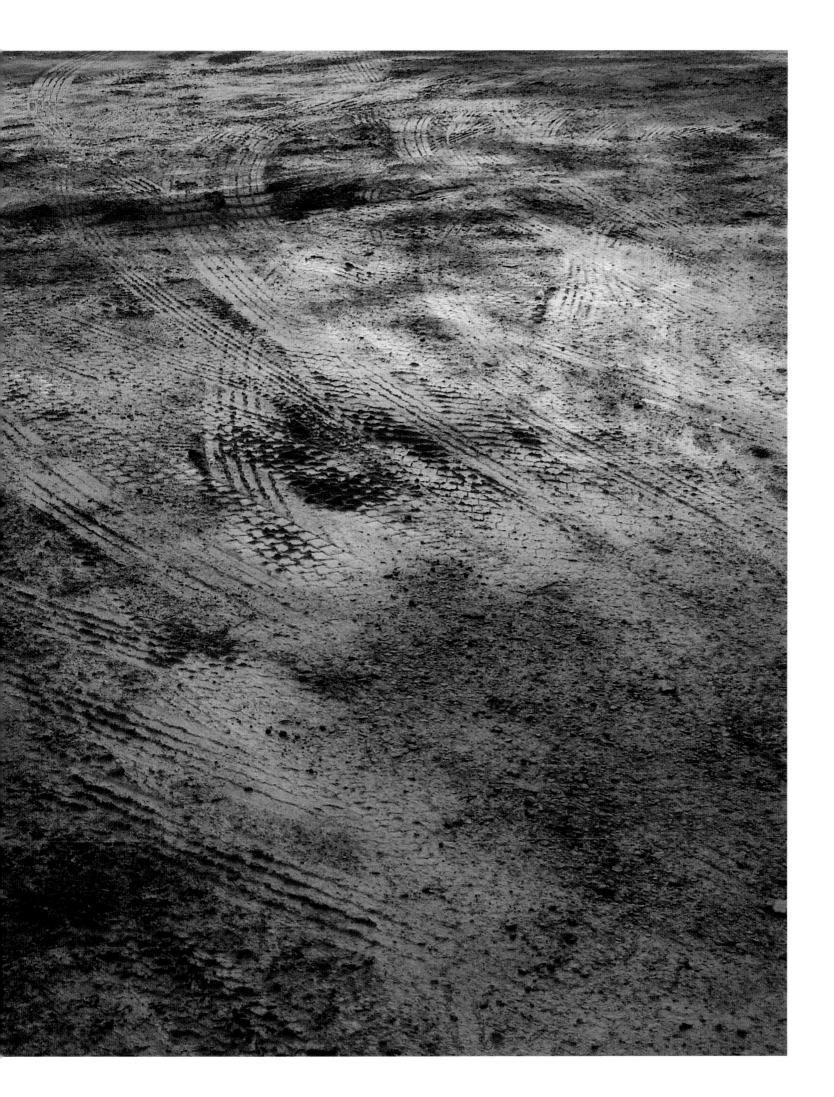

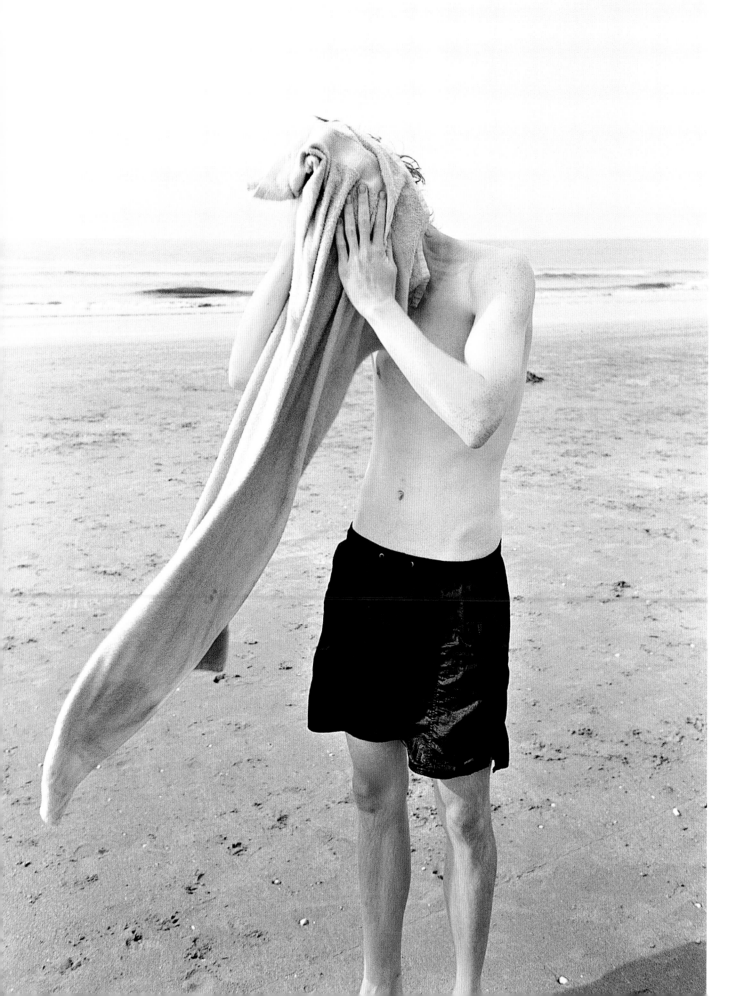

LINUS BILL

In describing his loose, seemingly offhand approach to photography, Linus Bill says, "I try to keep my technique as easy as possible, so that it does not get in my way." This informal approach reflects Bill's personal involvement with his subjects, most of whom are his family or friends, which lends his images a spontaneous, almost naïve quality. Born, and currently living in Bienne, Switzerland, he has published several zines with the Swiss imprint Nieves and the Scandinavian publisher Hassla, often using simple mono-color printing. This deliberately raw style reinforces the looseness of Bill's approach. "Errors are very welcome, and I constantly help them to appear in my work," Bill says. "It's much more about the selection of images than single ones." This accumulation of images only adds to our sense of involvement with the subjects of his photographs.

Untitled
2003 (previous page)

Untitled
2007 (left)

Untitled
2007 (center)

Untitled
2004 (right)

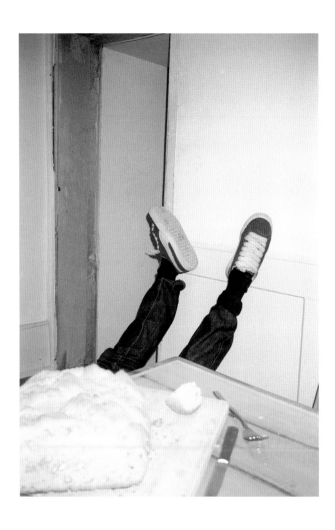

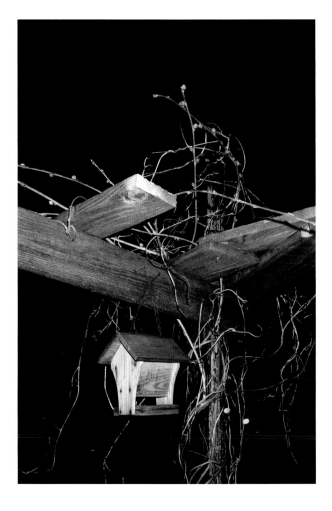

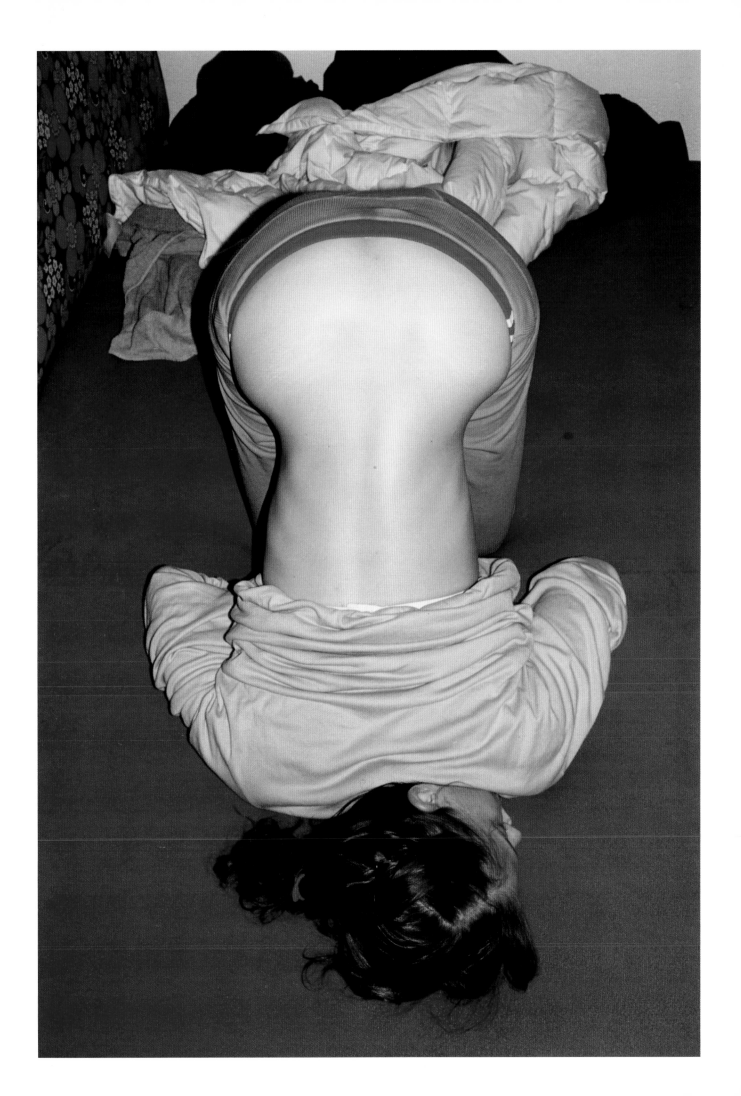

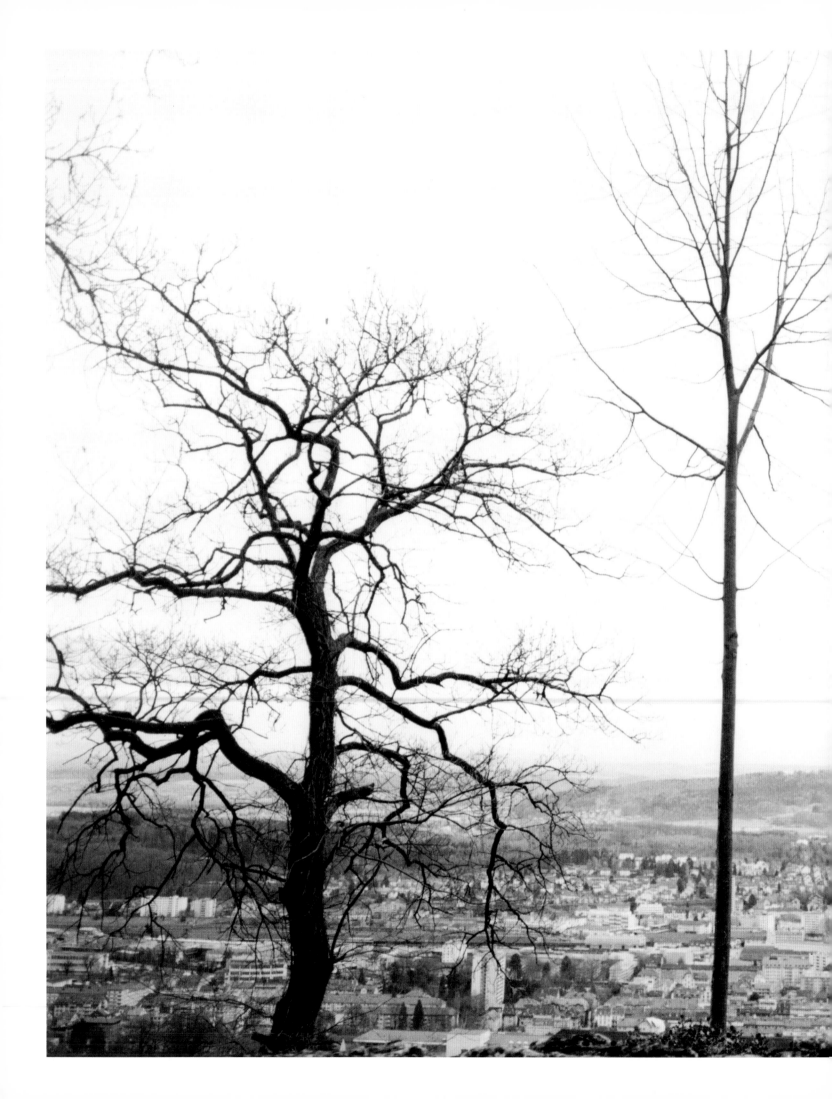

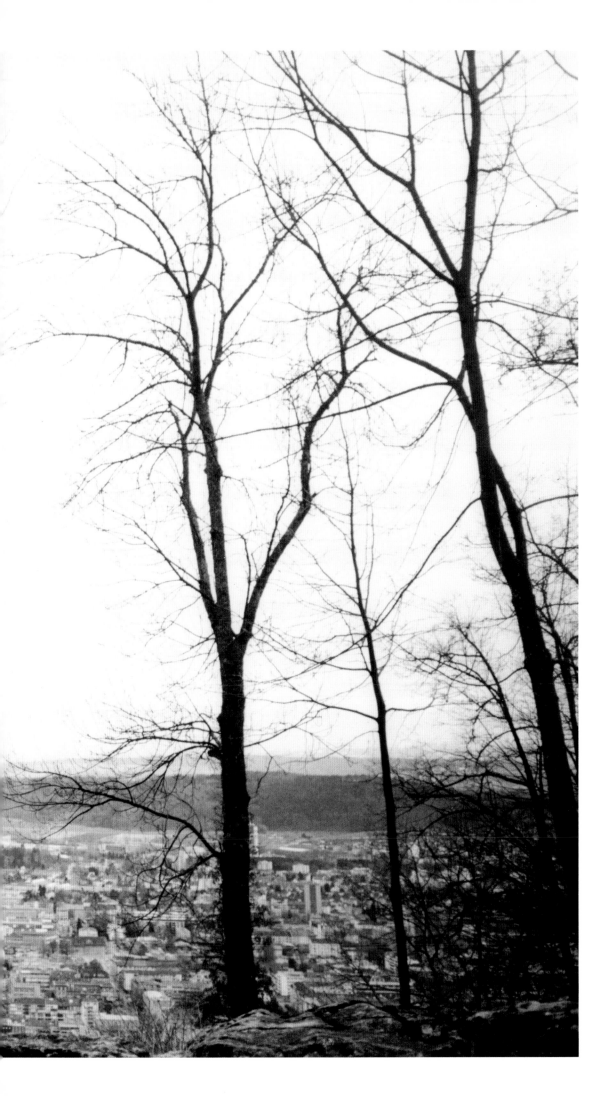

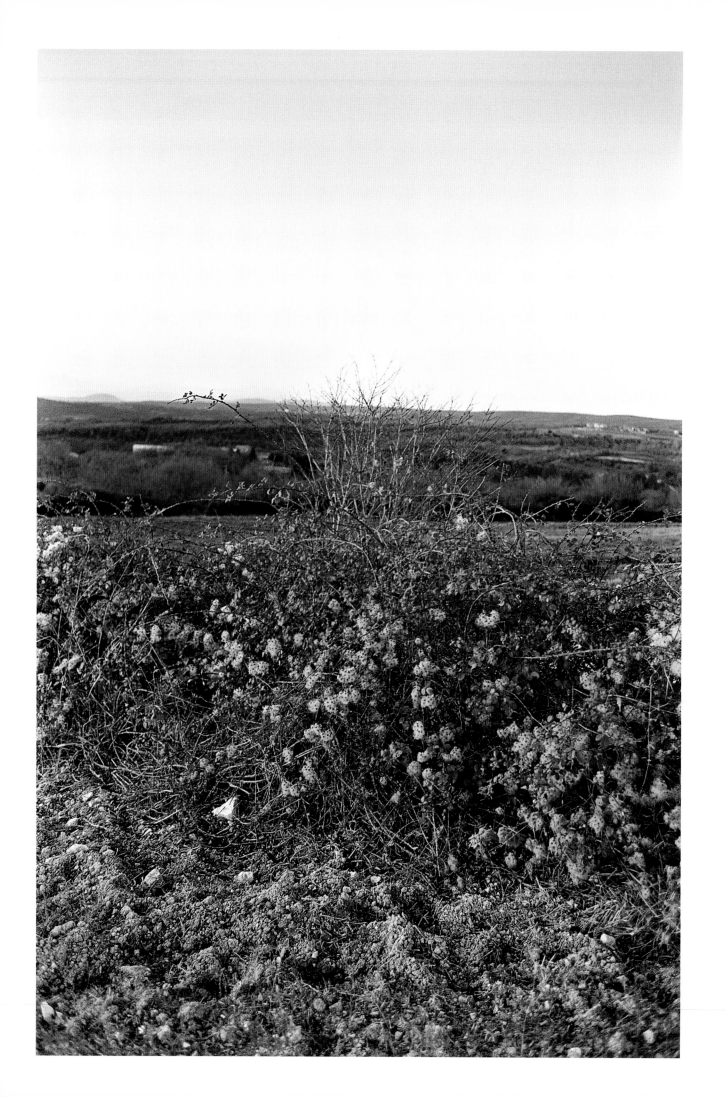

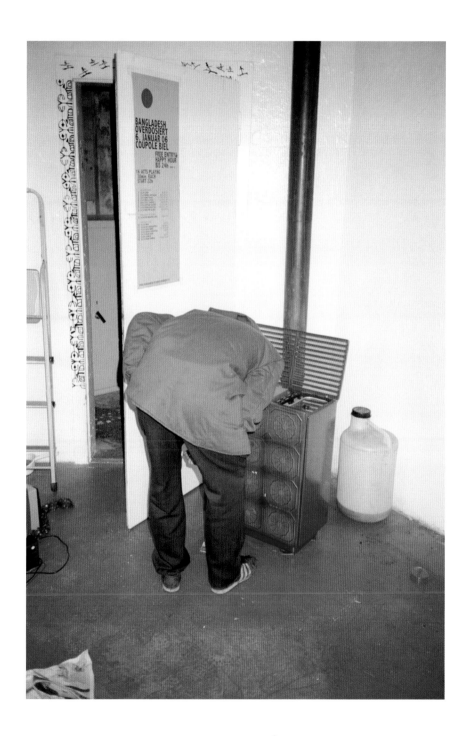

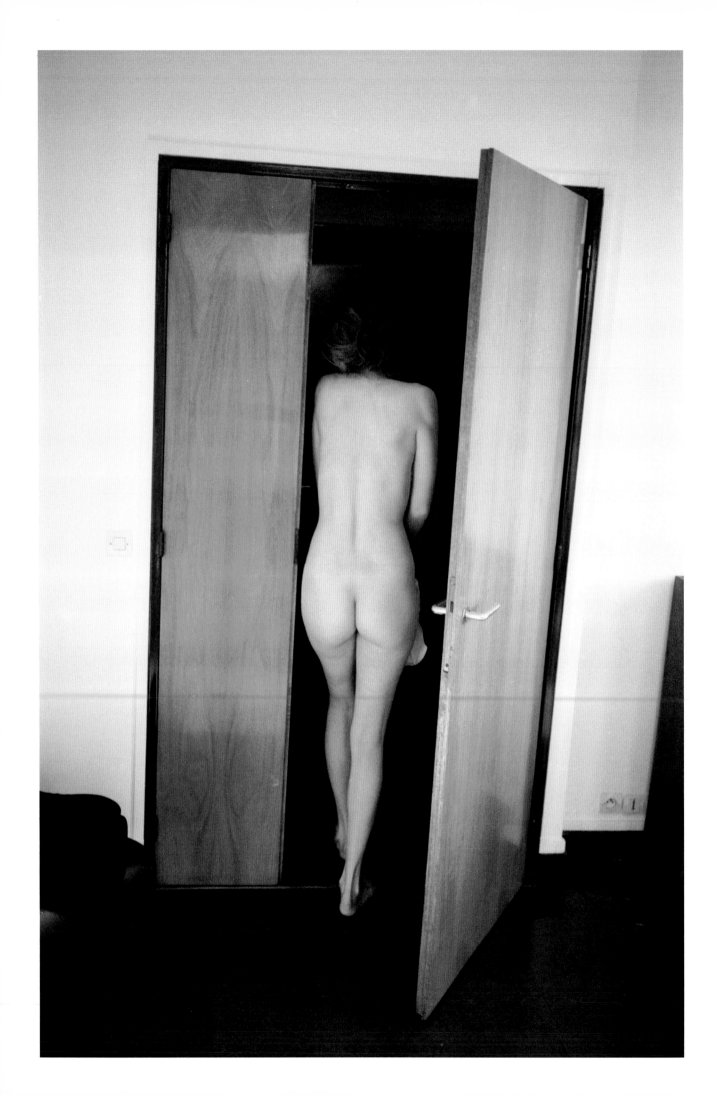

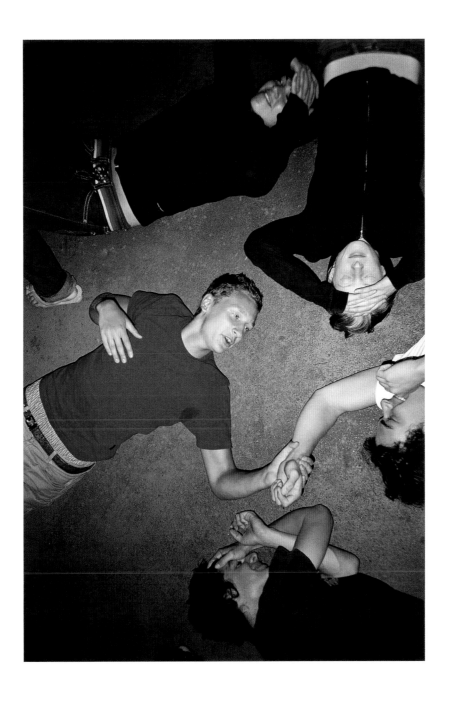

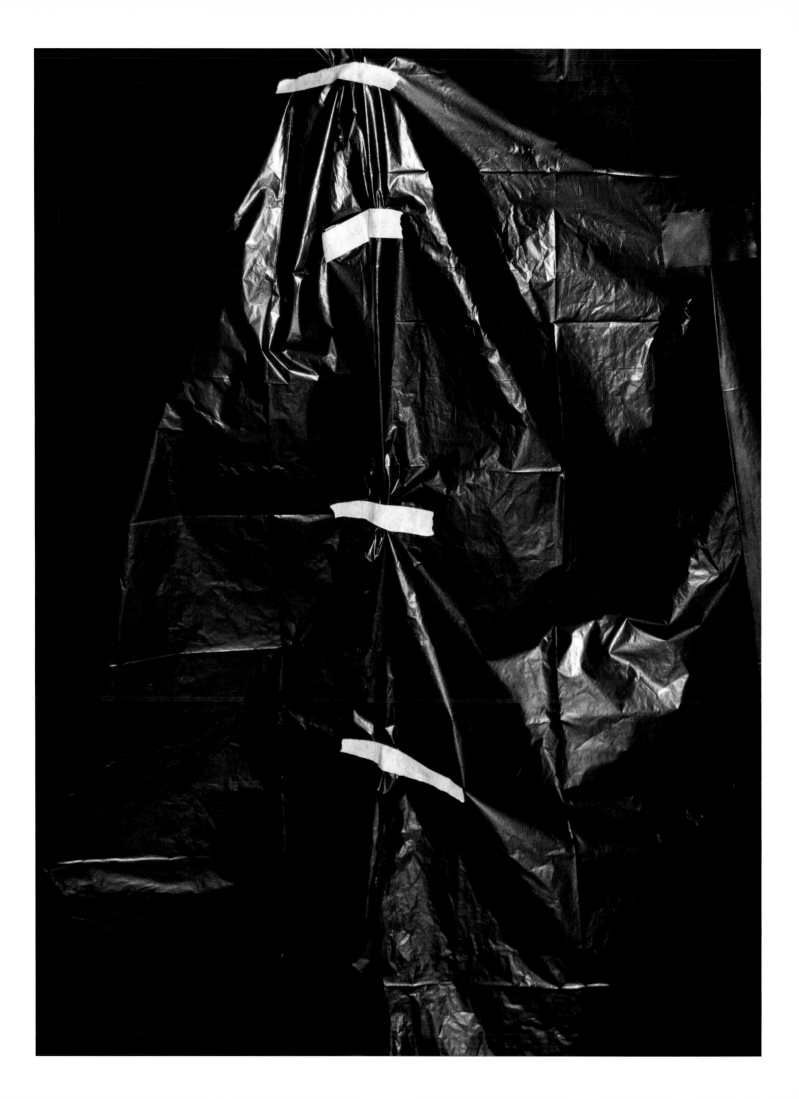

JASON NOCITO

"More and more photographs seem like good photographs to me," Jason Nocito says. "Not because I think they are actually good photos, but because my bar is so low now that I think anything can be a good photo." Born and raised in New York, Jason Nocito now splits his time between the city and Vancouver, Canada. After a series of documentary and editorial photo projects, his all-inclusive approach to photographs has now been most fully manifested in *Loads*, a book for the Aperture foundation and on his personal site, The Ego Has Landed. Intuitively associative, Nocito has established a remarkable imagistic vocabulary that enters into an uncanny dialogue with the effluvia of our consumer culture's visual output. "I like insinuating things by putting images together that provoke a reaction," he says, "but a reaction that you shouldn't necessarily trust."

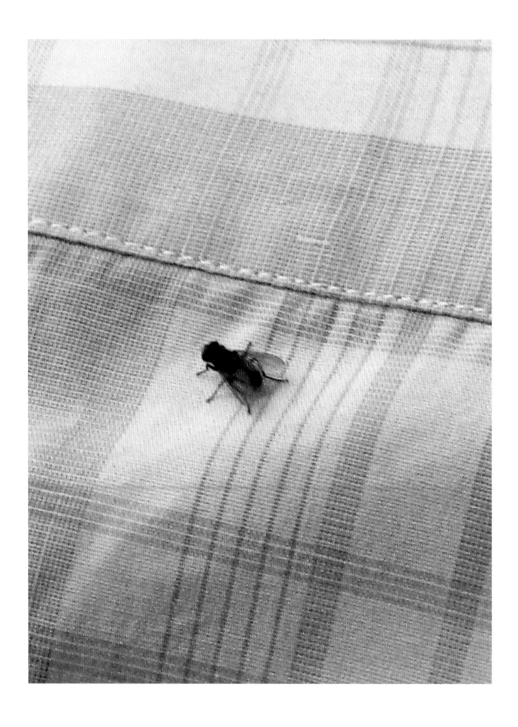

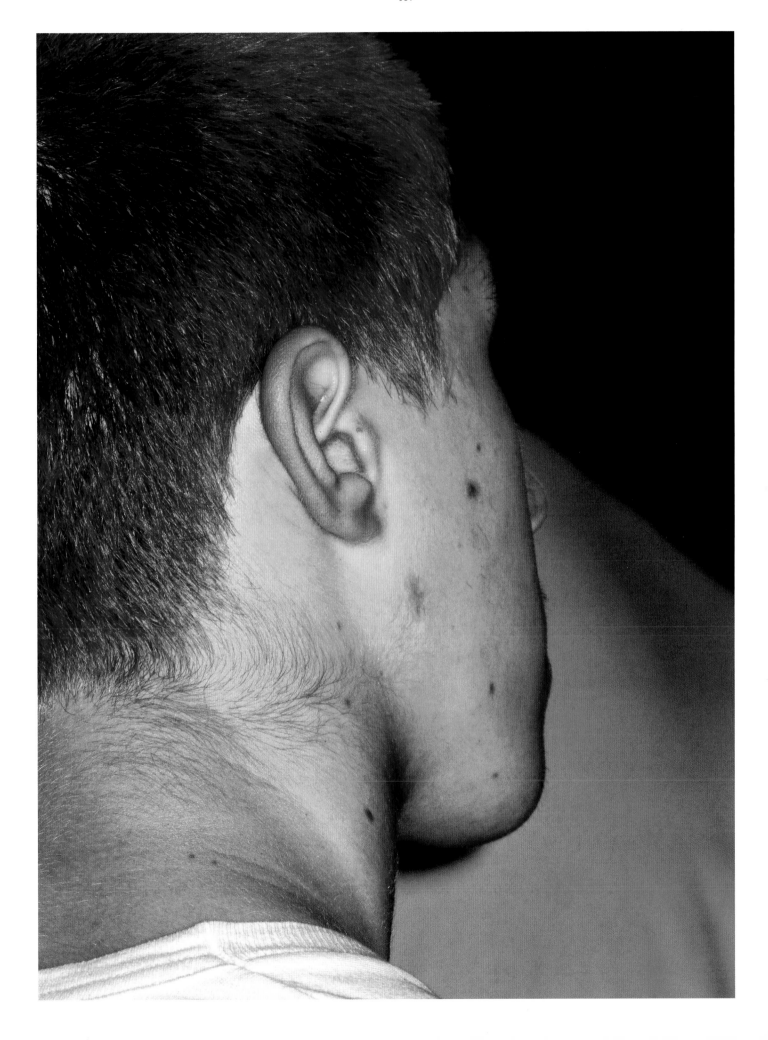

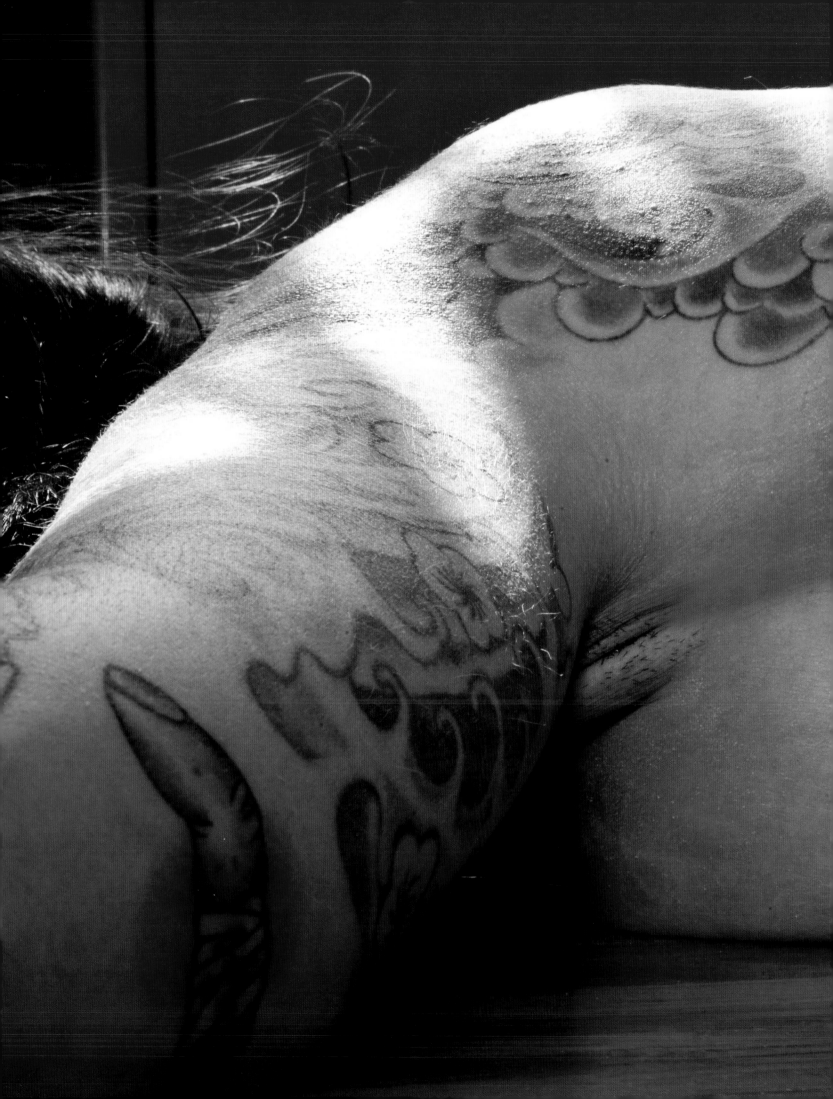

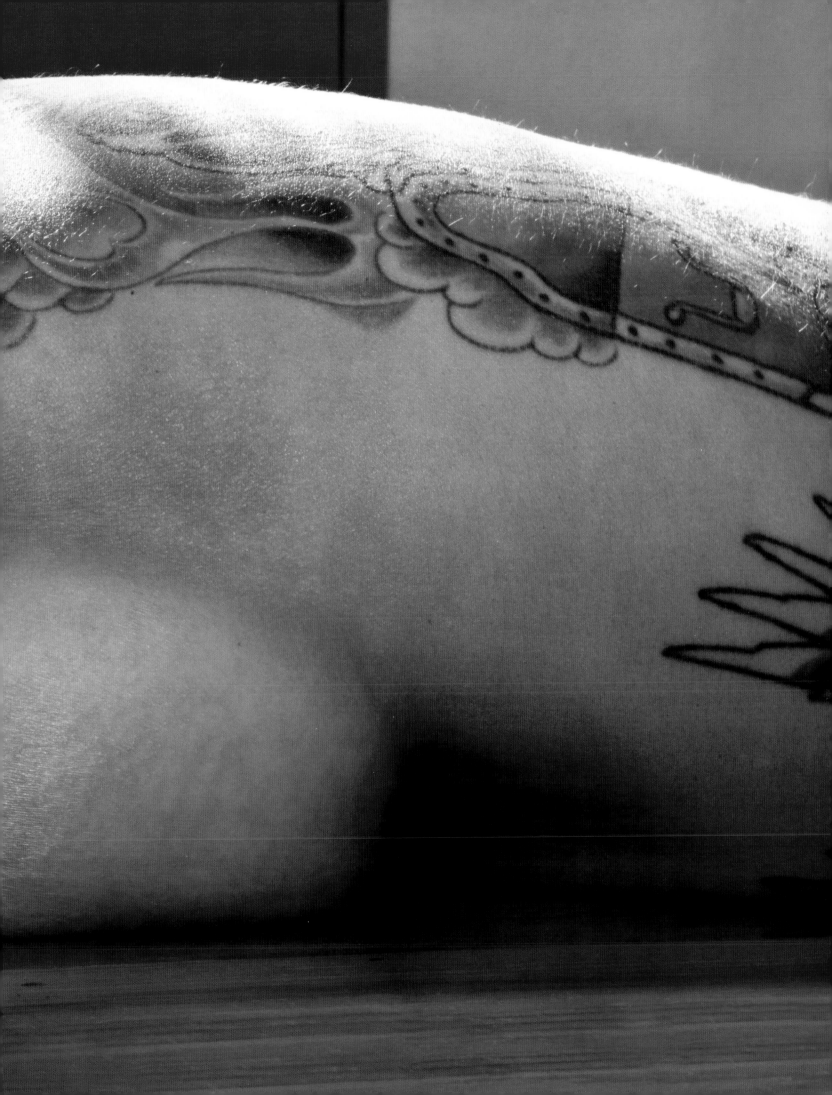

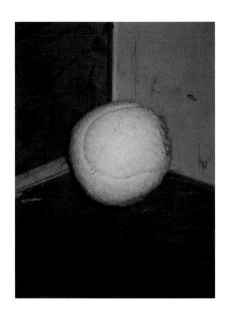

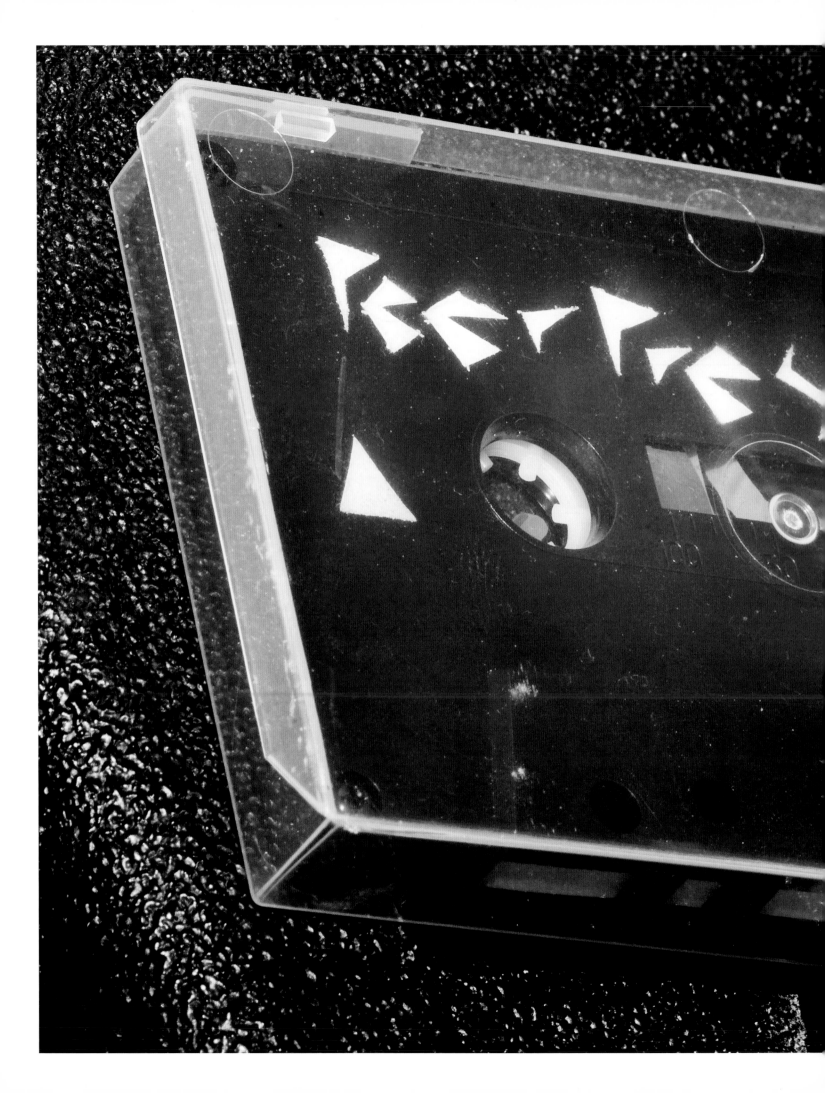

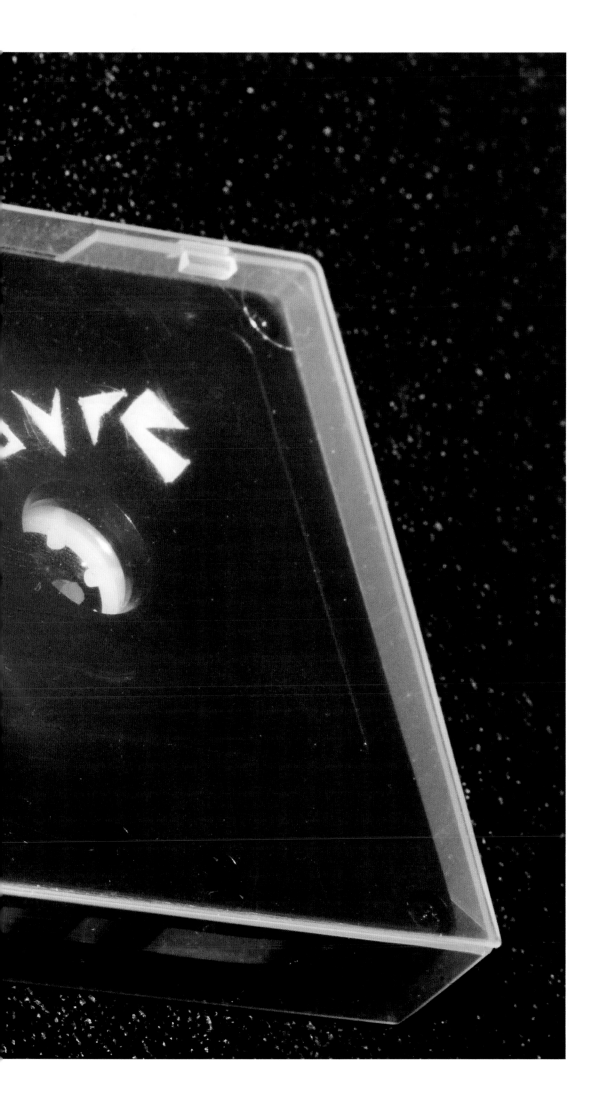

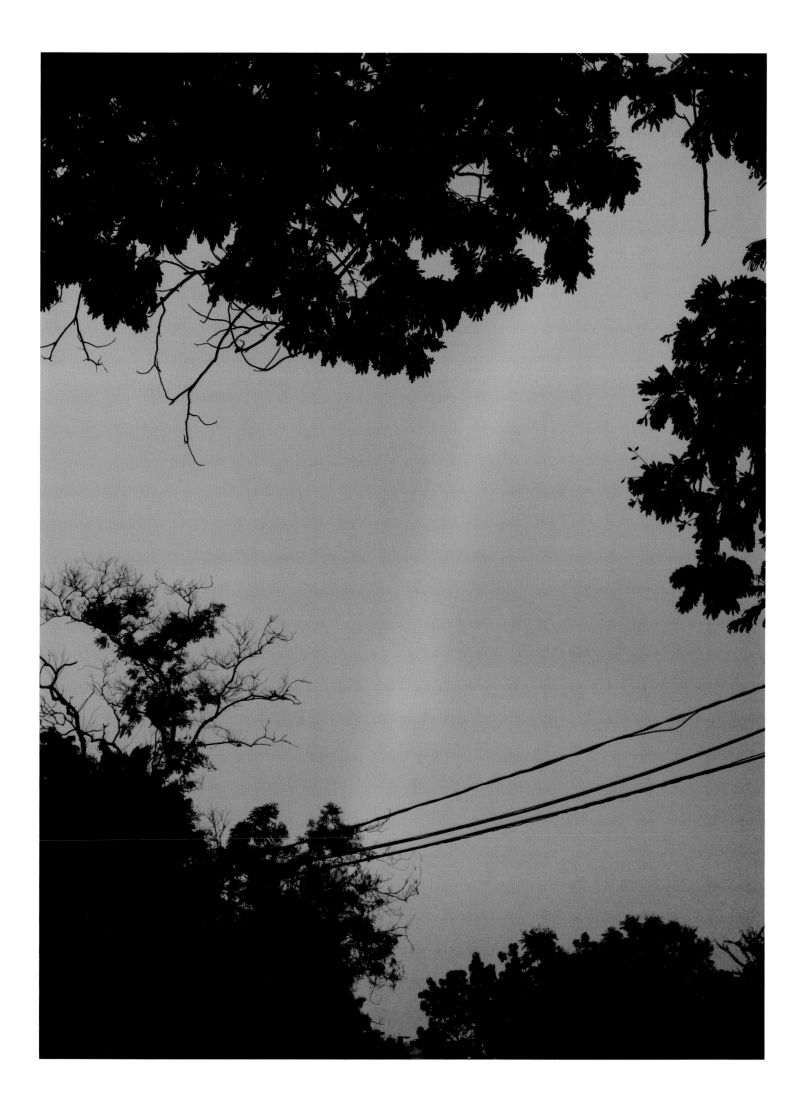

SECTION 8

EVOLUTION OF MAN

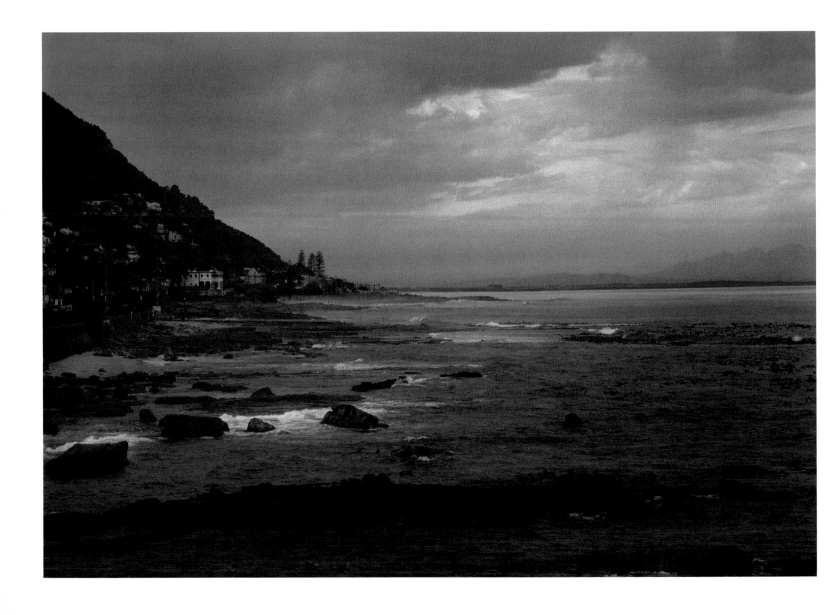

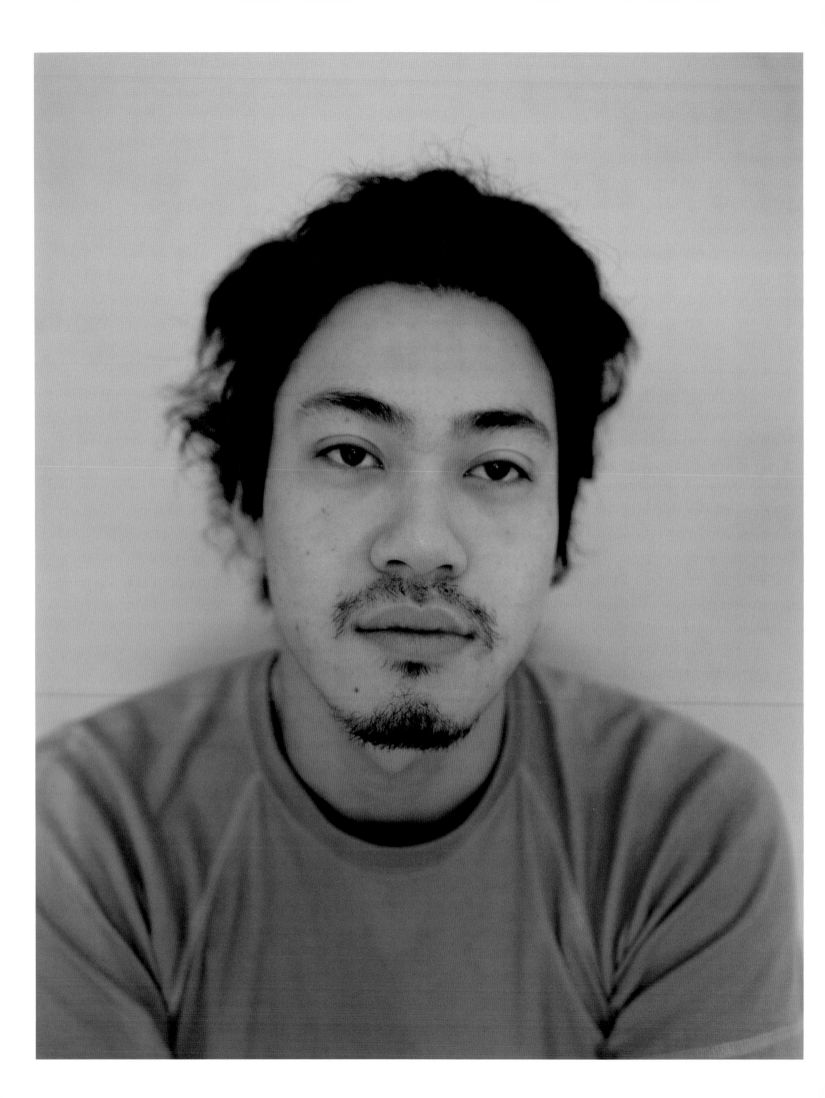

YURIE NAGASHIMA

Born and residing in Tokyo, Yurie Nagashima received acclaim in the 1990s, as a forerunner of a generation of female Japanese photographers. Finding the attention overwhelming, she relocated to the United States for several years, where she honed her intimate style. "I struggled for a long time with what I should shoot and how I should do it," she recalls. "After all of that, I feel like I have now chosen the easiest way to work. I always look to my own comfortableness, and my style strongly links to my lifestyle. I don't climb up a high mountain to go shoot, but I might look at weeds growing in my garden and take pictures of them." Over the past decade, she has published five books filled with images of her family, captured with disarming intimacy. "I like looking at someone I love while not letting him or her notice that I am looking."

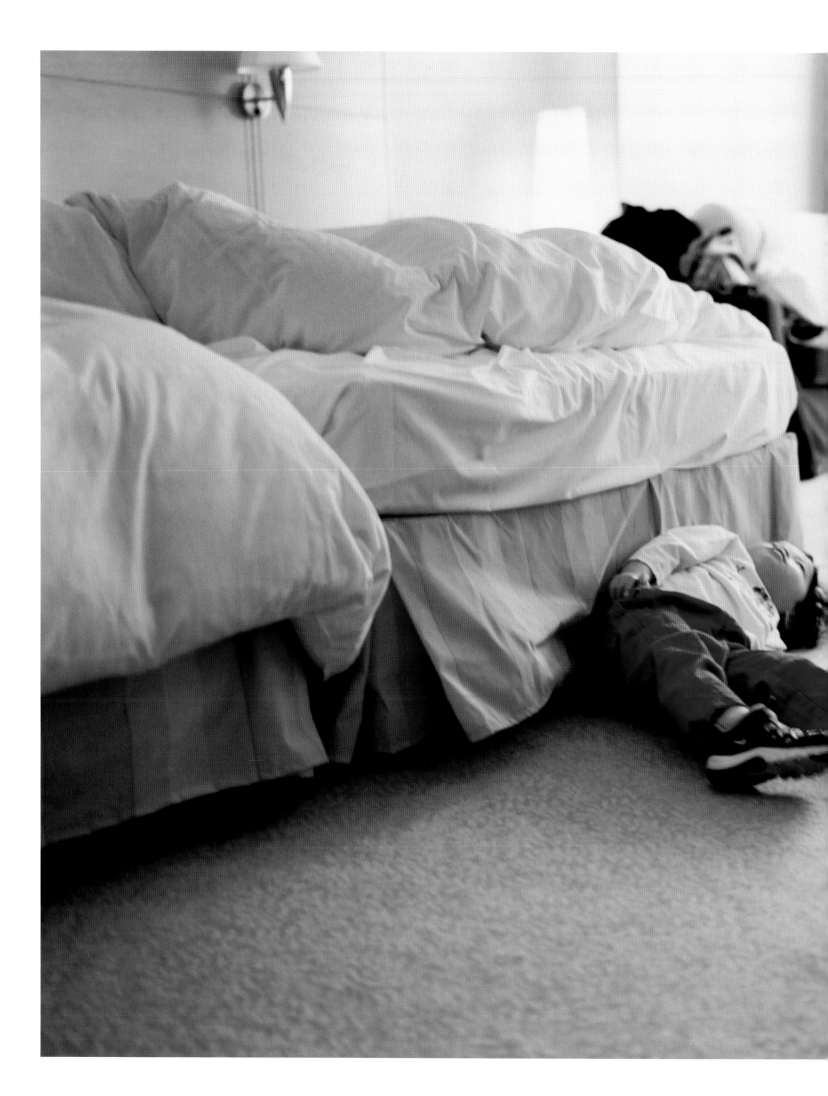

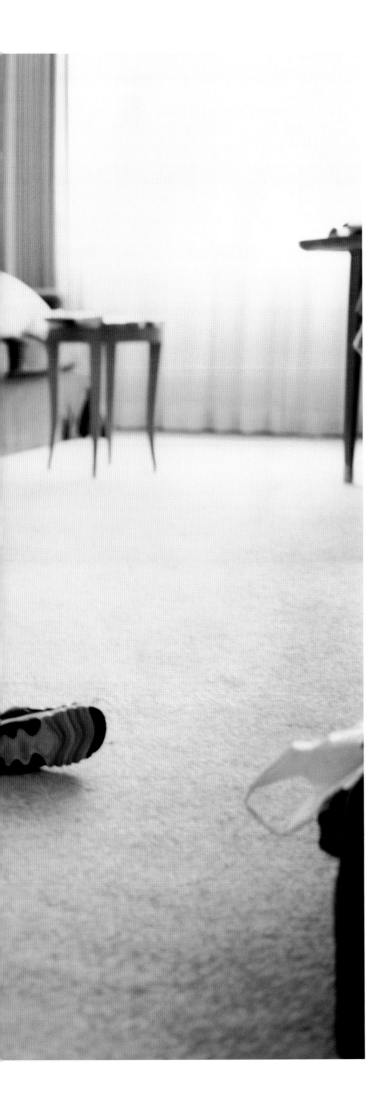

Portrait of Hide
2002 (previous page)

Little R Spaced Out
in a Hotel Room
2004

Dots on My Right Leg
2007 (left)

Spanish Reflection
2008 (right)

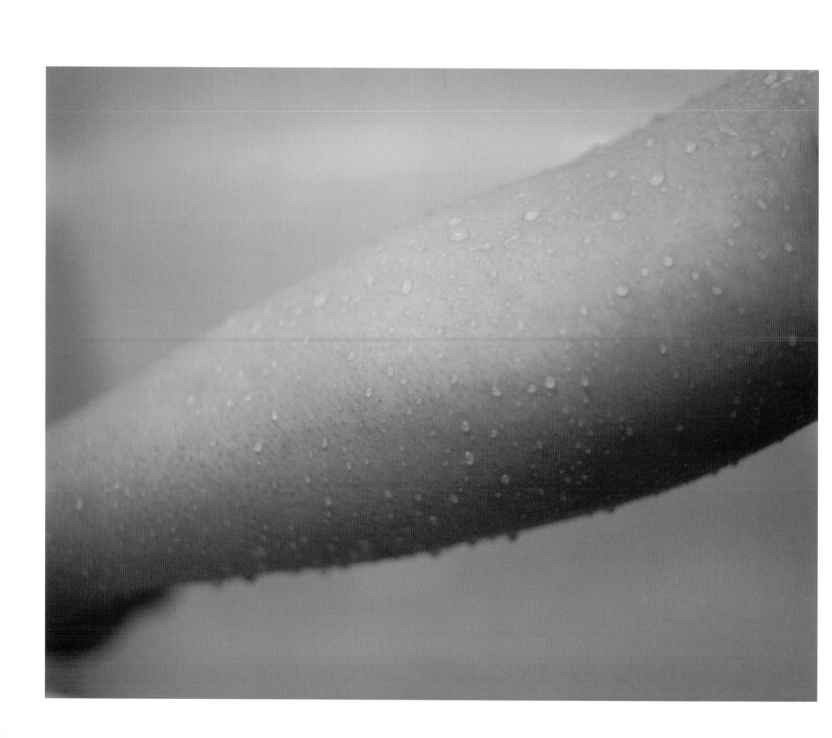

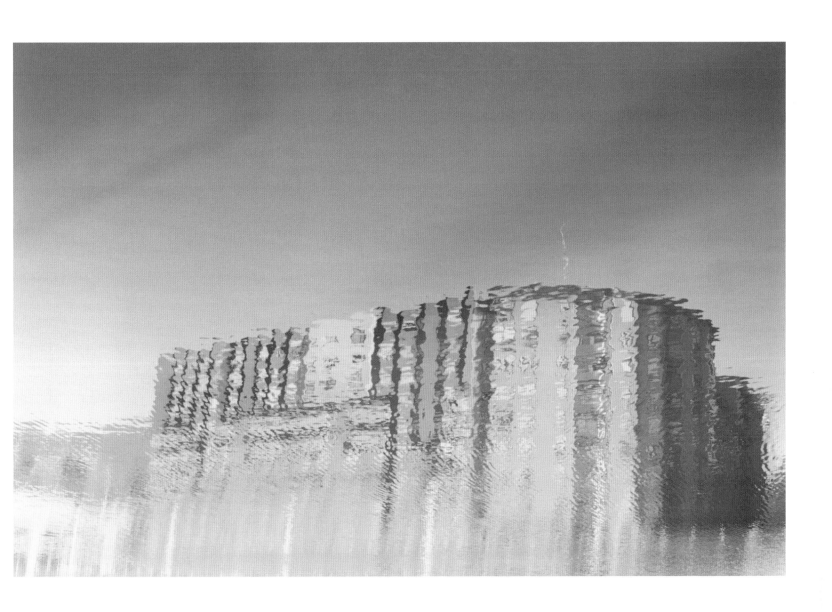

I Am Not Angry
2005 (left)

Washing by Hand While Baby
Is Dreaming
2008 (right)

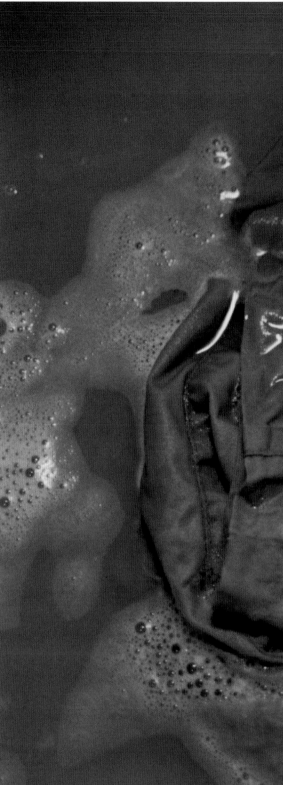

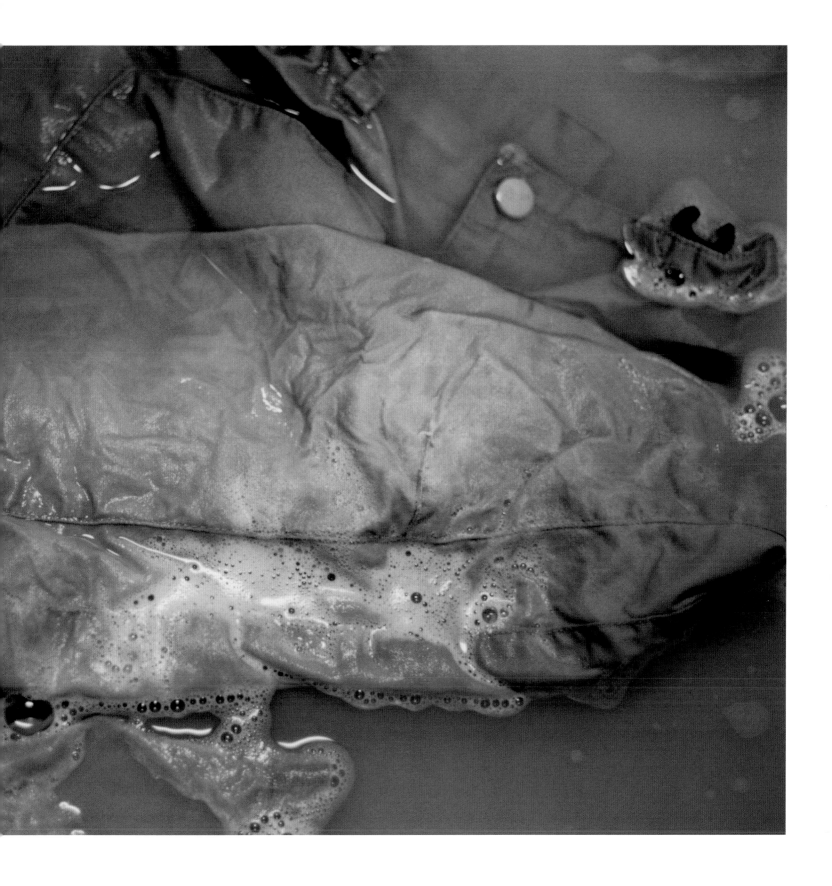

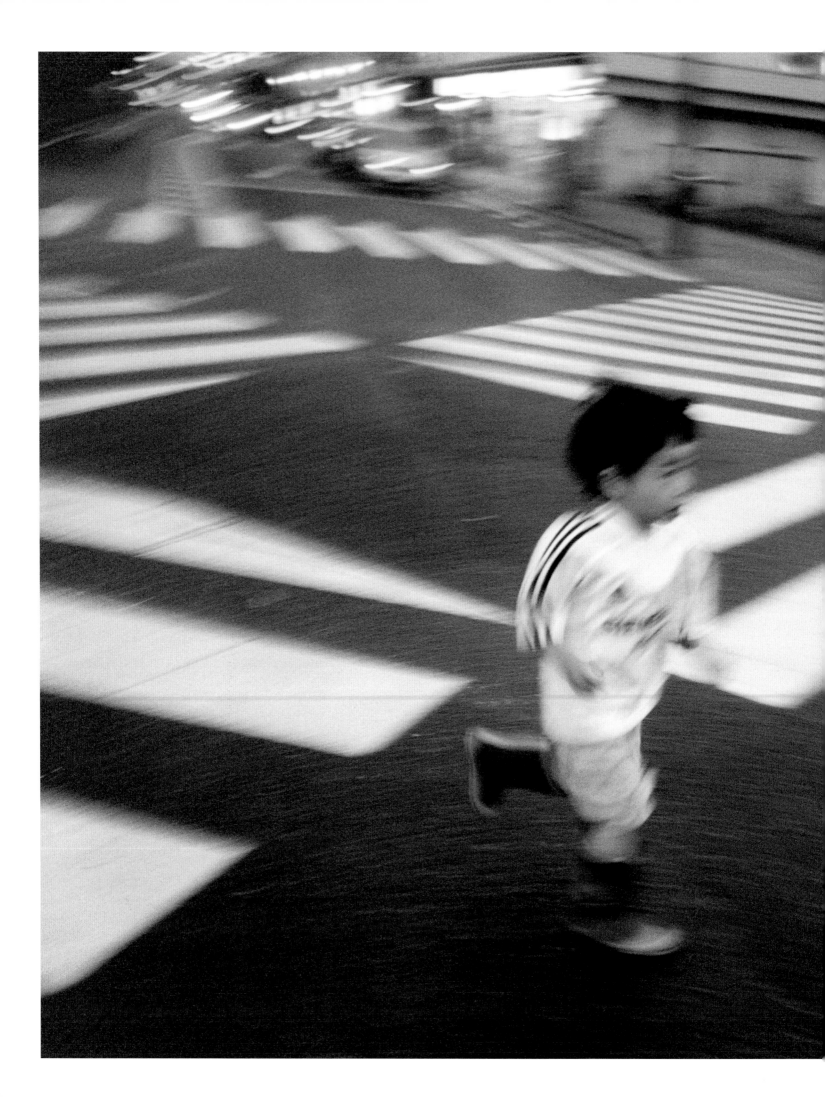

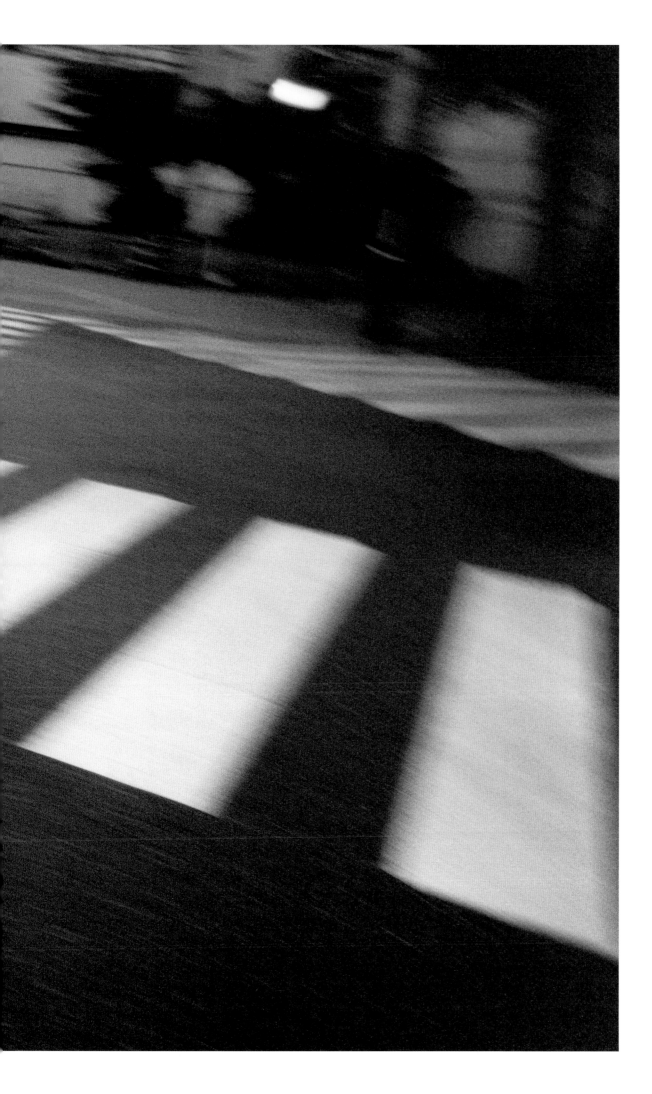

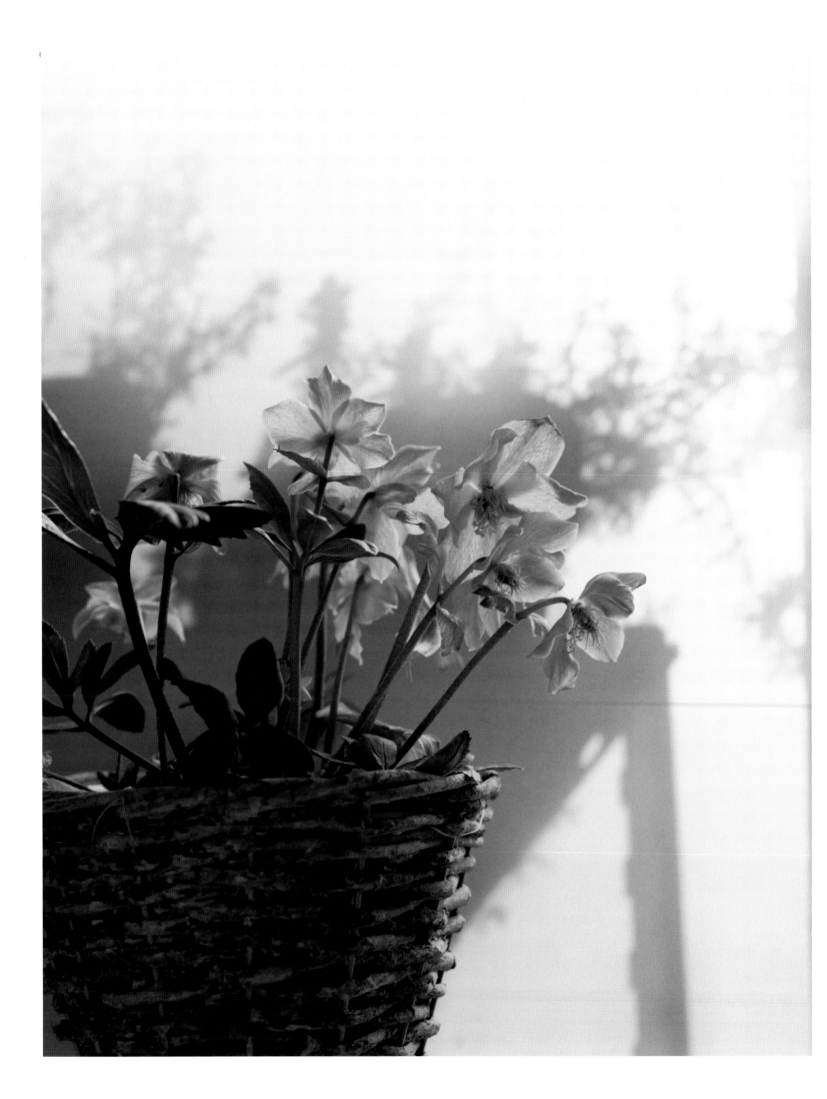

A Crowd of Well-Known People
2006

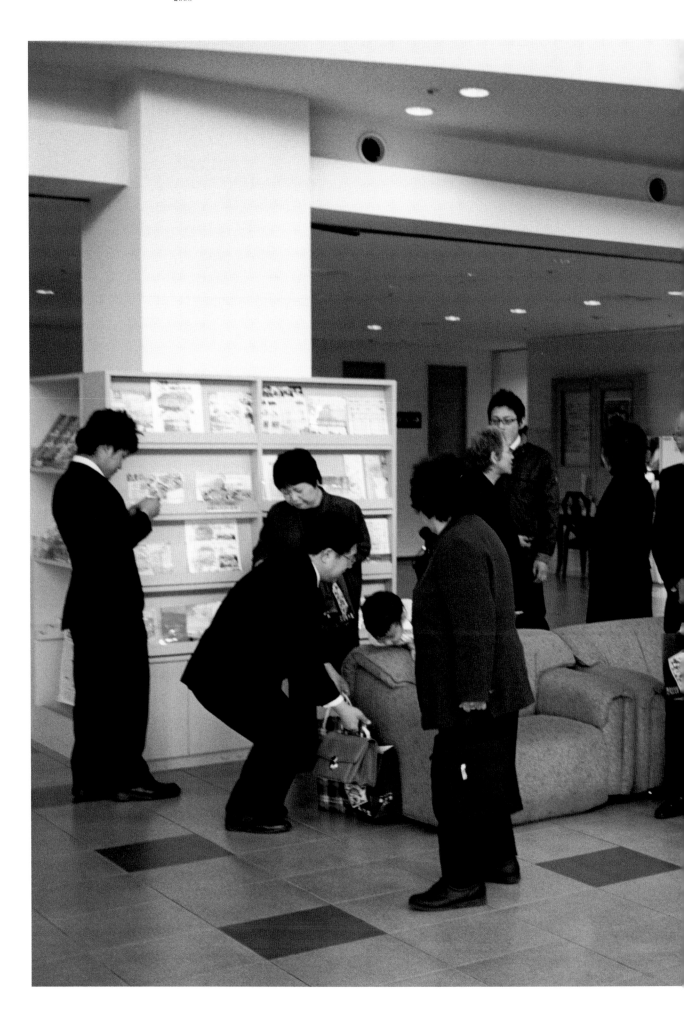

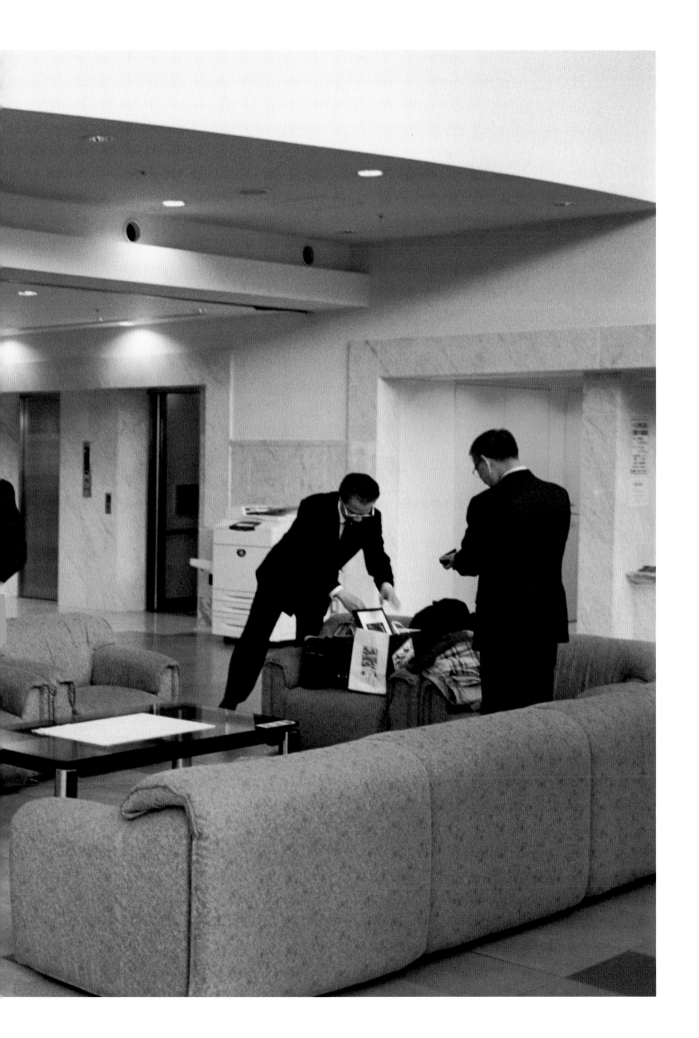

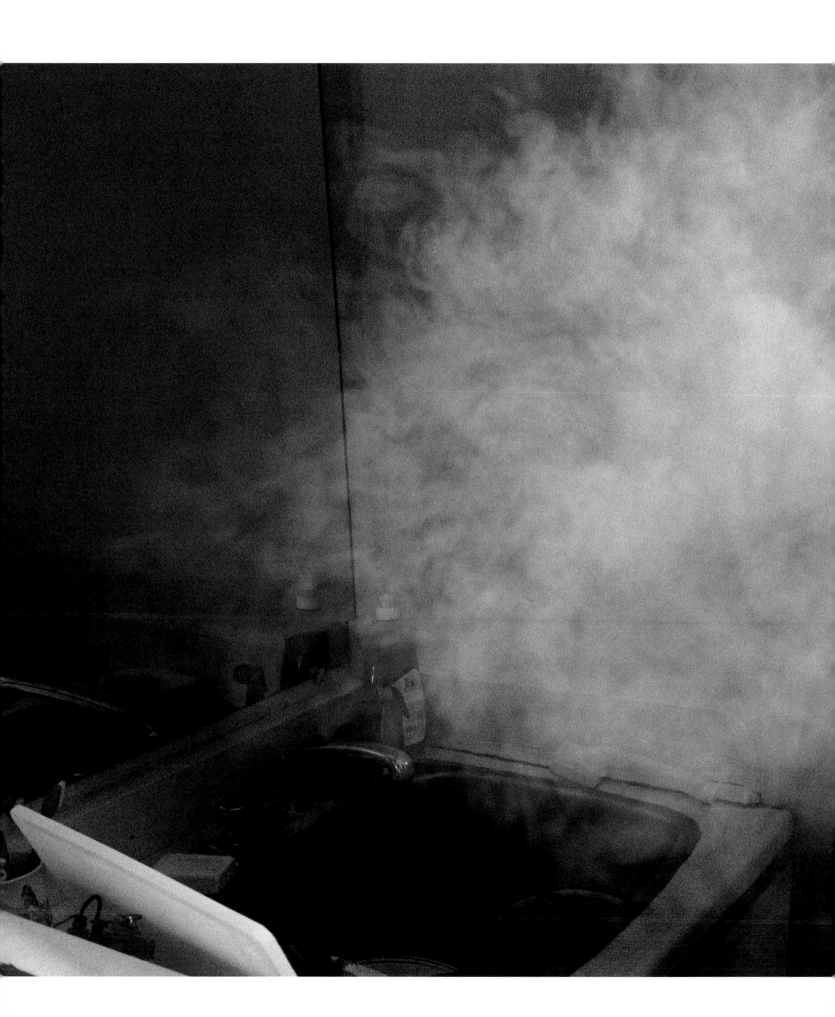

TIM BARBER

Perhaps recognized as much as a curator as a photographer, Tim Barber was the photo editor for *Vice* magazine from 2003 until 2005, when he left to found the influential tinyvices.com website and Tiny Vices imprint. In addition to publishing work by other artists, he has been a curator for the New York Photo Festival and for Aperture. He first gained attention as a photographer while studying in Vancouver, Canada (after growing up in Massachusetts and Vermont and before moving to New York), and he has since contributed to numerous magazines, as well as Miranda July's *Learning to Love You More* project. As for taking a photograph, he says "It's like what Henri Cartier-Bresson wrote about, how you wait and wait and then you get this feeling like things are going to line up, and then you take the photo and hopefully everything lined up for you."

Untitled
2004 (left)

Untitled
2008 (top)

Untitled
2008 (bottom)

Untitled
2003 (next page)

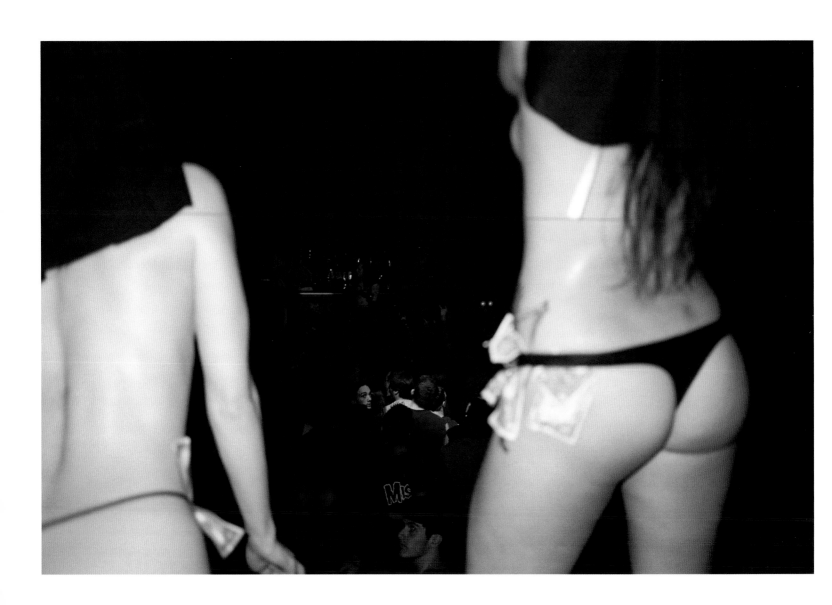

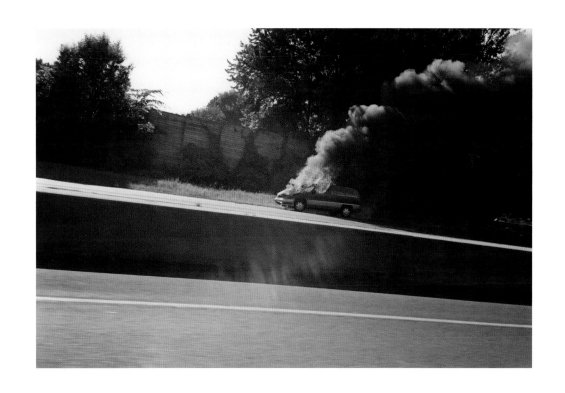

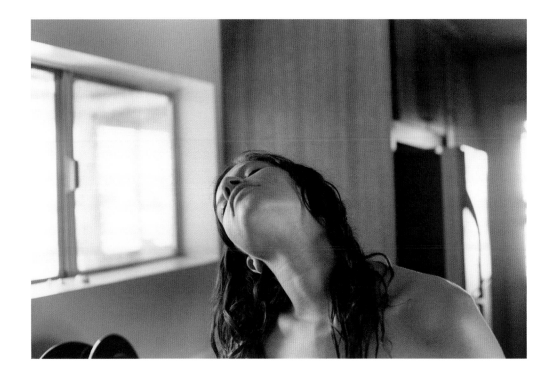

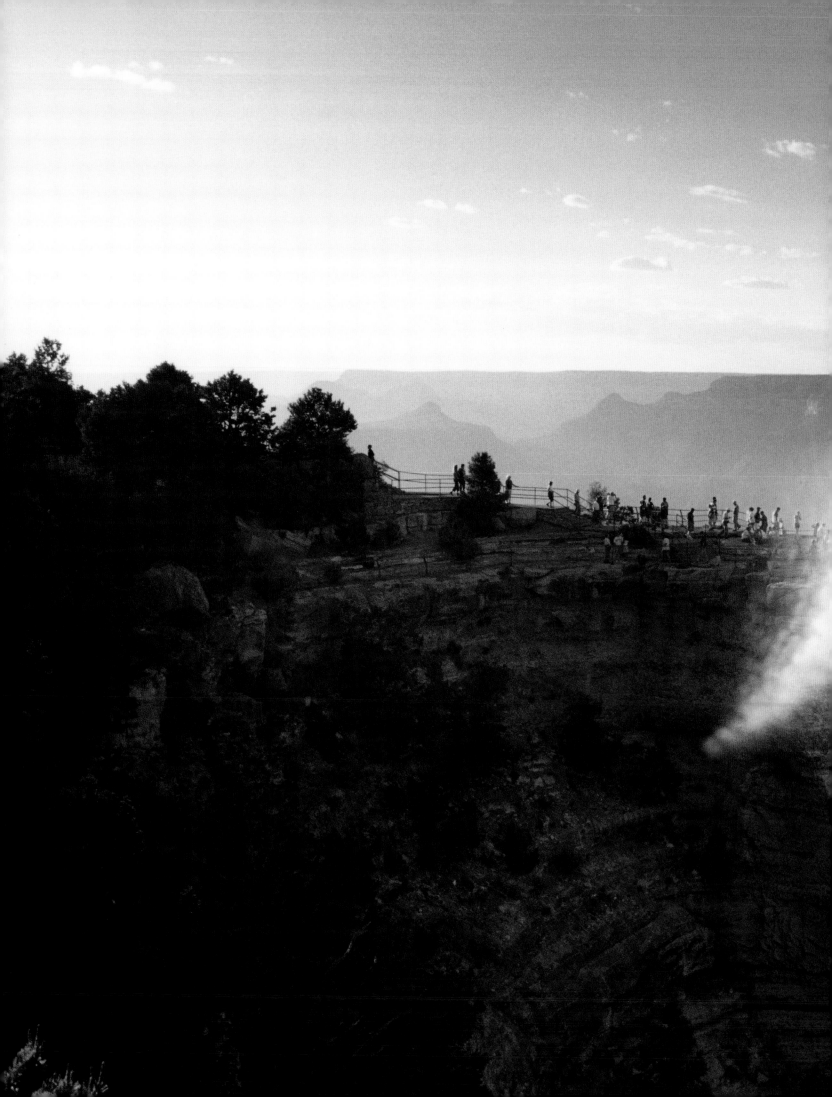

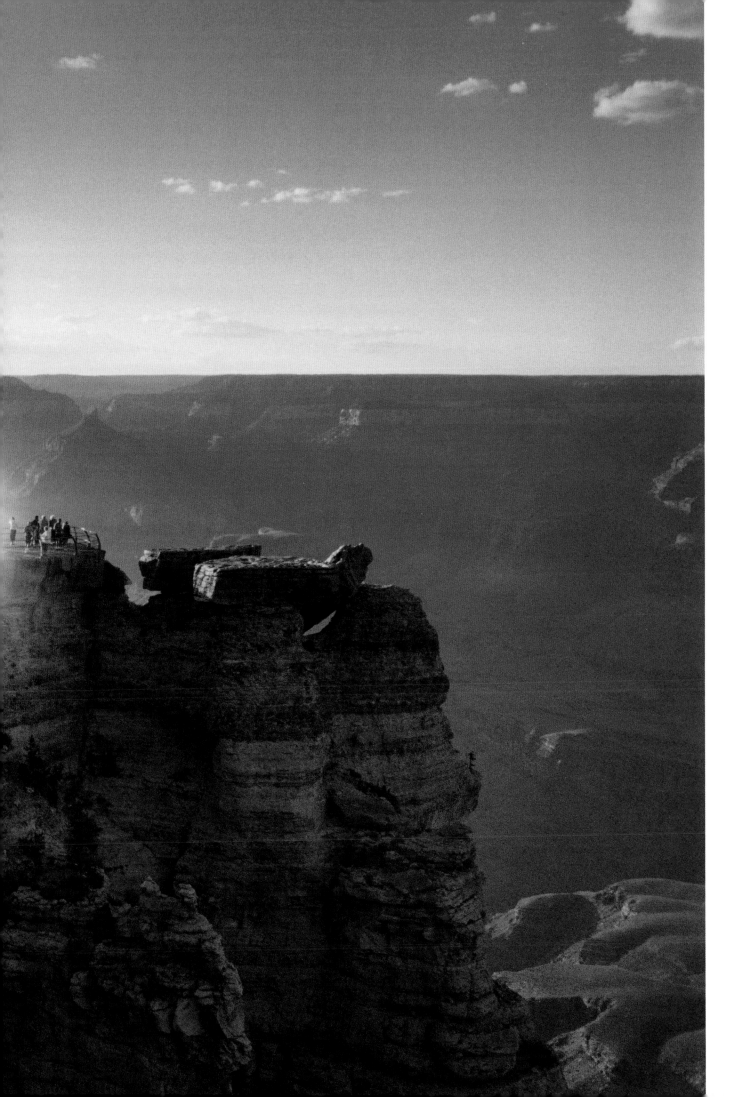

Untitled
2003 (left)

Untitled
2003 (center)

Untitled
2008 (right)

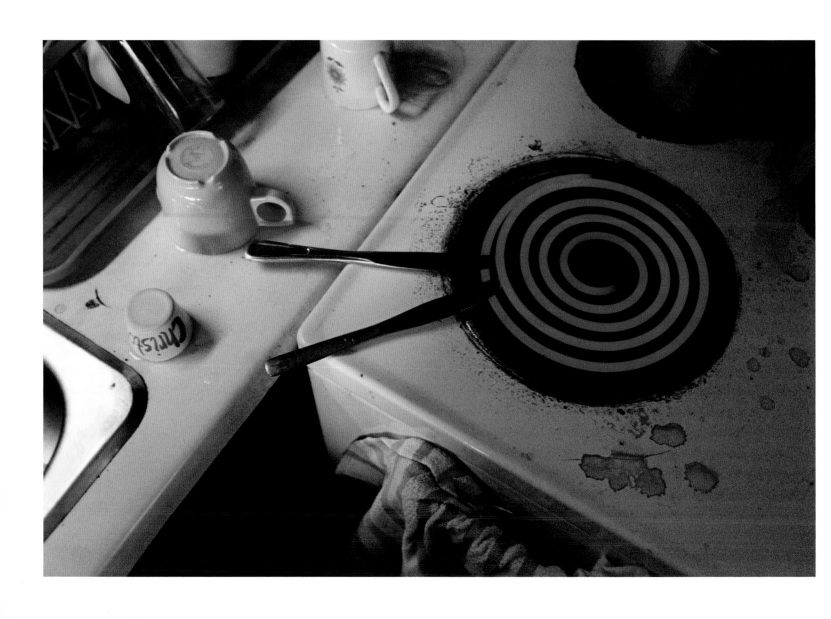

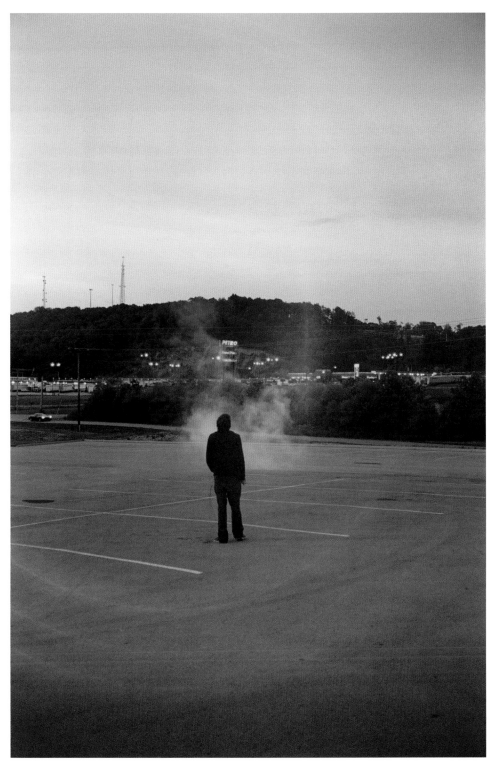

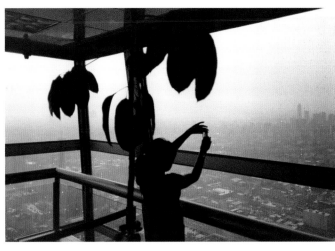

Untitled
2004

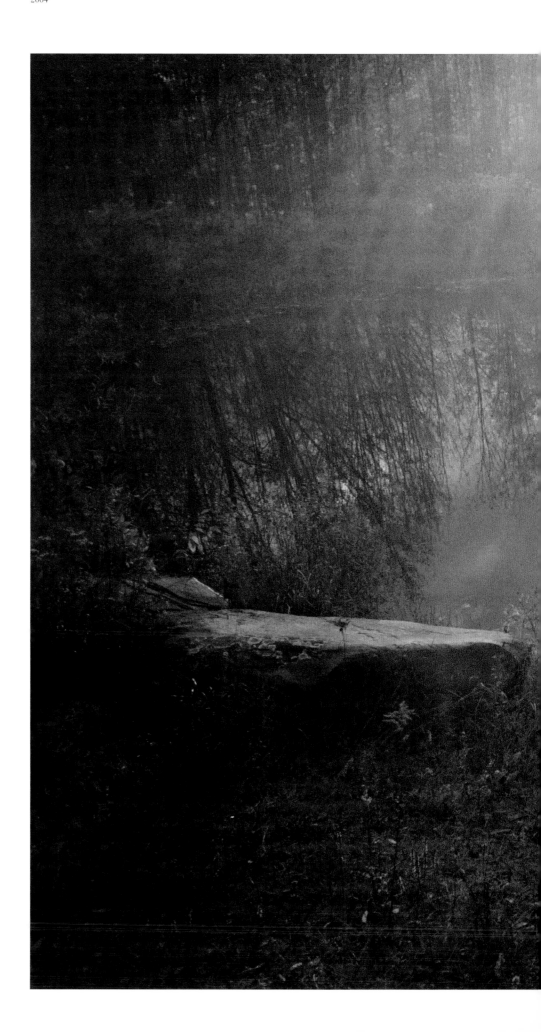

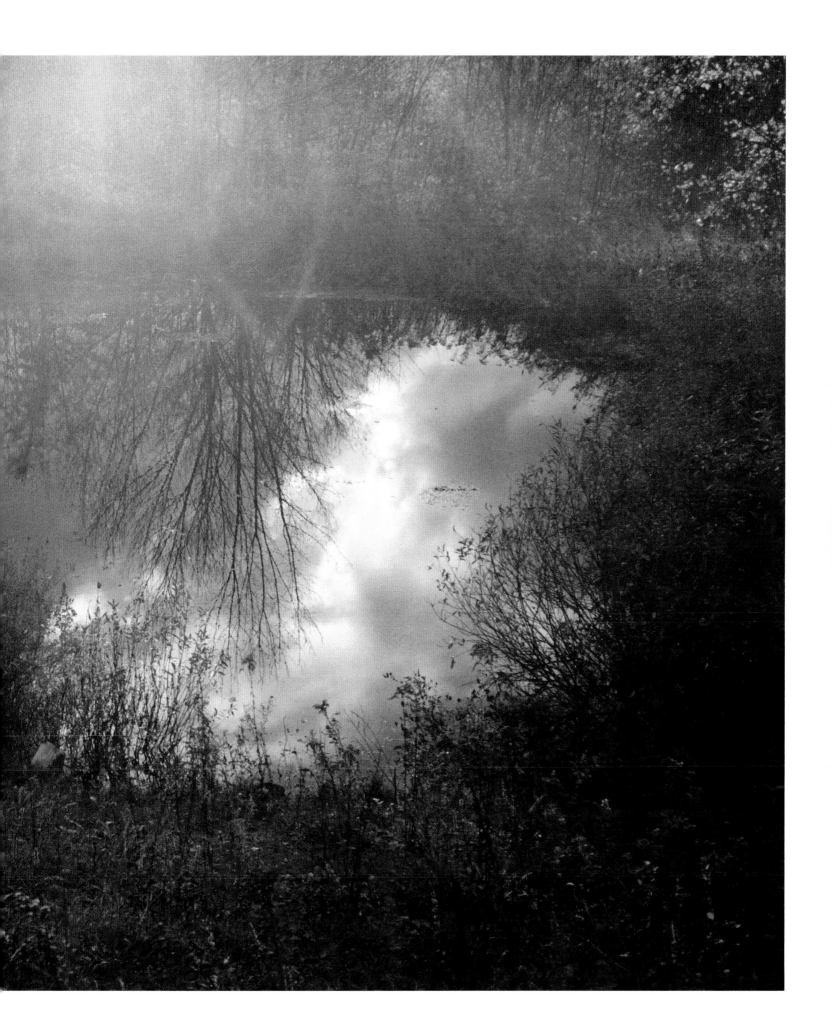

Thinning the Flock–Colorado Springs, CO
2006

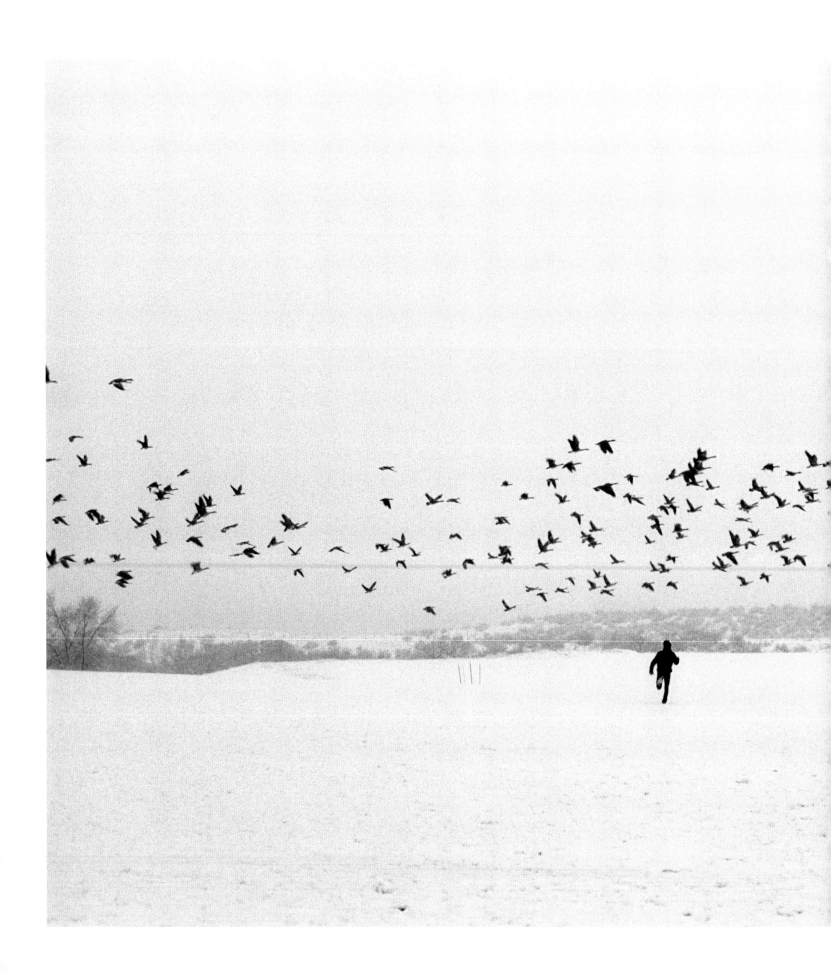

PETER SUTHERLAND

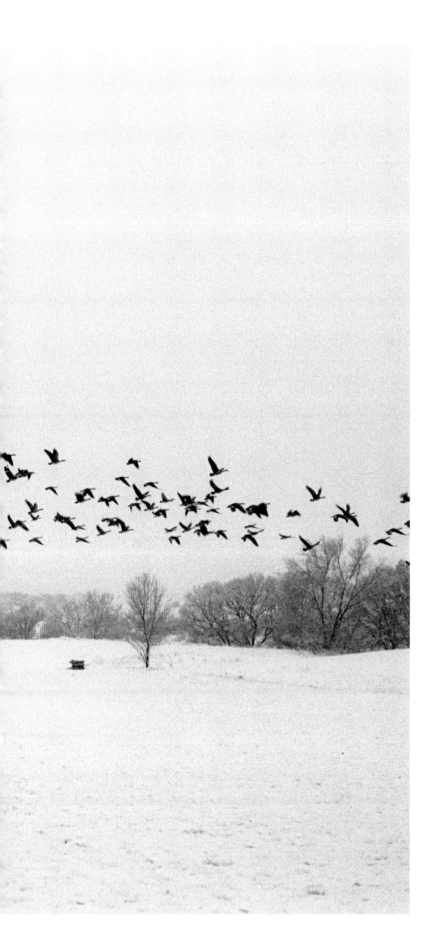

Peter Sutherland recalls that while he was growing up, "There used to be a swarm of gnats that would funnel around in my front yard in Colorado. I got a few good shots of the swarm and I was excited about photography from that point on." Now based in New York, he has continued to focus on topics with which he has an intimate acquaintance. He first gained recognition with *Autograf* and *Pedal*, two books (and a documentary DVD) about urban street culture. Recently, he has continued to direct documentaries—about photographer Tierney Gearon and painter Richard Prince—while devoting his photography to subjects familiar from his youth in the American West. "I like shooting in America, or shooting in places that look or feel like America," he says. "This is not a patriotic thing. It's more about my connection to this country and my understanding of it. If a kid carves the word SLAYER into a picnic table in America, I probably knew a kid like that, and I can feel that connection. If a French kid carves it into a French picnic table, I have no idea what might be going through that kid's head and the connection is lost. I like to feel that connection to my subject matter." His book *Buck Shot* (from powerHouse) documents the effects of an overdeveloped landscape through photographs of wild deer in suburban environments, and he continues to produce books and zines for the Nieves and Seems independent imprints at a prolific pace.

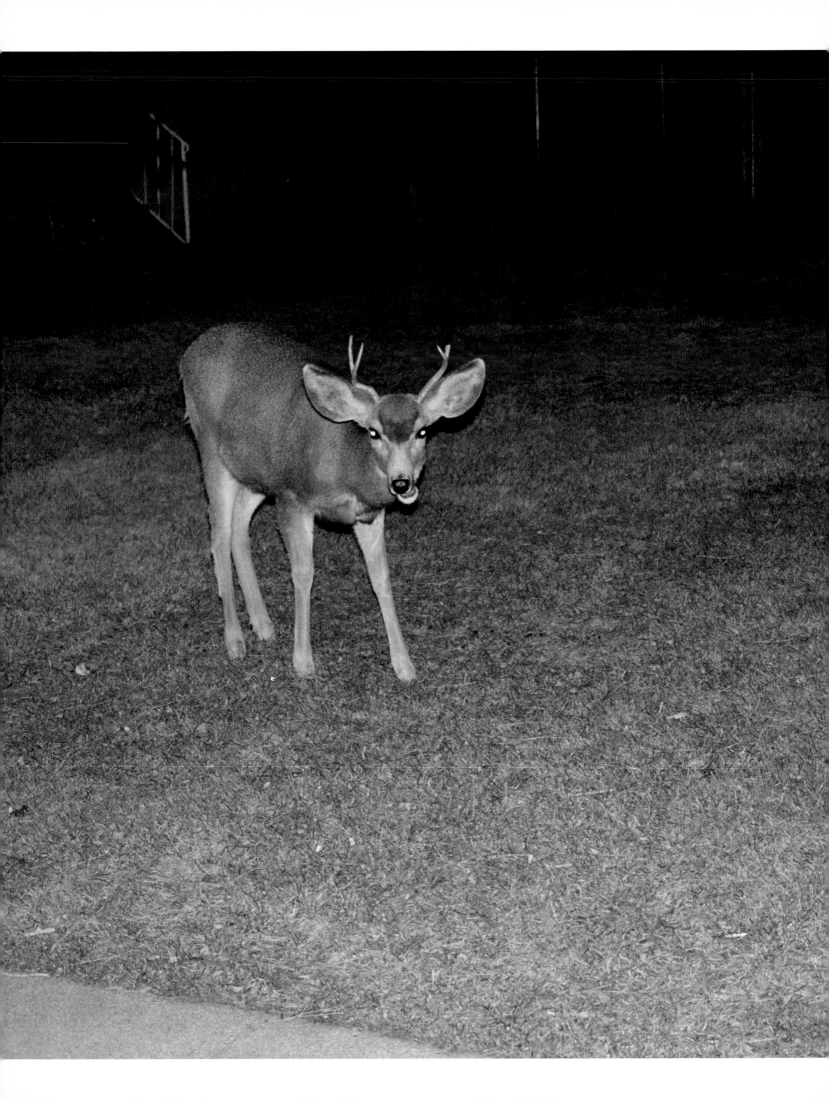

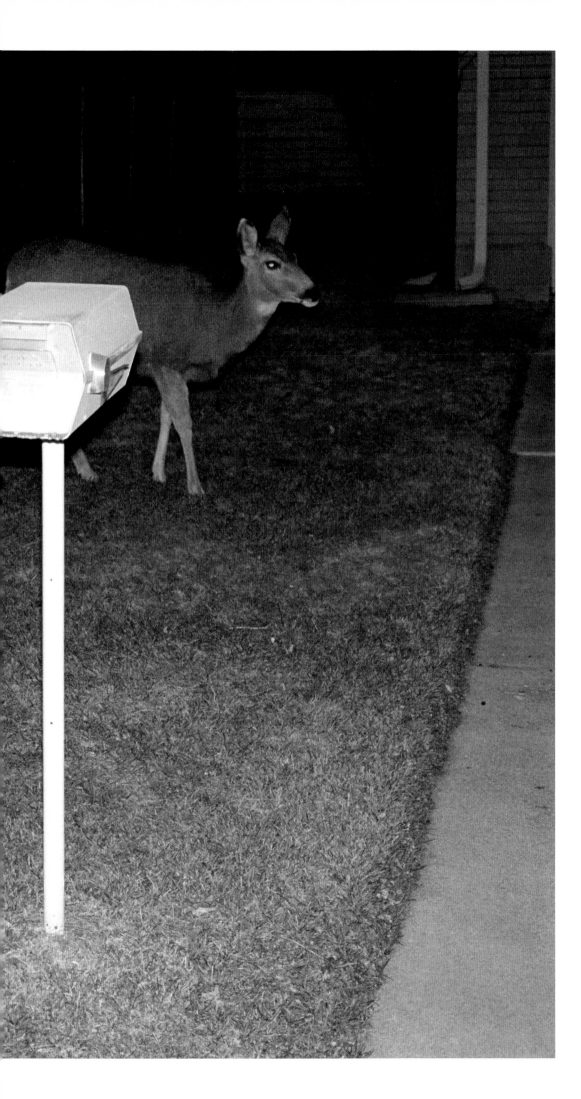

Lawn Grazers–Colorado Springs, CO
2006

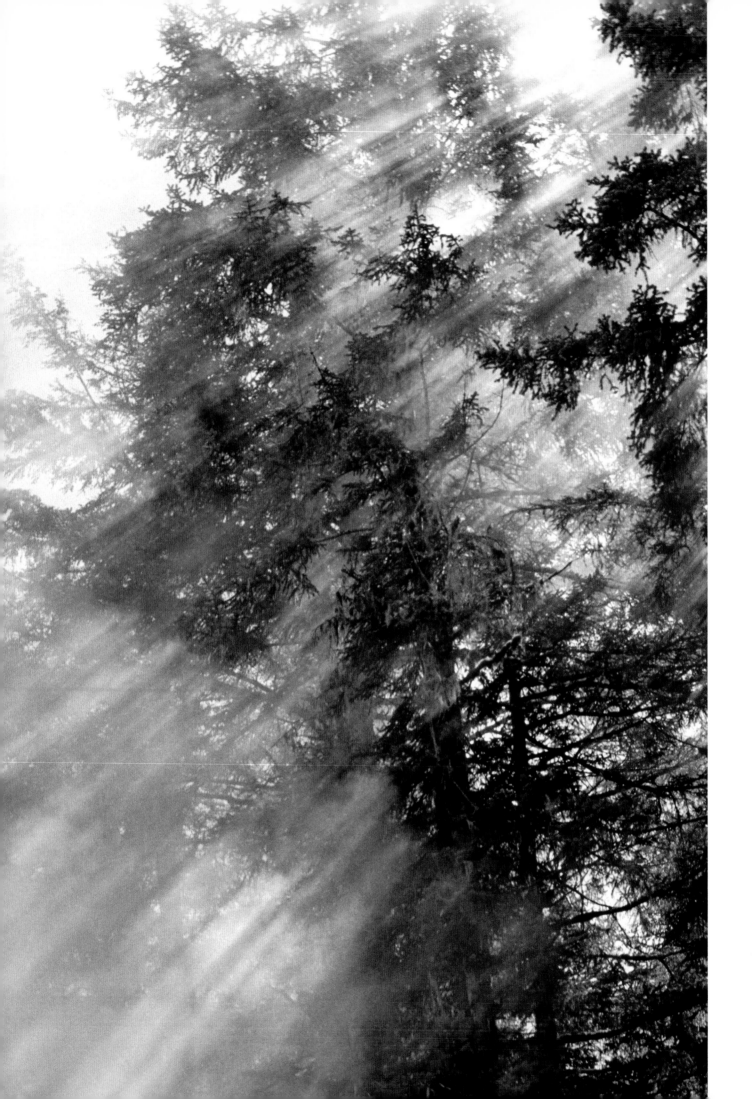

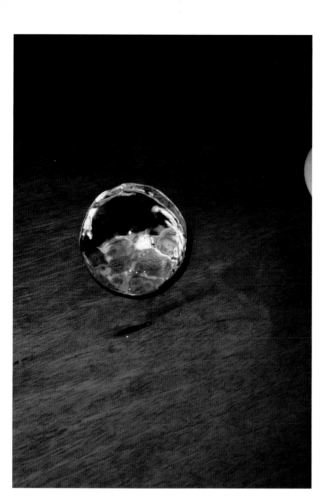

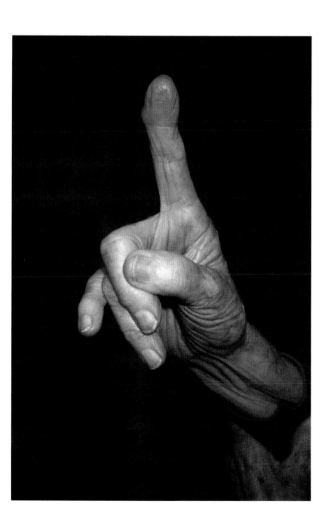

Smoke the Tree–Ukutat, AK
2007 (left)

Future Ice Ball–Tokyo
2006 (top)

*My Gramma's Bent
Pointer–Alabama*
2007 (bottom)

Notty Lace Nots–Vancouver, BC
2008 (left)

Dead Saggy Tape–Salt Lake City, UT
2008 (right)

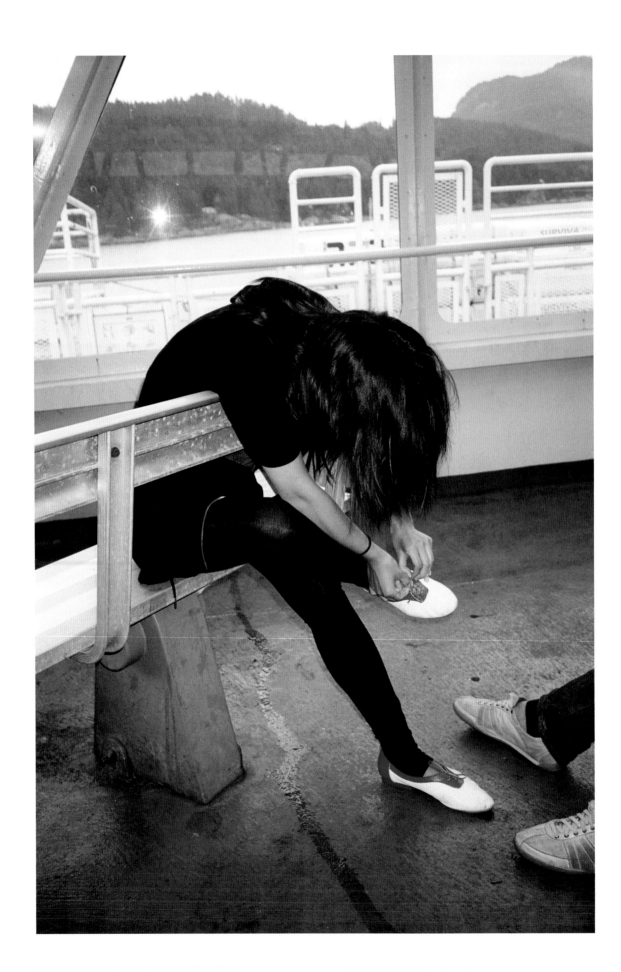

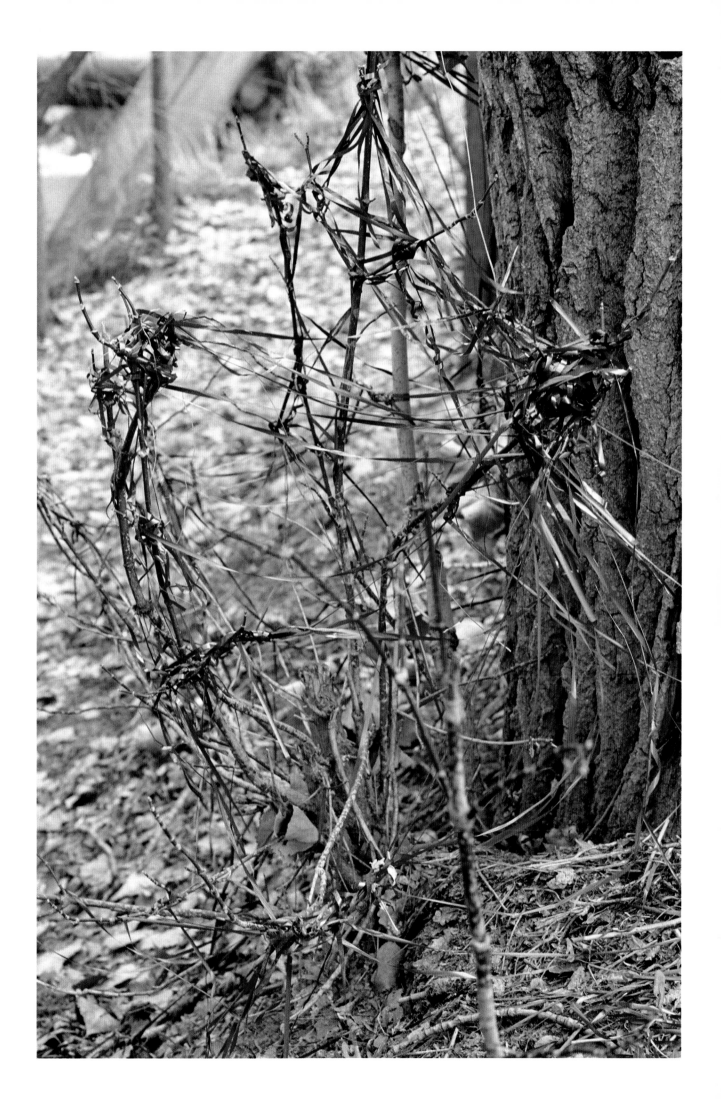

Smoke the Smoke–NYC
2005 (left)

Ice Wins–Park City, UT
2008 (right)

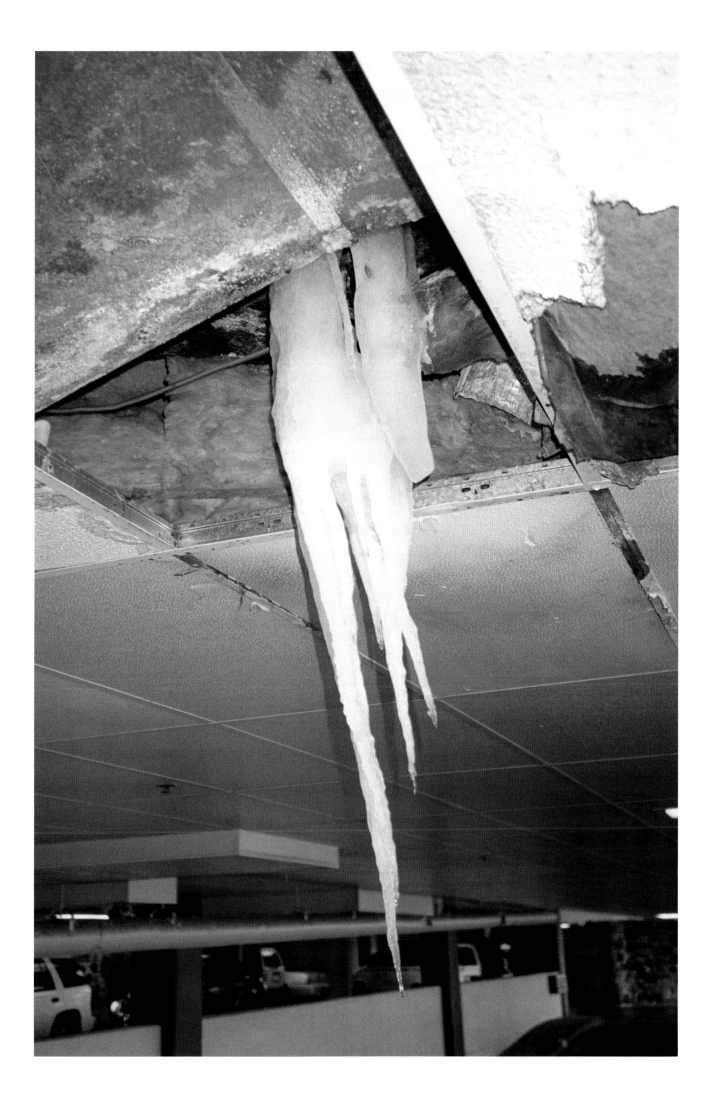

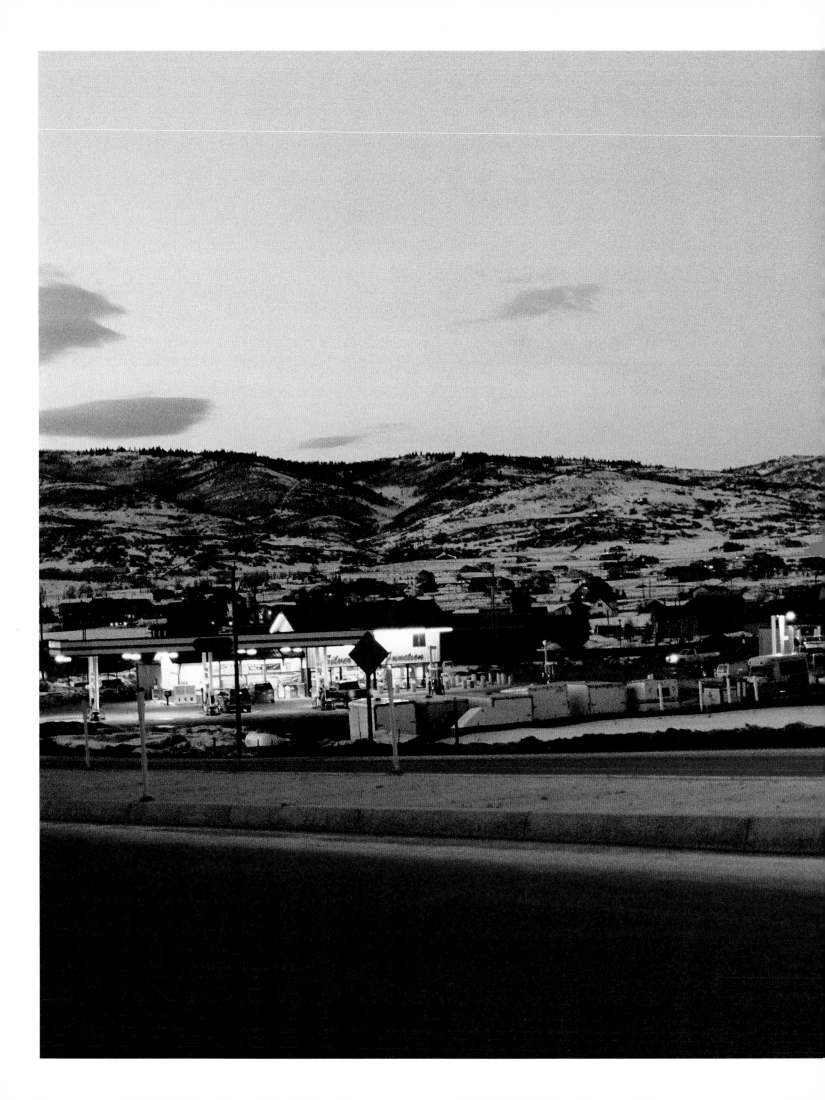

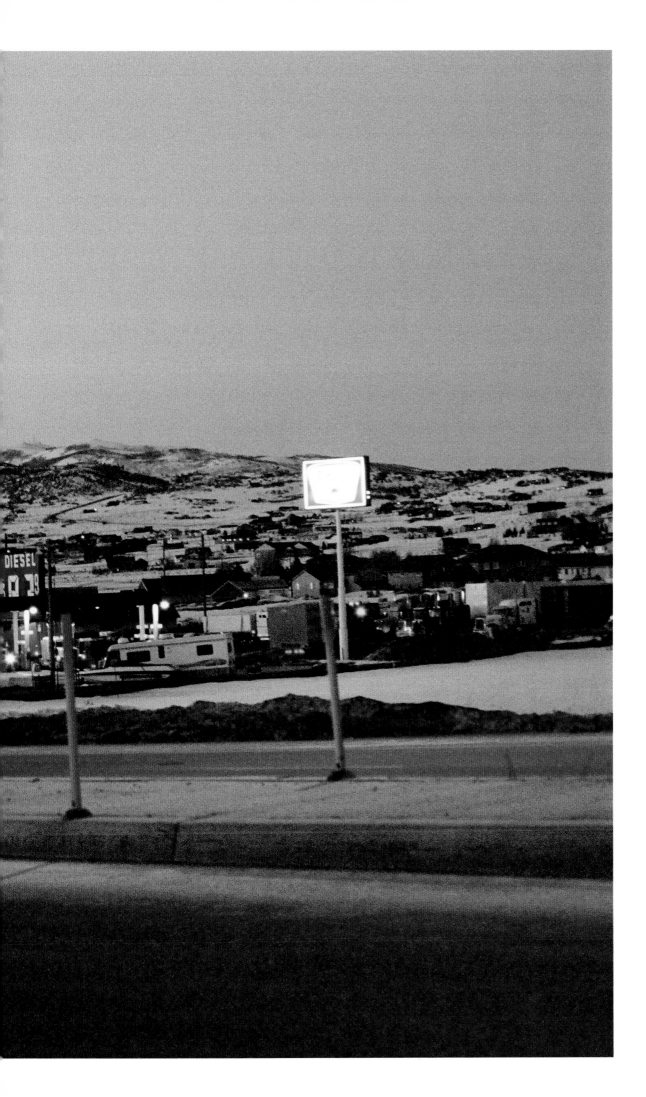

All photos
Untitled (from the series Haunts)
2006

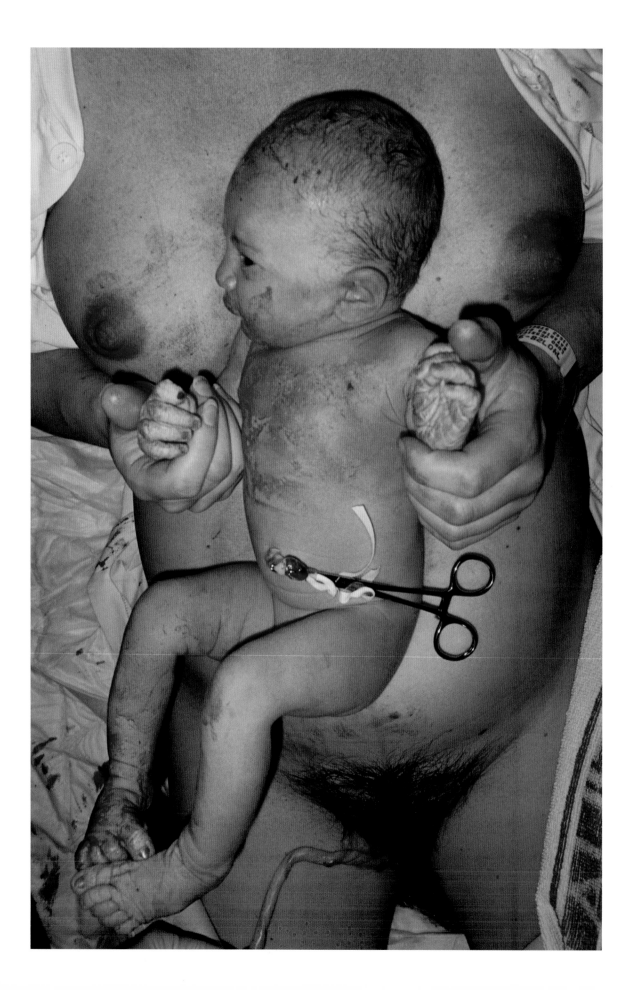

JH ENGSTRÖM

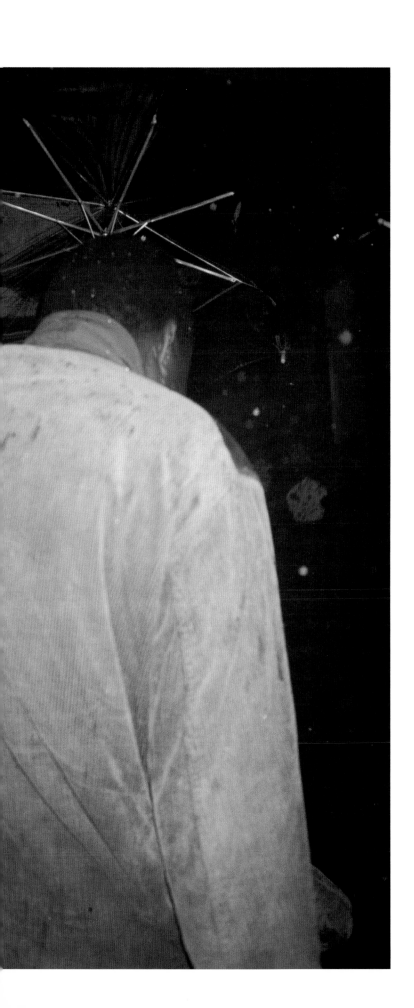

Swedish photographer JH Engström's images offer a discon-
certing mixture of brutalism and tenderness—they're both
jaundiced and romantic. Whether shooting deliberately
pallid landscapes of Charles de Gaulle Airport or awkwardly
familiar documentation of drunken nights out, Engström's
odd juxtaposition of moods and styles is reflective of his open-
ended approach. "You never arrive to a style," he says. "It's in
motion. You have to move. Try out things. Reject things.
Surprise yourself." Over the past decade, Engström has pub-
lished several books with the Steidl imprint and has received
museum exhibitions throughout Europe. He has also shot
films for Swedish television, including a documentary on the
photographer Anders Petersen. Discussing how he edits
each series of photographs, he says, "I get to know my pho-
tographs. I look a lot at them. I think of them and live with
them. In the end, you know which ones to keep."

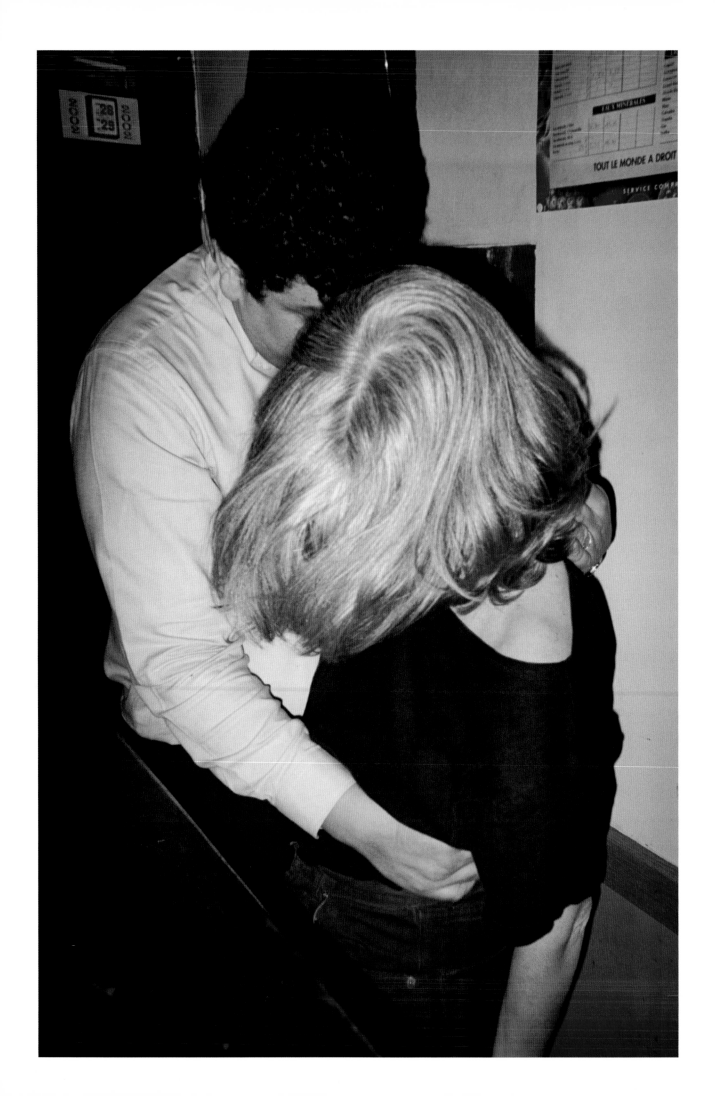

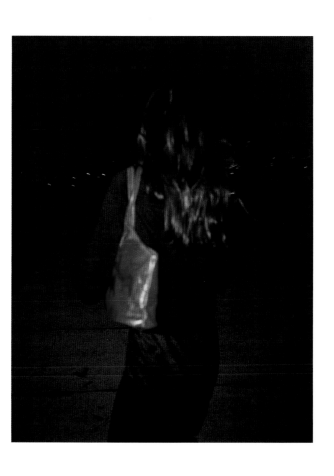

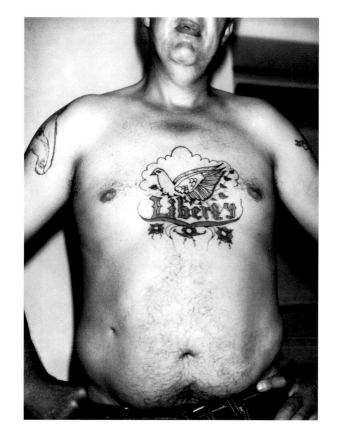

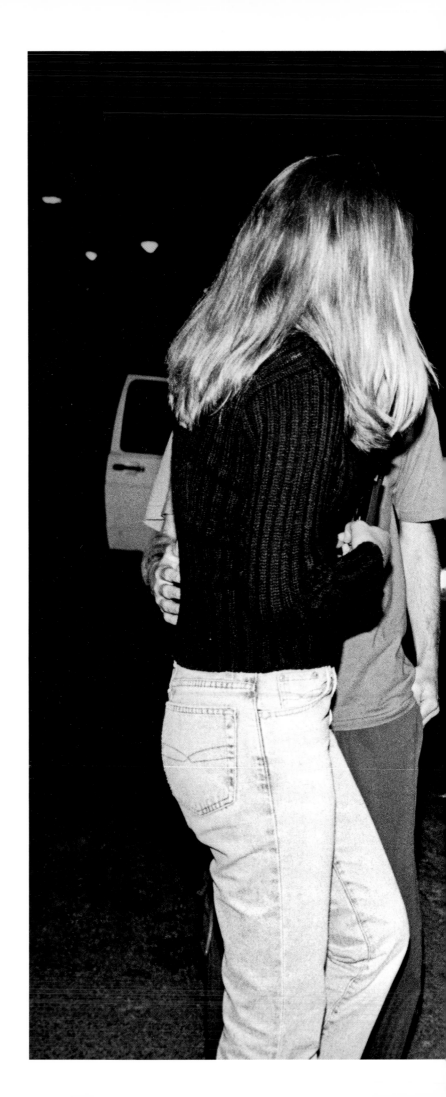

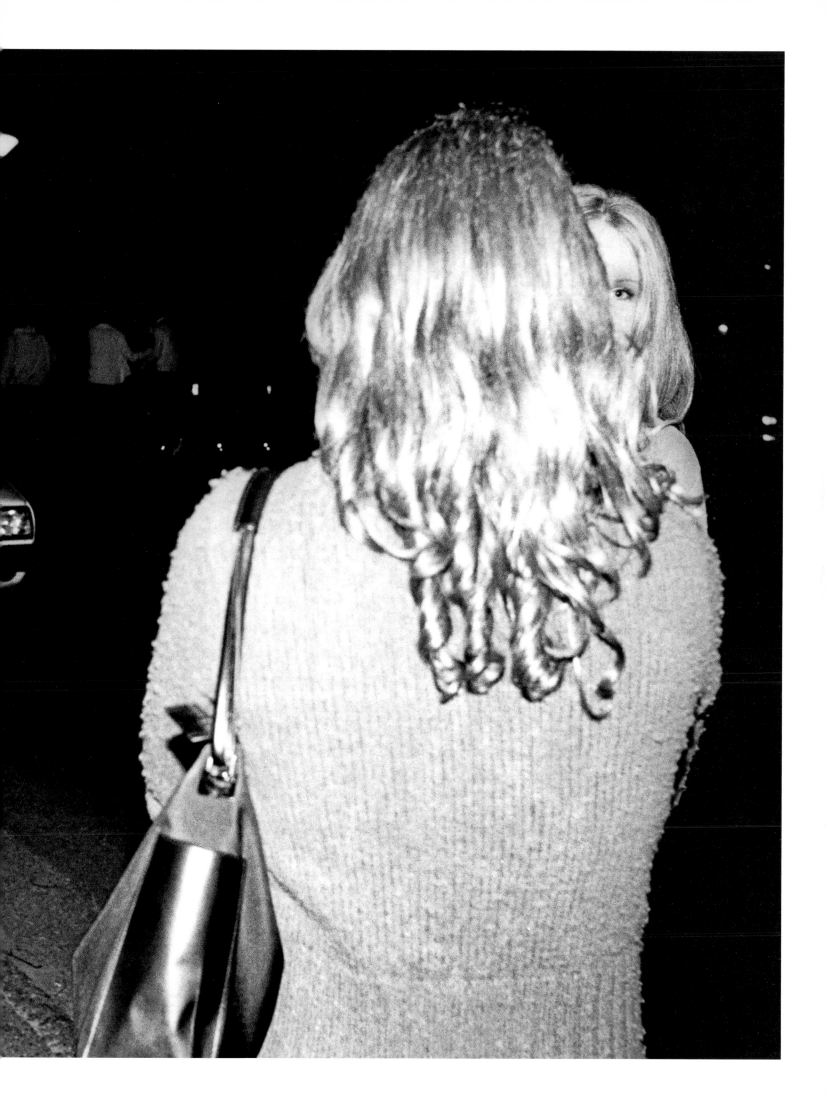

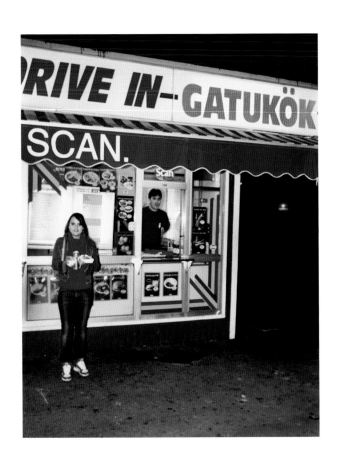

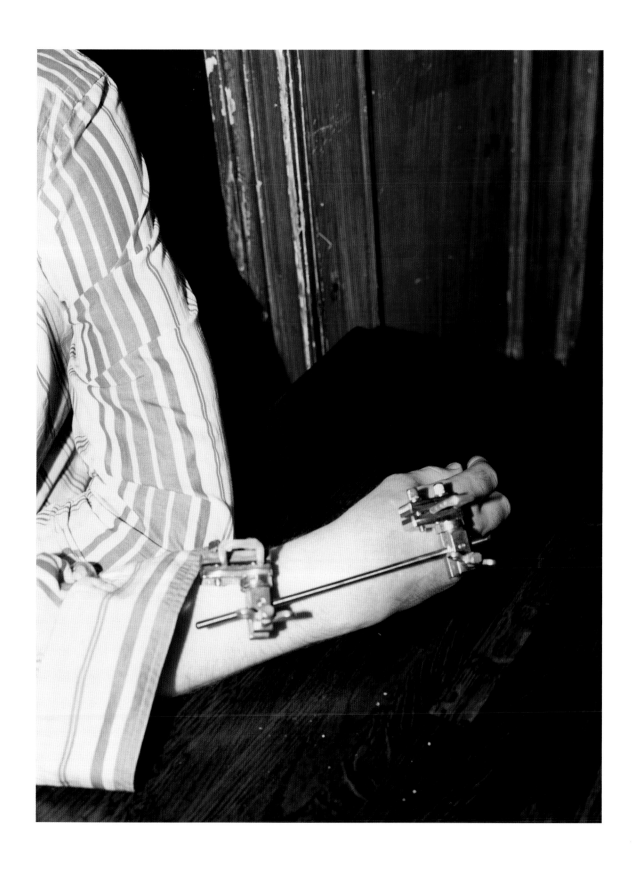

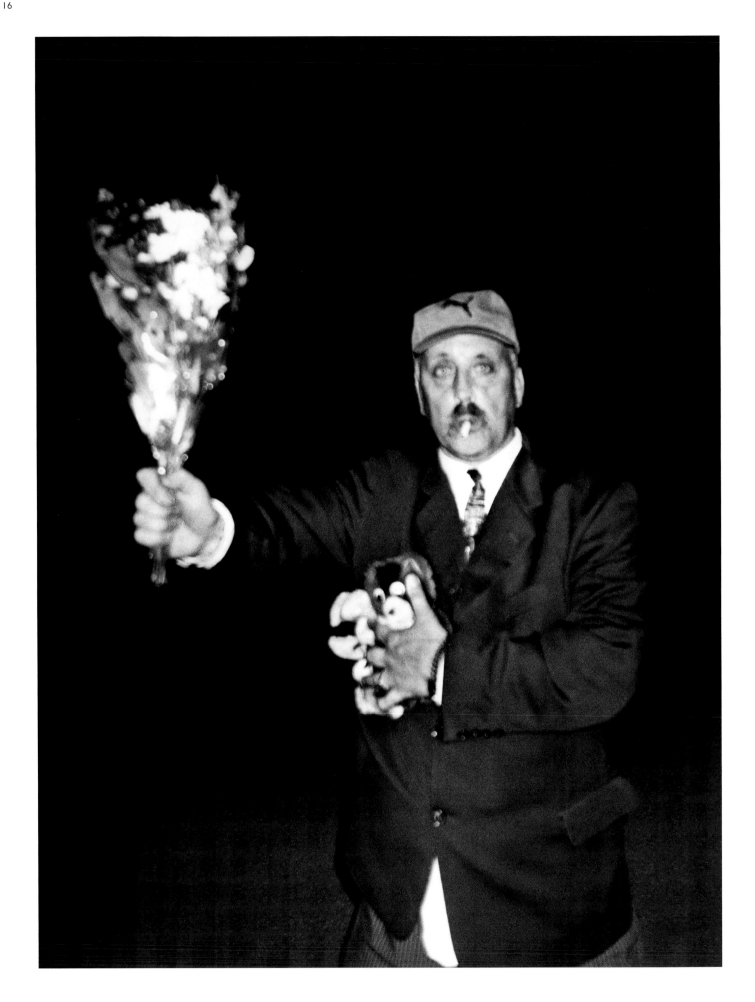

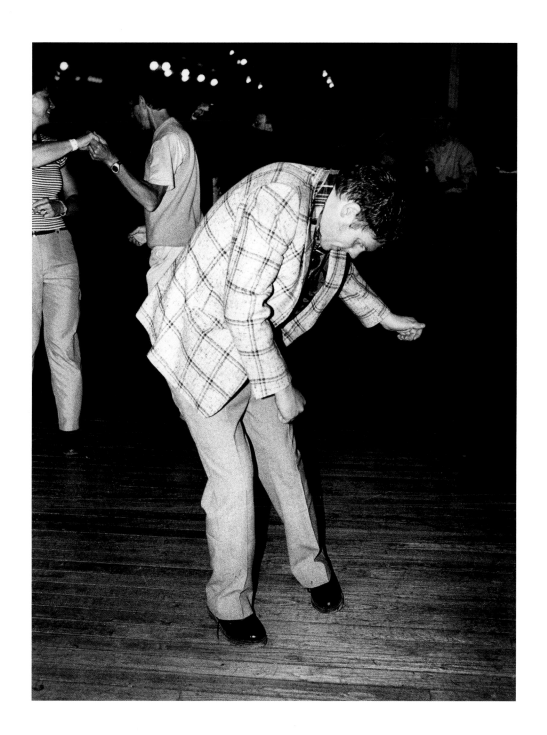

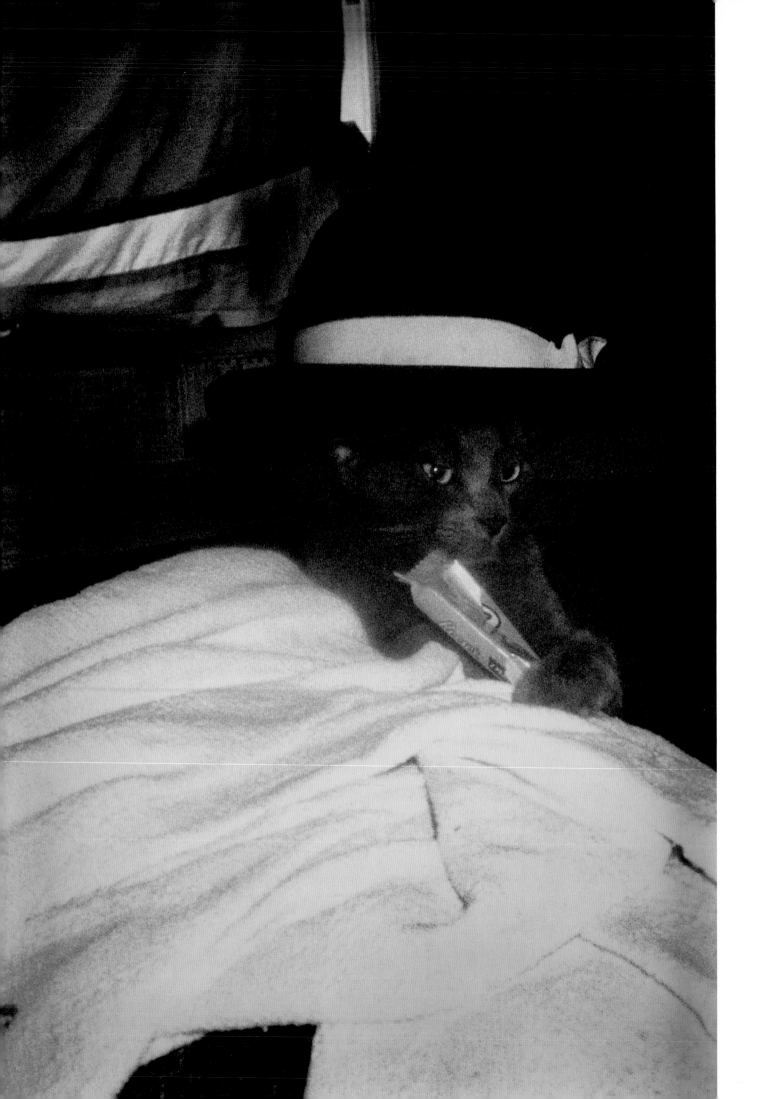

DASH SNOW

More than anyone else in *SHOOT*, New York artist Dash Snow blurs the distinction between photographer and subject. Initially renowned (or reviled) for his prolific series of Polaroid images, Snow documented a youthful existence that seemed simultaneously grimy and glamorously debauched. His more recent 35mm black and white images document his girlfriend Jade while she was pregnant with their daughter. In combination, these two bodies of work both reinforce and question the "realness" of the photographs: Are these images unconsidered self-documentation or is the life presented in Snow's photographs an artful construct? His work has been exhibited at the Royal Academy in London and the Whitney Museum in New York; in 2008 Snow published a book of his Polaroids, titled *Polaroids*.

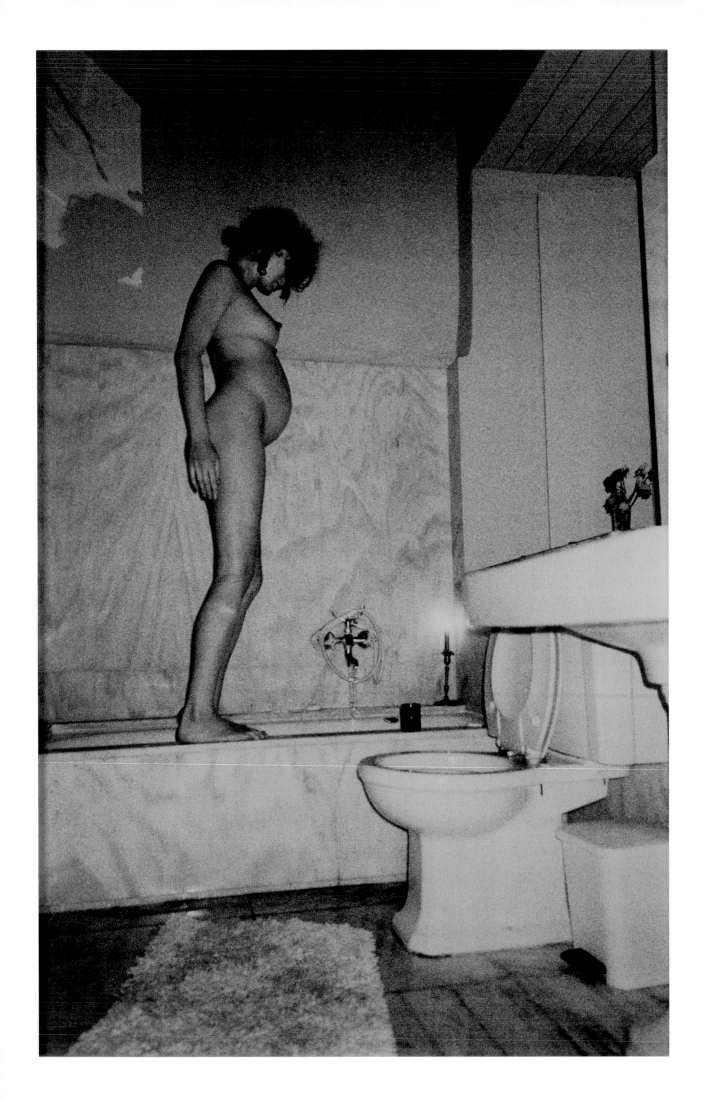

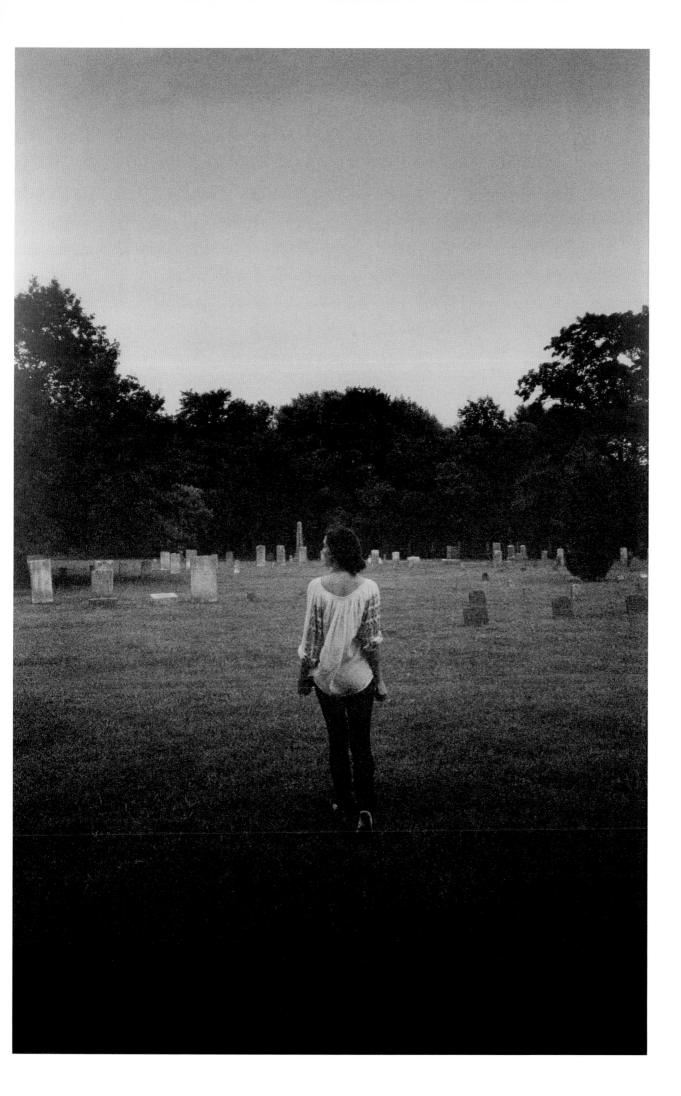

Untitled
2007 (previous page)

Untitled
2007 (left)

Untitled
2007 (right)

Untitled
2004 (left)

Untitled
2004 (right)

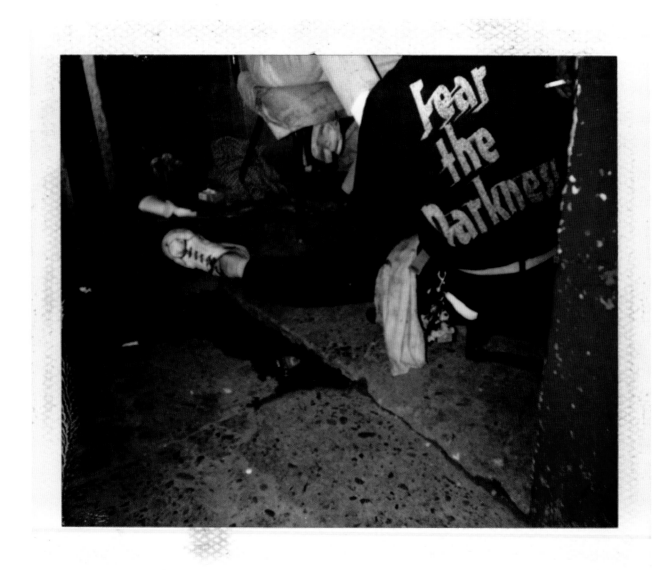

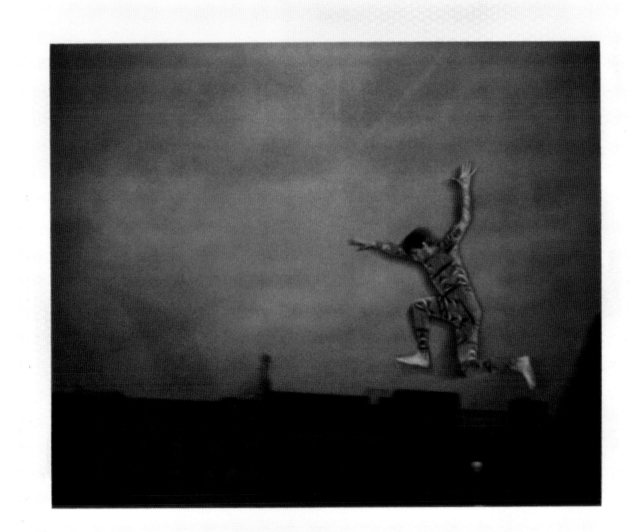

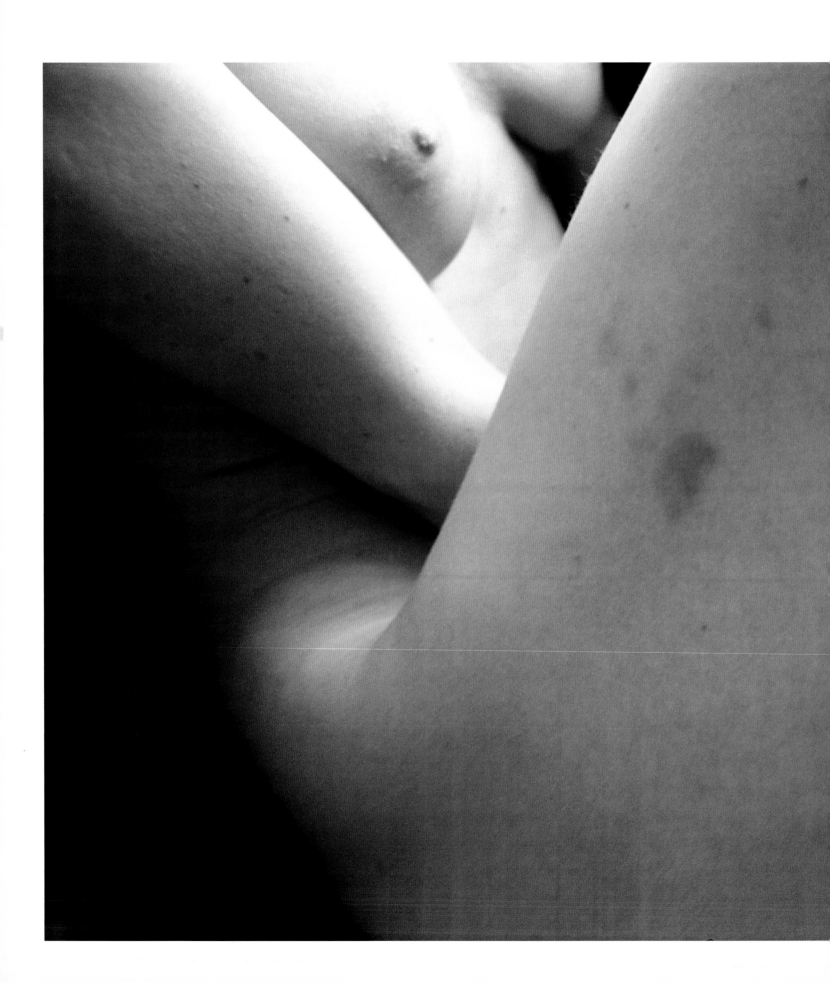

KENNETH CAPPELLO

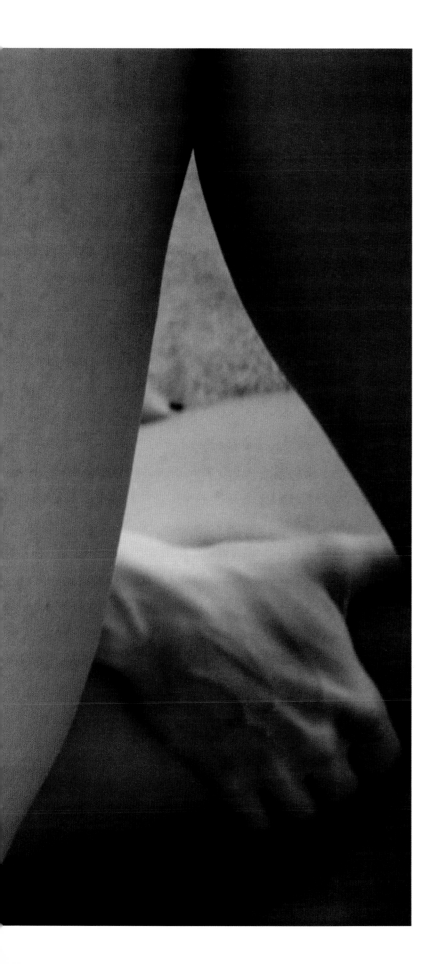

Born and raised in Houston, Texas, Kenneth Cappello began shooting photographs as a teenager, documenting friends skateboarding and at punk shows—a body of work that was recently published as *Acid Drop*, a book by Tiny Vices for the Aperture foundation. After apprenticing with high-gloss photographer David LaChapelle, Cappello has exhibited and published his work internationally as a successful editorial portrait, fashion, and commercial photographer. (He now directs videos as well, and splits his time between New York and Los Angeles.) This varied output is due to his belief that, in the end, the image is often secondary to the act of taking the photograph. He says, "The cool thing about taking photos—besides the fact that I love looking at photos—is meeting different people and walking into their world for a few hours or them walking into my world for a few hours. If I really like someone, the photos are going to be good, and if I really hate somebody, the photos are going to be good. Because we're creating an energy. Sometimes I walk away with a new friend, and sometimes I'd rather put my fist in their mouth. But either way, it was an experience...."

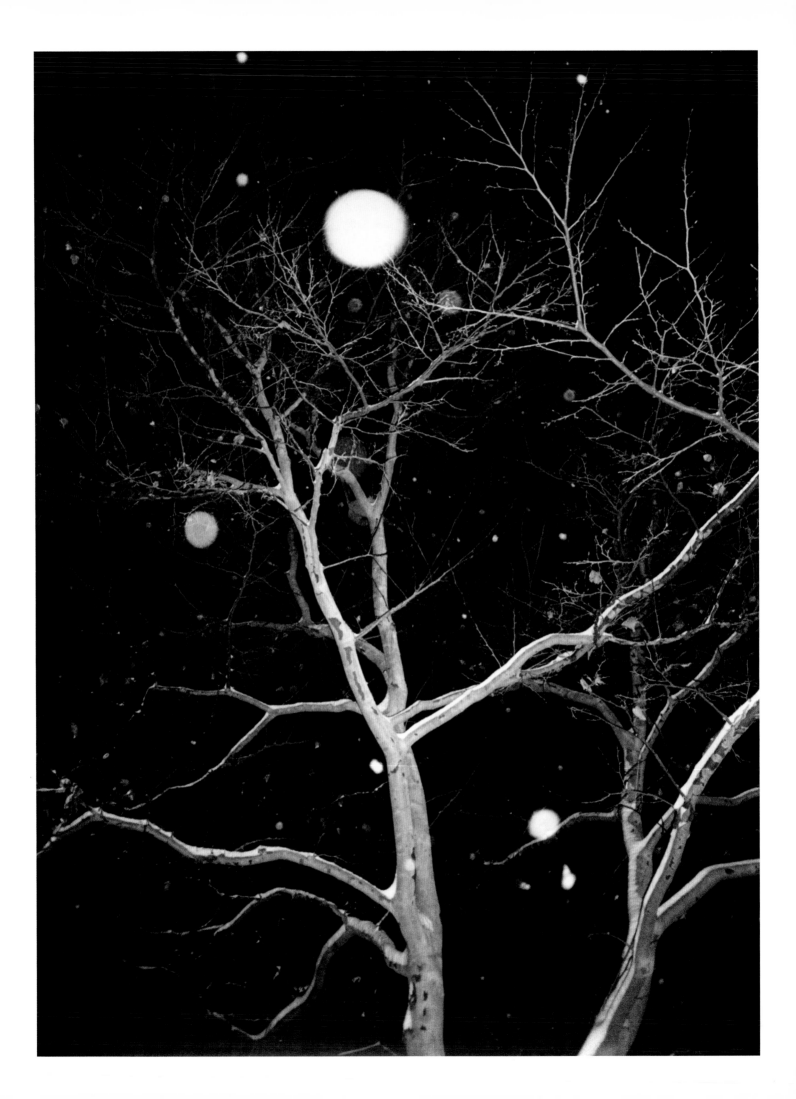

Snow Tree
2001 (left)

Hotel Room
2007 (center)

Liberated
2006 (right)

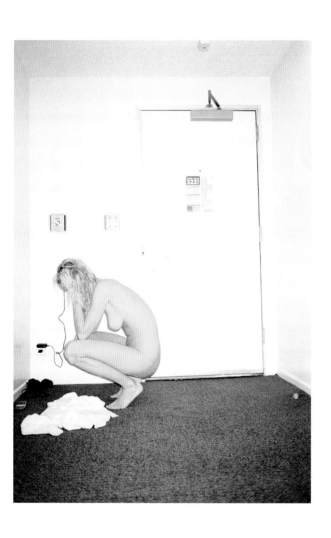

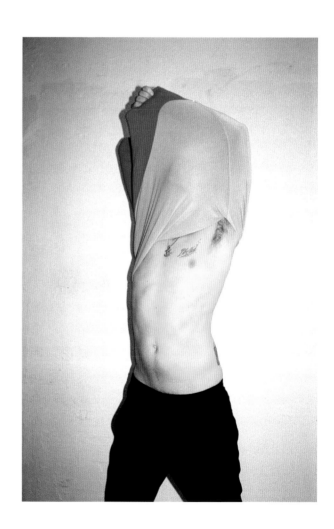

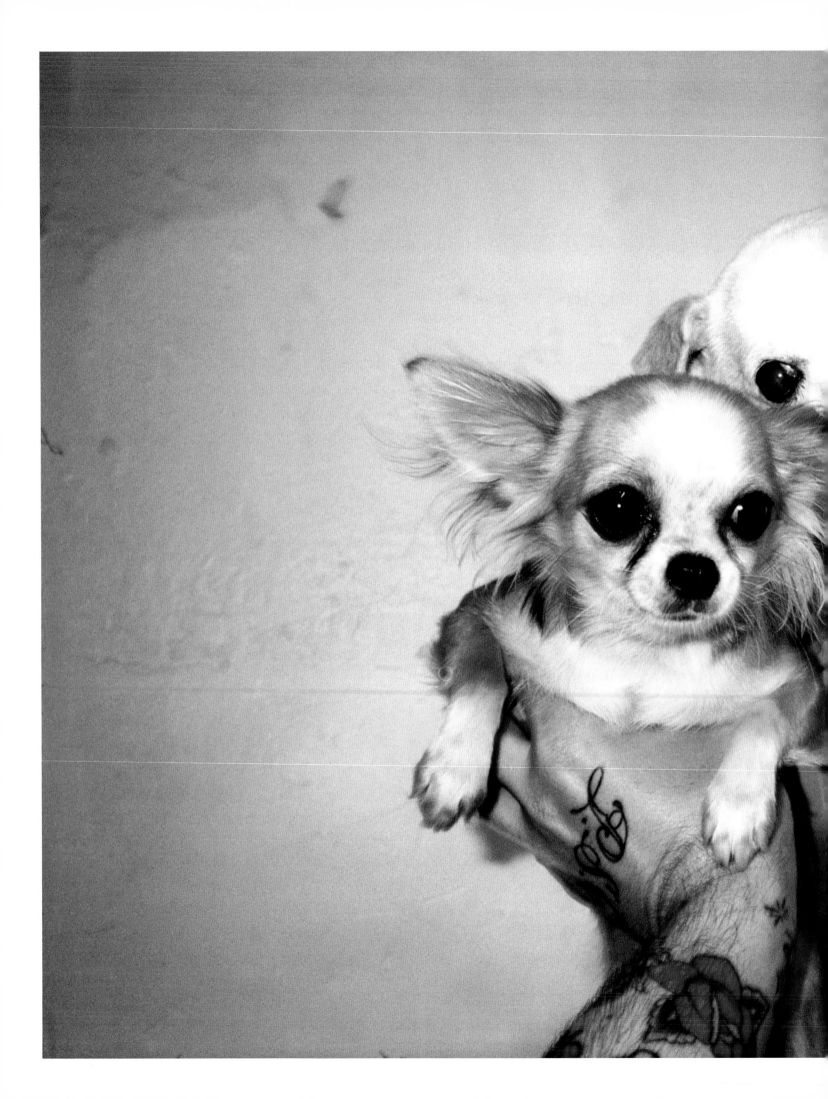

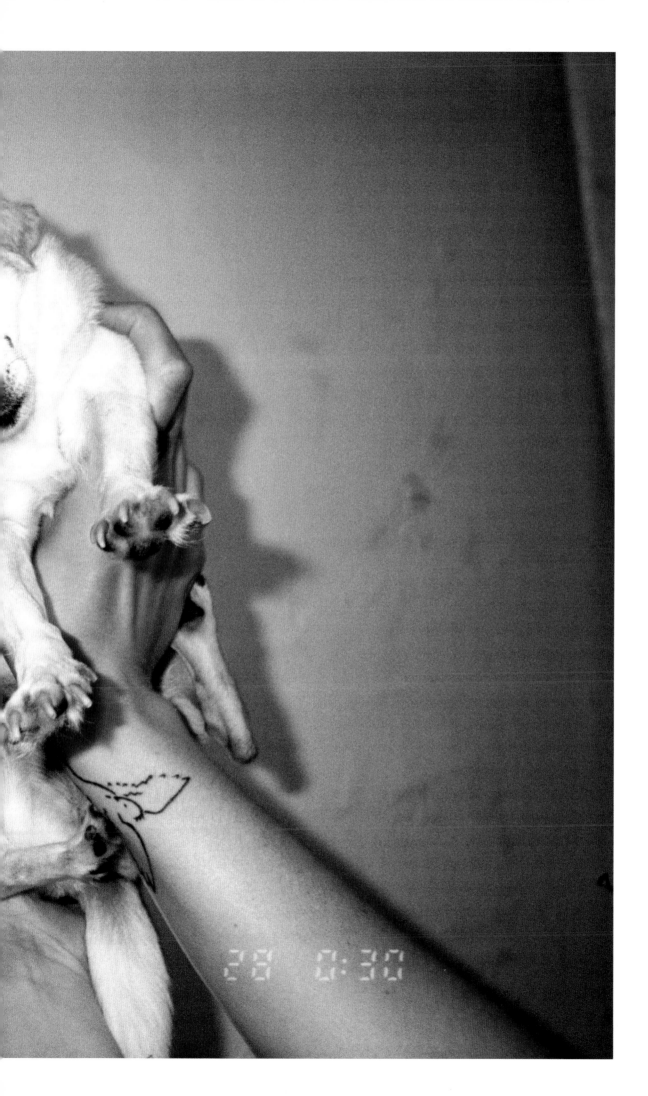

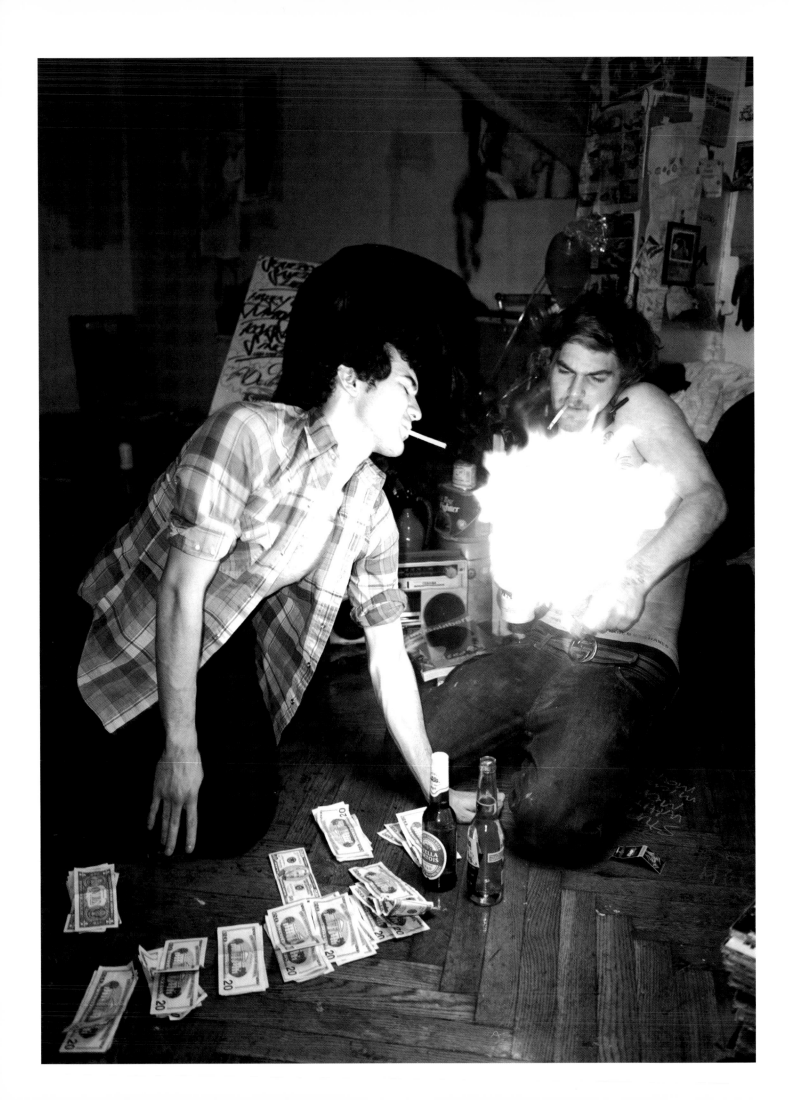

Lighting Cigarette
2003 (left)

Anaconda
2006 (right)

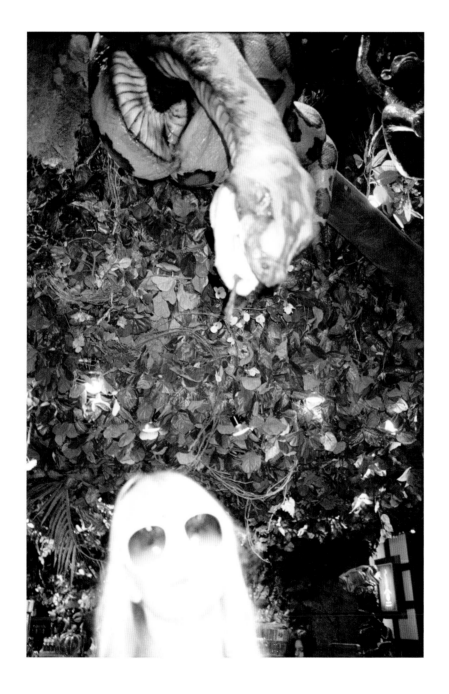

LOUISE ENHÖRNING

Paris-based Swedish photographer Louise Enhörning creates simple, dreamy images filled with suggestions of romance. Her approach emphasizes engagement with her photographic subjects. "I don't like to snap the image when you're supposed to. I don't find that interesting," she says. "I like to wait and snap during a moment when something is happening: when I'm *with* them and it's not them against us." Widely published as an editorial and street fashion photographer, Enhörning's photographs have an off-the-cuff casualness and tension that suggests the dynamism generated by interaction.

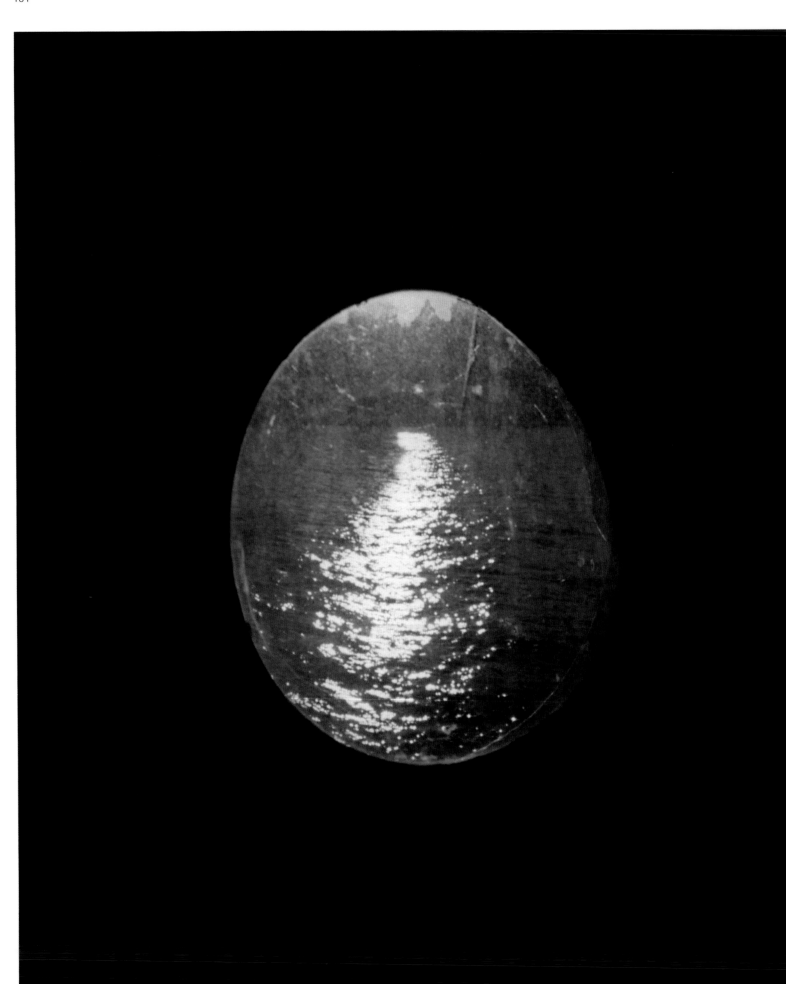

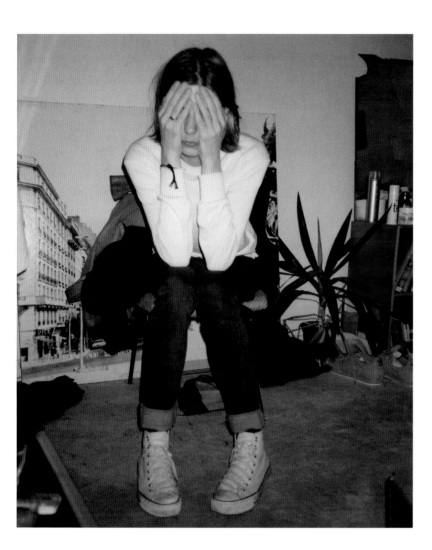

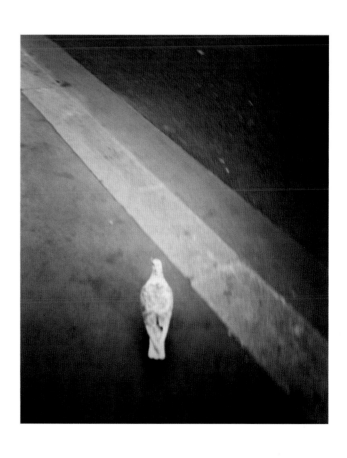

Untitled
2005 (left)

Secret H
2006 (center)

Sunday Walk
2006 (right)

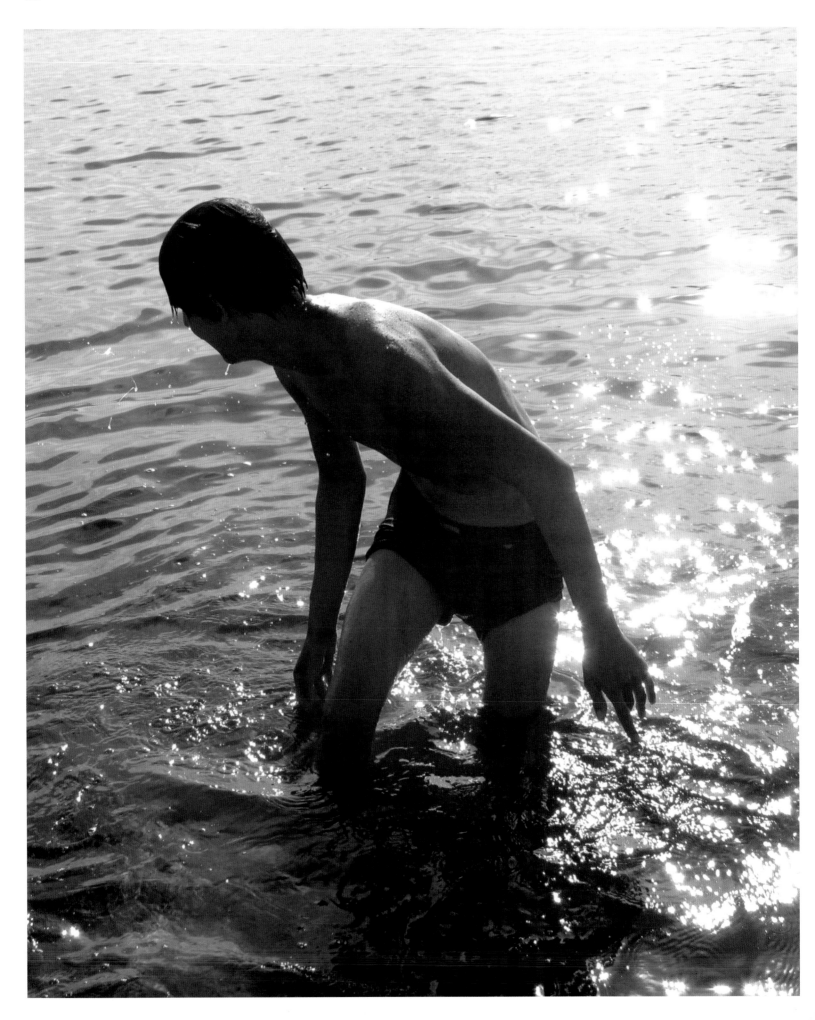

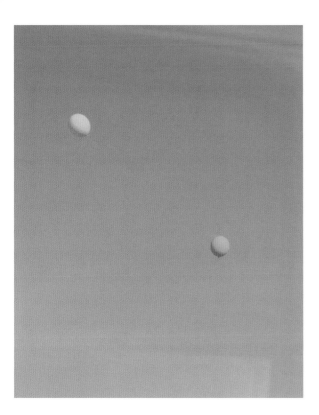

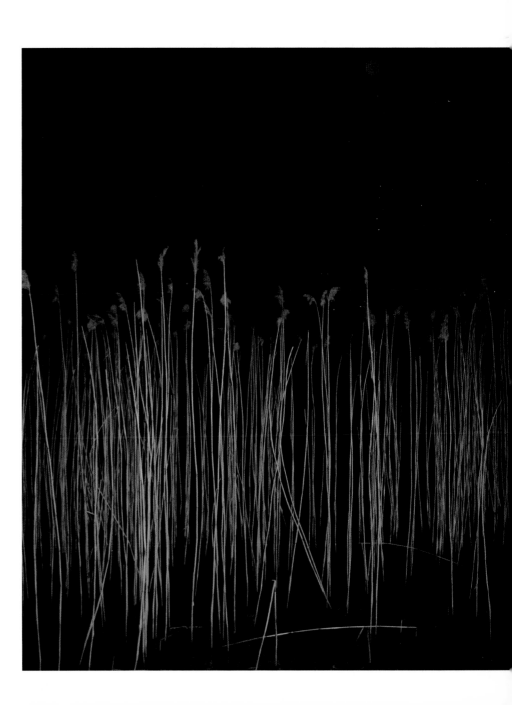

Martin
2008 (left)

On the Road
2008 (center)

Nämdö
2008 (right)

Don't Remember
2005 (next page)

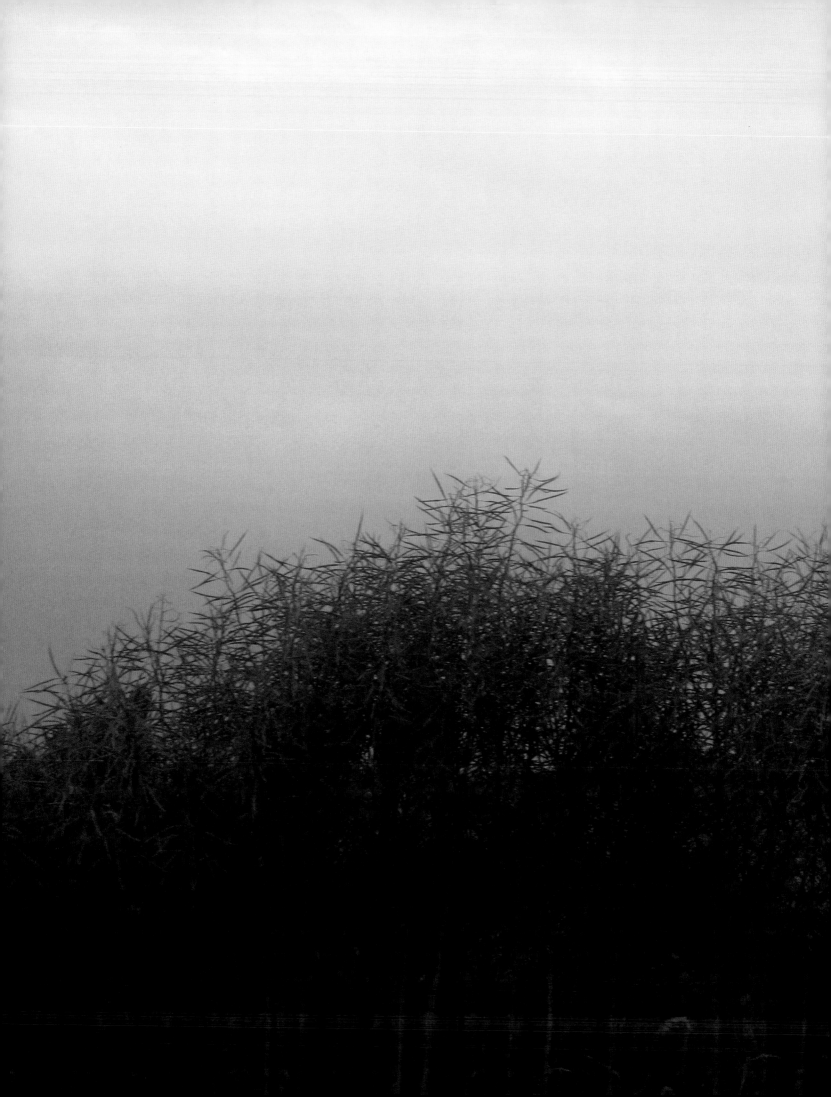

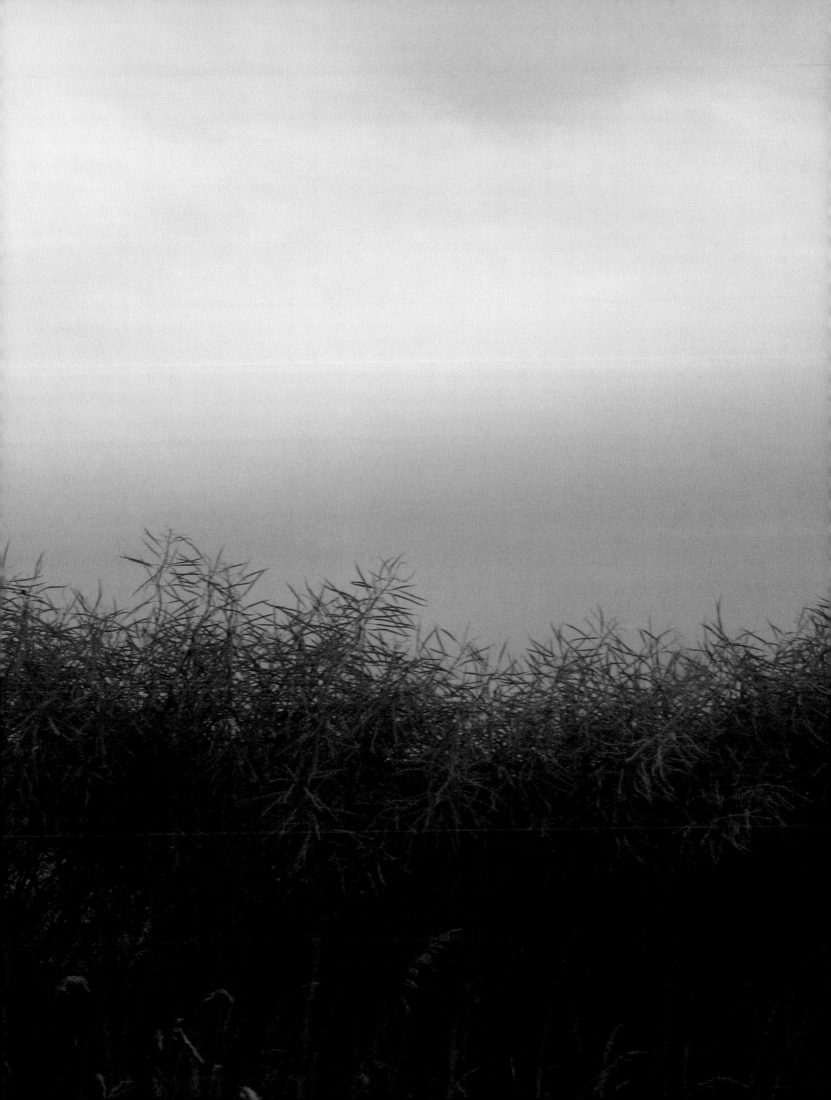

Without You
2008 (left)

Beach Mirror
2005 (center)

N.Y.
2008 (right)

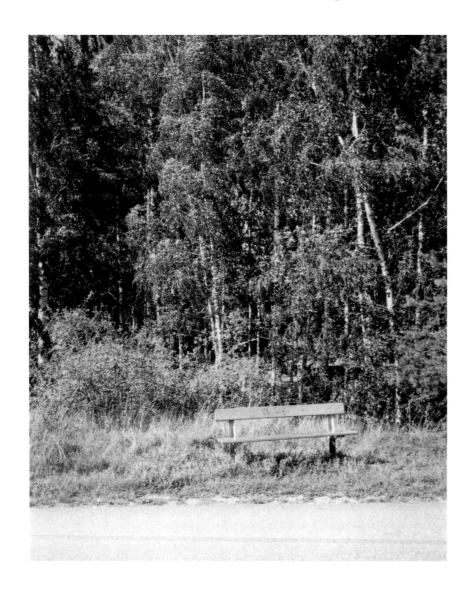

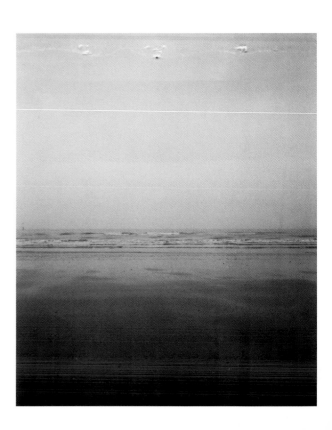

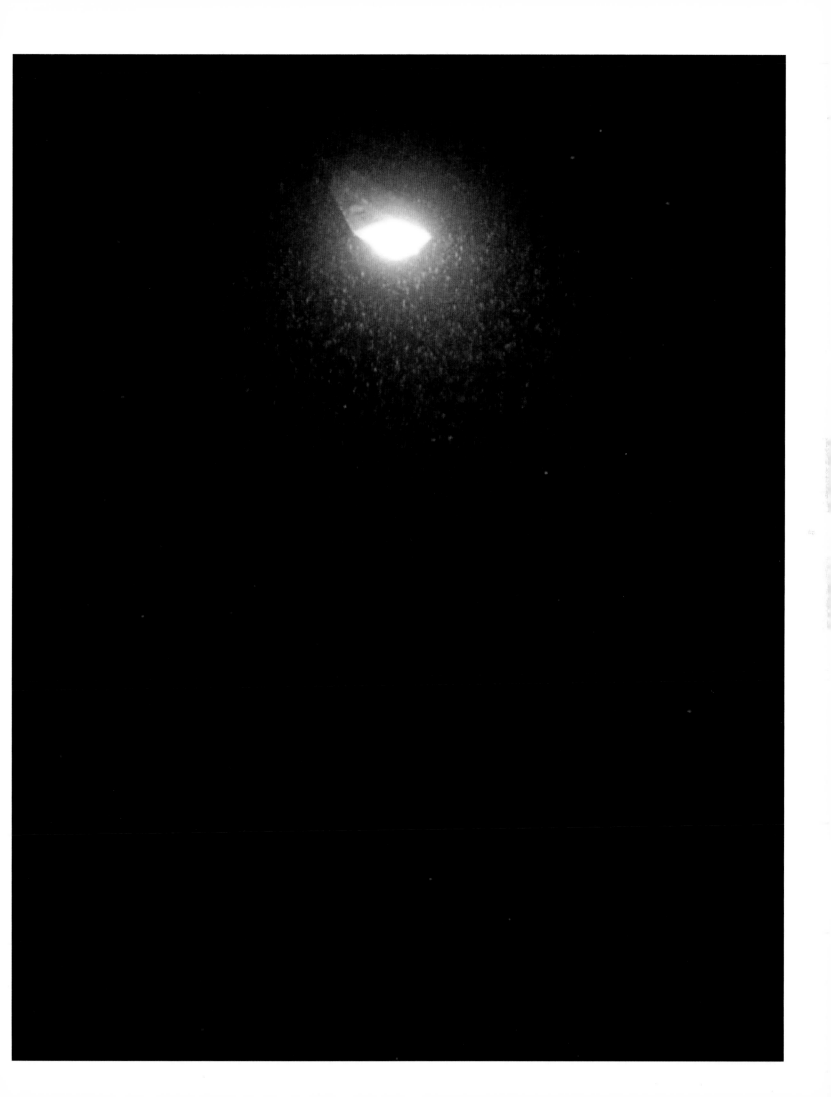

Untitled (Door)
2002 (left)

Untitled (Lamp)
2006 (right)

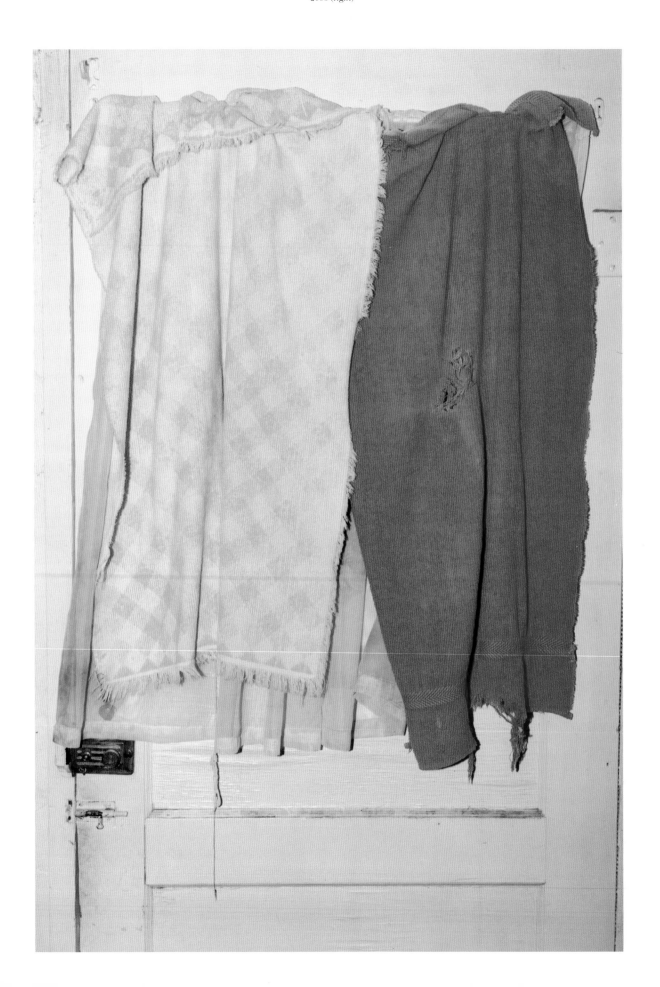

MICHAEL SCHMELLING

For Michael Schmelling, images gain power through association, so he has focused his work on a series of extended photo documentary projects on seemingly marginal subjects: music video groupies in Atlanta; obsessive compulsive hoarders and male strippers in New York; a solitary man in Texas. In a sense, he is repurposing media to reflect the overlooked. As he says, "The images that have left the biggest impression on me have been from editorial spreads, newspapers, and other media such as film and books. In the end, I guess what attracts me to an image all comes from context." To date, Schmelling has published four books (two with J+L Books), including a prominent collaboration with the rock band Wilco.

Untitled (Semi-colon)
2006 (left)

Untitled (James, Tooth)
2004 (right)

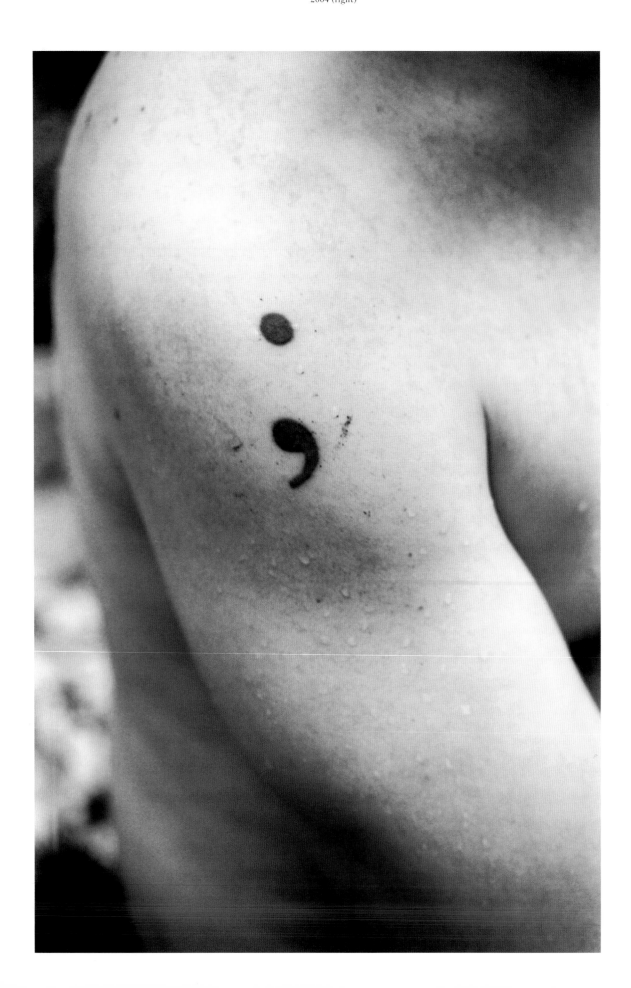

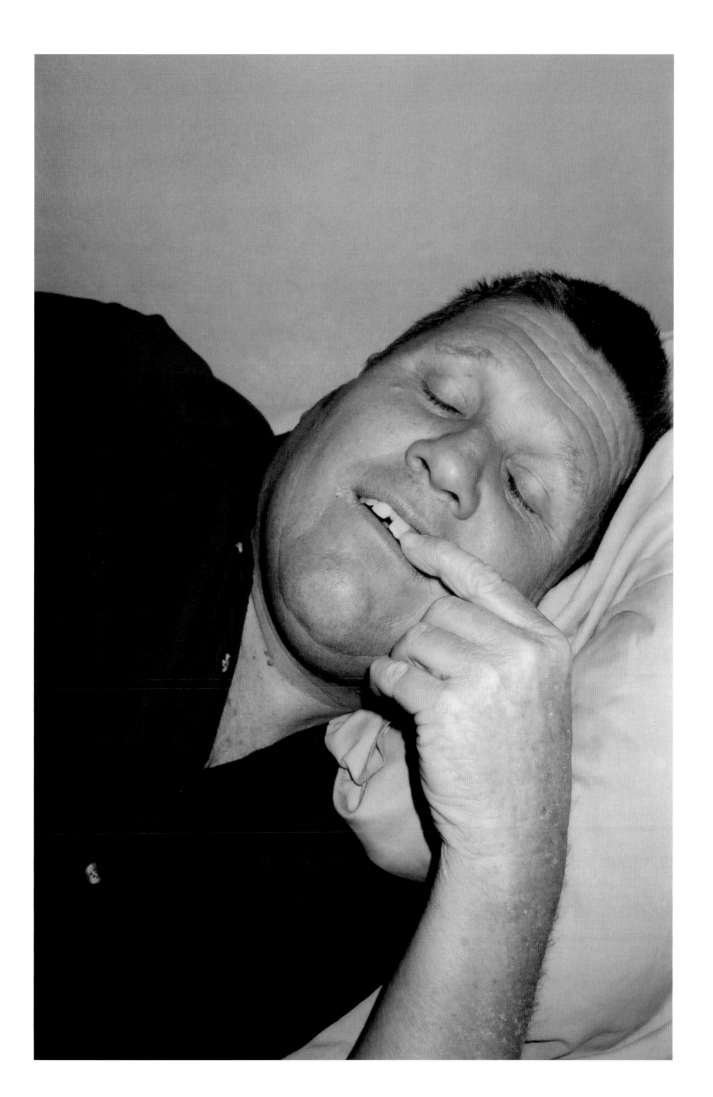

Untitled (Dallas.11)
2004 (left)

Untitled (Saskia)
2007 (right)

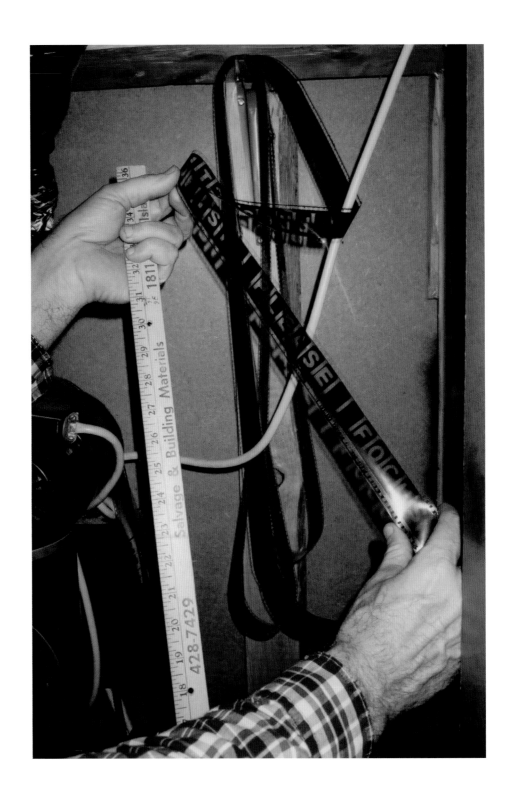

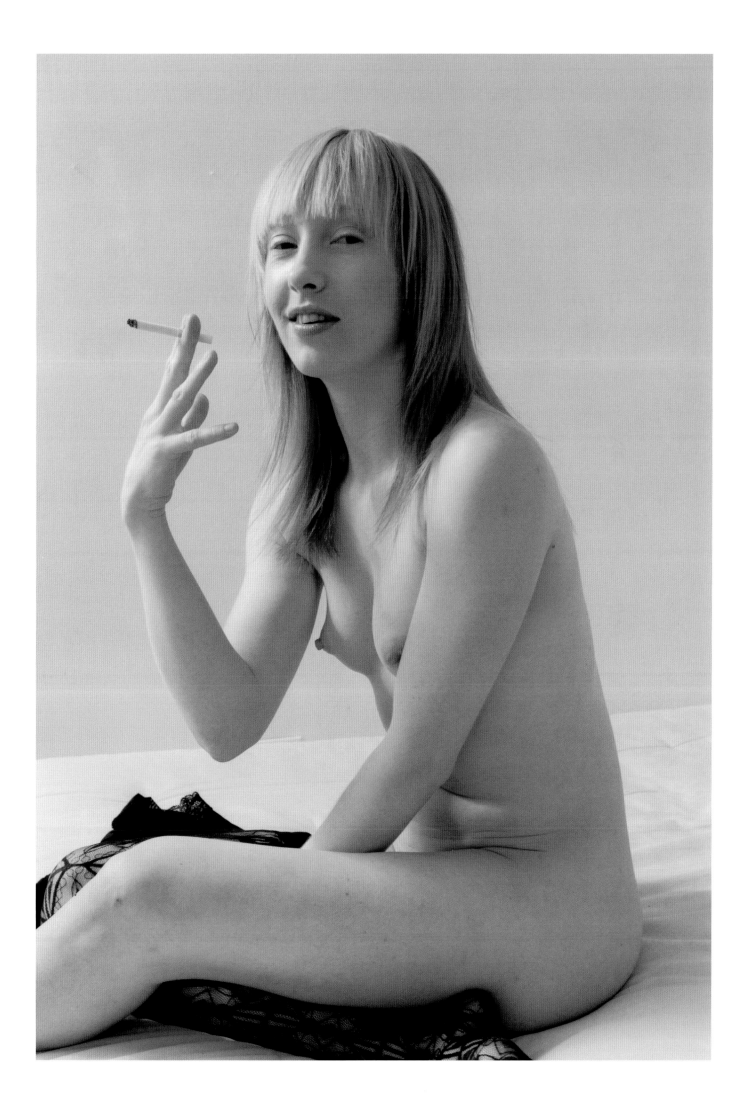

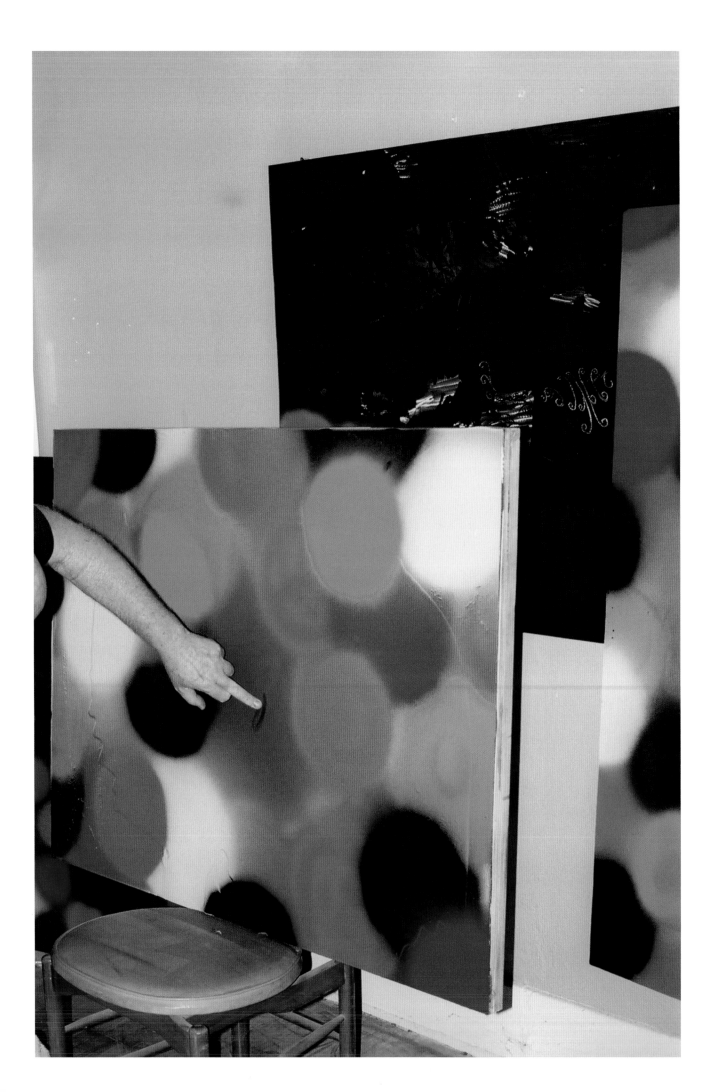

Untitled (Painting)
2008 (left)

Untitled
(Principle Video Girl)
2008 (right)

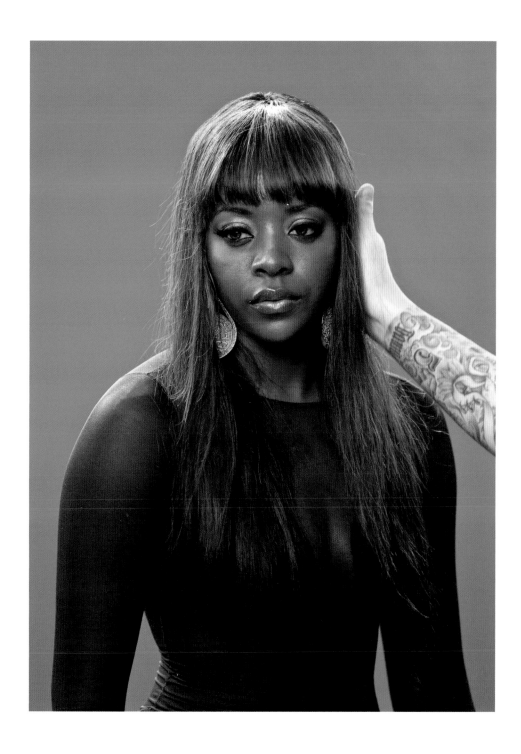

Untitled (Pyramid)
2007 (left)

Untitled (Clapton)
2007 (right)

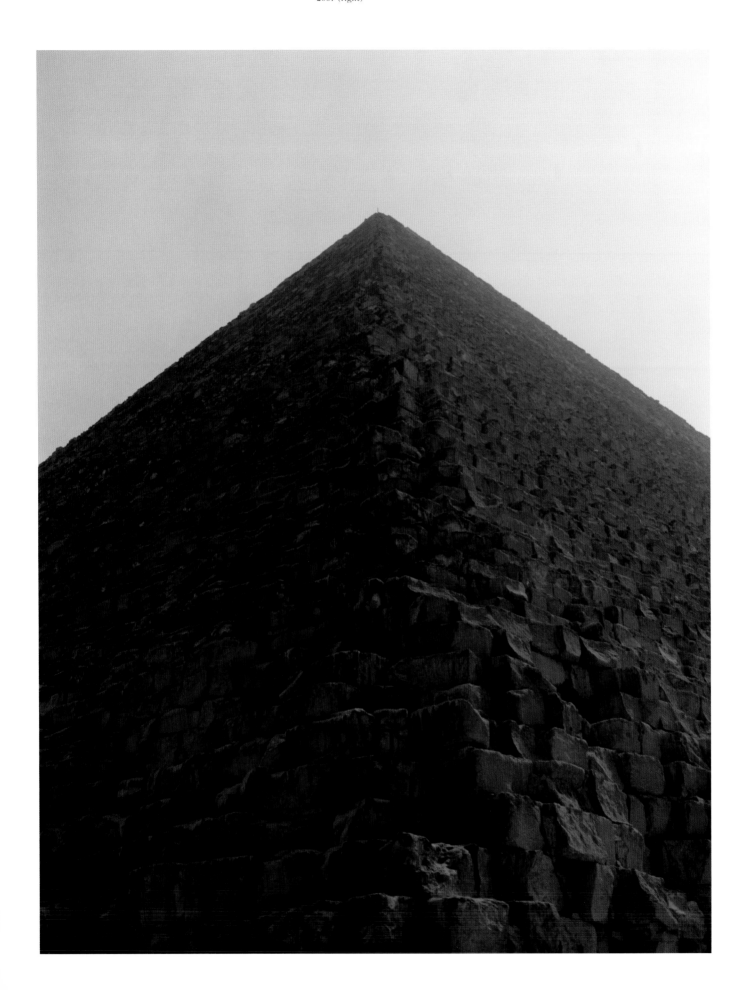

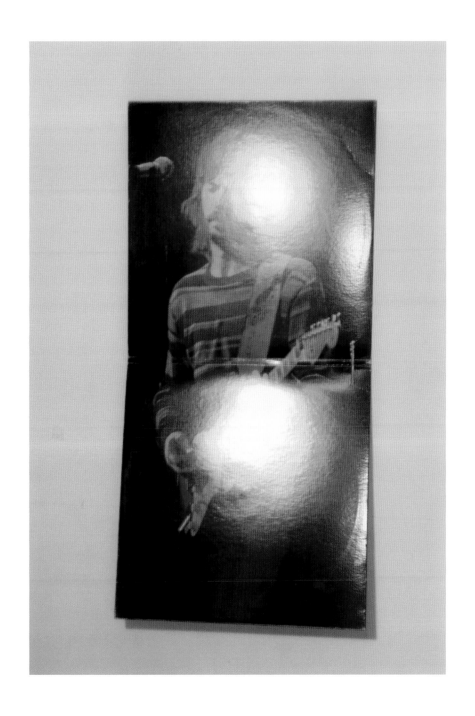

Tamariu, St John's Night
2003

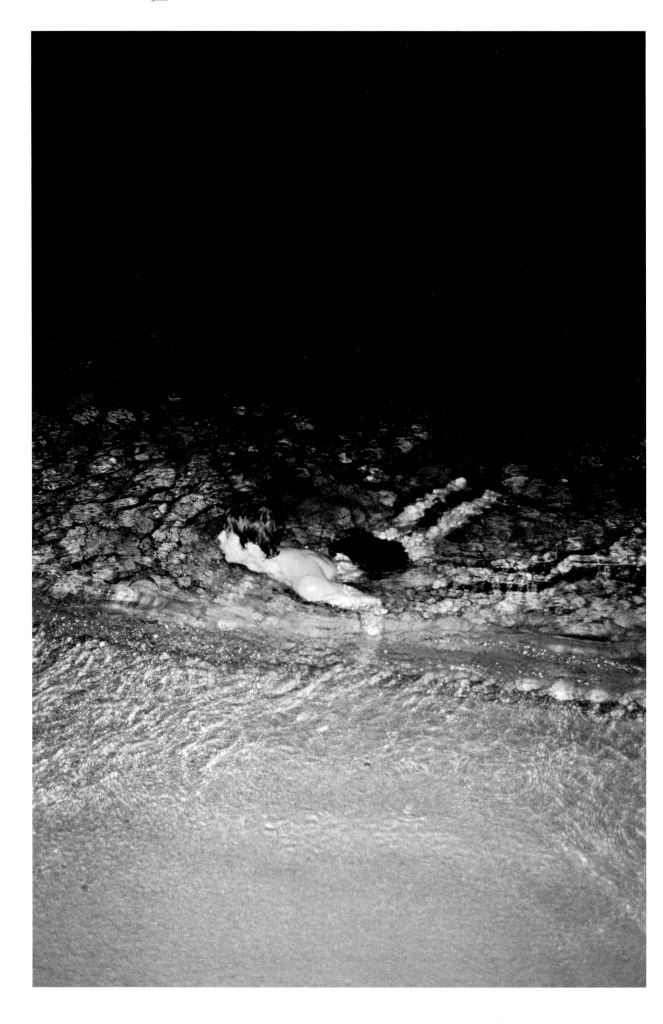

NACHO ALEGRE

A prolific self-publisher, Barcelonan photographer Nacho Alegre published the *Fucklet* zine from 2004–2006 and now publishes *Apartamento*, a magazine of interior decor. His diaristic approach to taking photographs, which are often presented pasted into journals, emphasizes the notion that photography and lifestyle are inseparable. Rather than simply shooting a portrait, Alegre is happier presenting a more complete exploration of his subjects, including their personal environment and daily activities. "I take photographs out of a craving to remember and the fear of forgetting. I also take pictures as my job… but that's a completely different thing."

Shy Couple, Naeba, Japan
2008 (left)

Carlotta, Antwerp
2003 (center)

Stretching Chick
2008 (right)

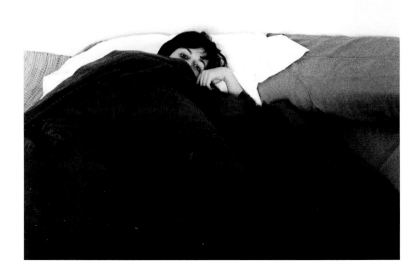

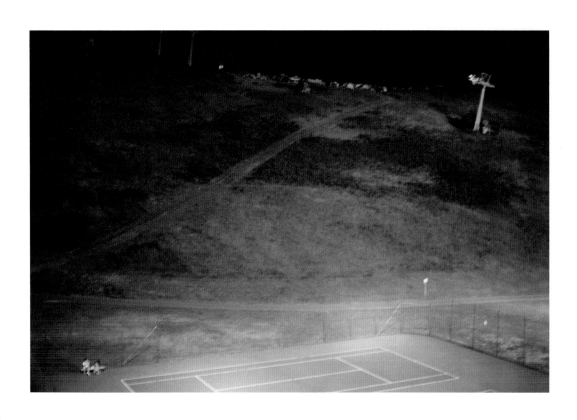

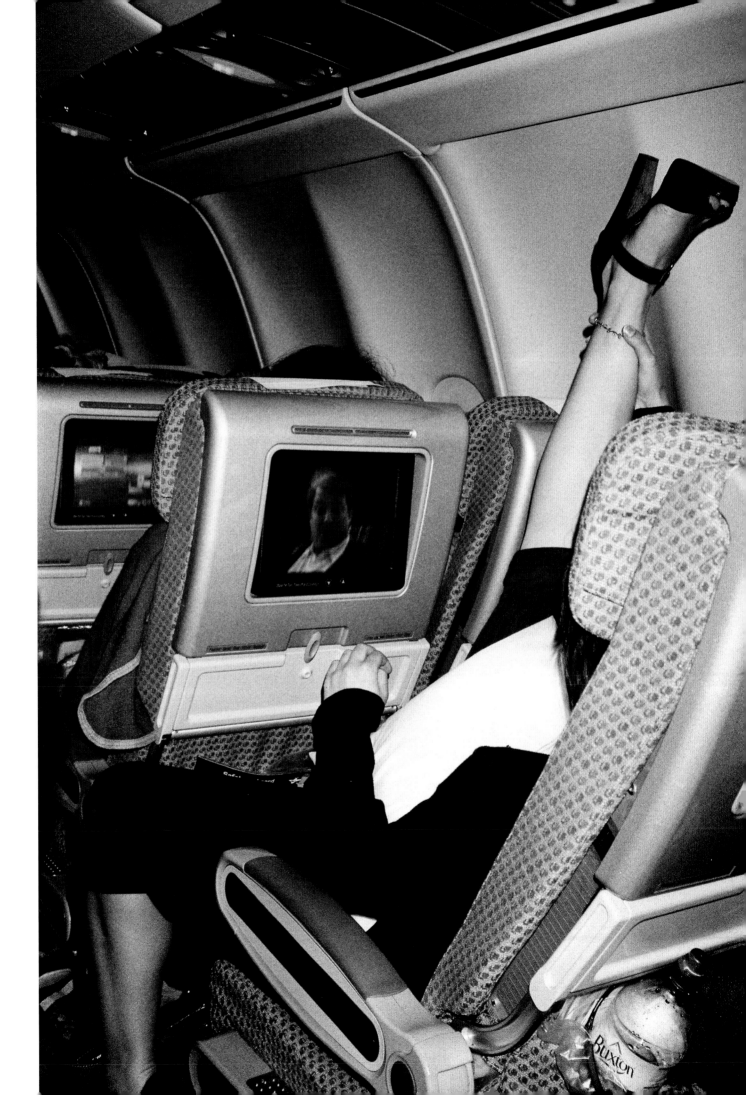

Untitled, Japan
2008 (left)

Blaine Moving Forward, Oxford
2008 (center)

FC Barcelona League Championship Celebration
2006 (right)

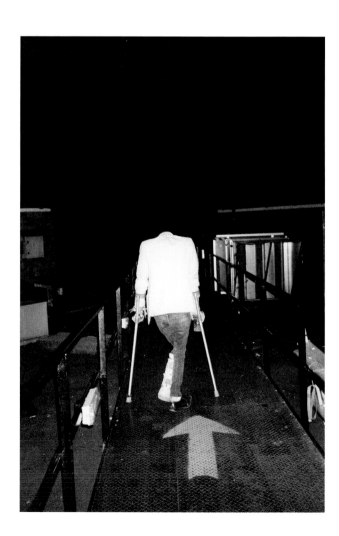

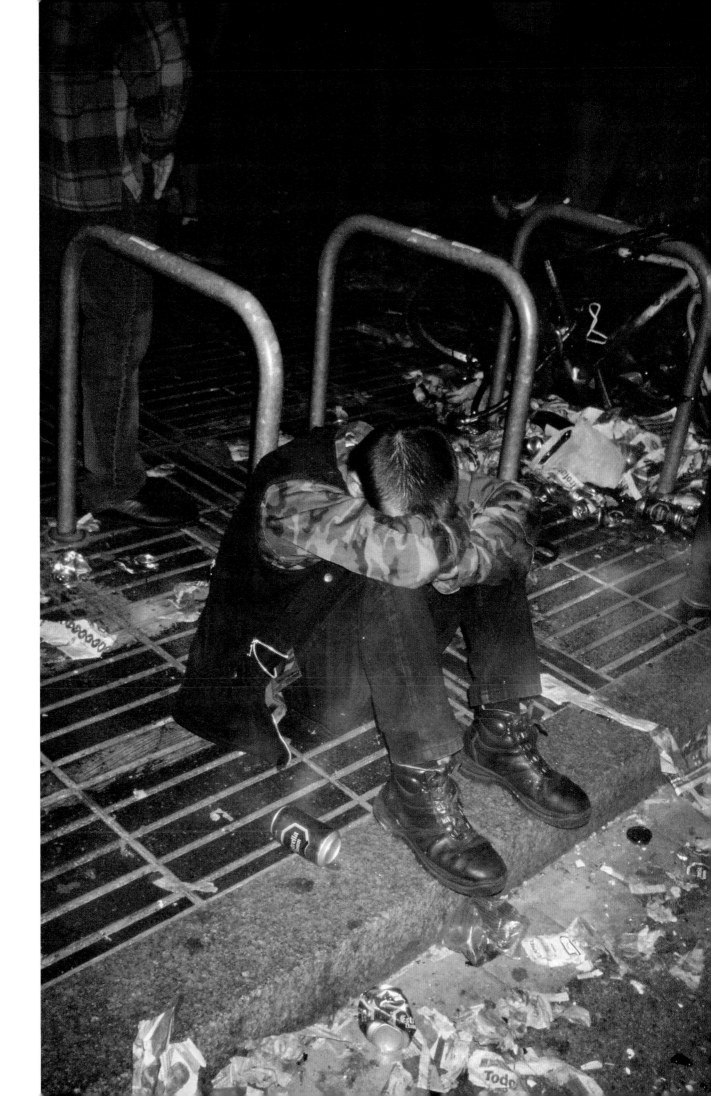

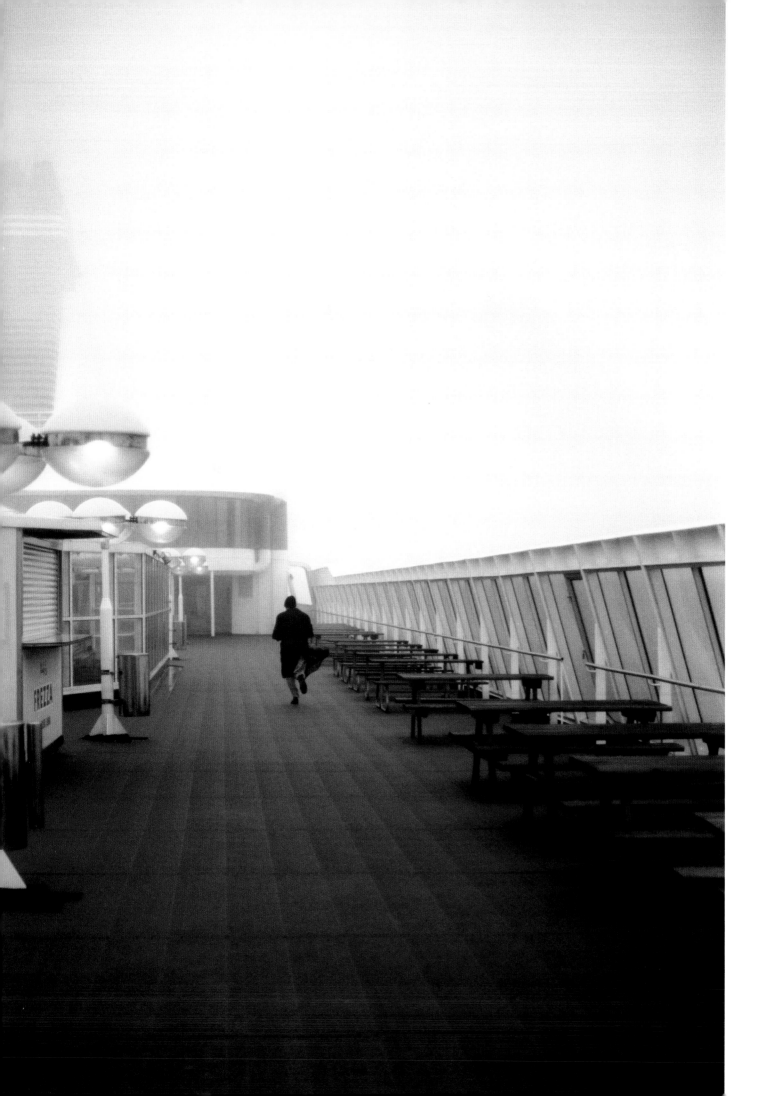

OLA RINDAL

Filled with spectral objects and creeping absence, Norwegian photographer Ola Rindal's work has a haunting emotional impact that lingers like an afterimage. Rindal believes that this unsettling effect is achieved by focusing on qualities of the image beyond the immediate object of focus. "For me, the light and the space around the subject are as important as the subject itself." Rather than a pedestrian representation of reality, he chooses to concentrate on more abstract qualities: "The change of distance, the volume and substance of the air, and the light all change the atmosphere and also my interest in the subject in front of me." He says, "What intrigues me the most is when the subject withholds information about what it is and why it has been photographed… When it is revealing only a little mystery." Now living in Paris, he has undertaken fashion projects with labels Maison Martin Margiela, Chanel, and Louis Vuitton Homme. In addition to several gallery exhibitions, his work is in the permanent collection of museums in Norway and Japan.

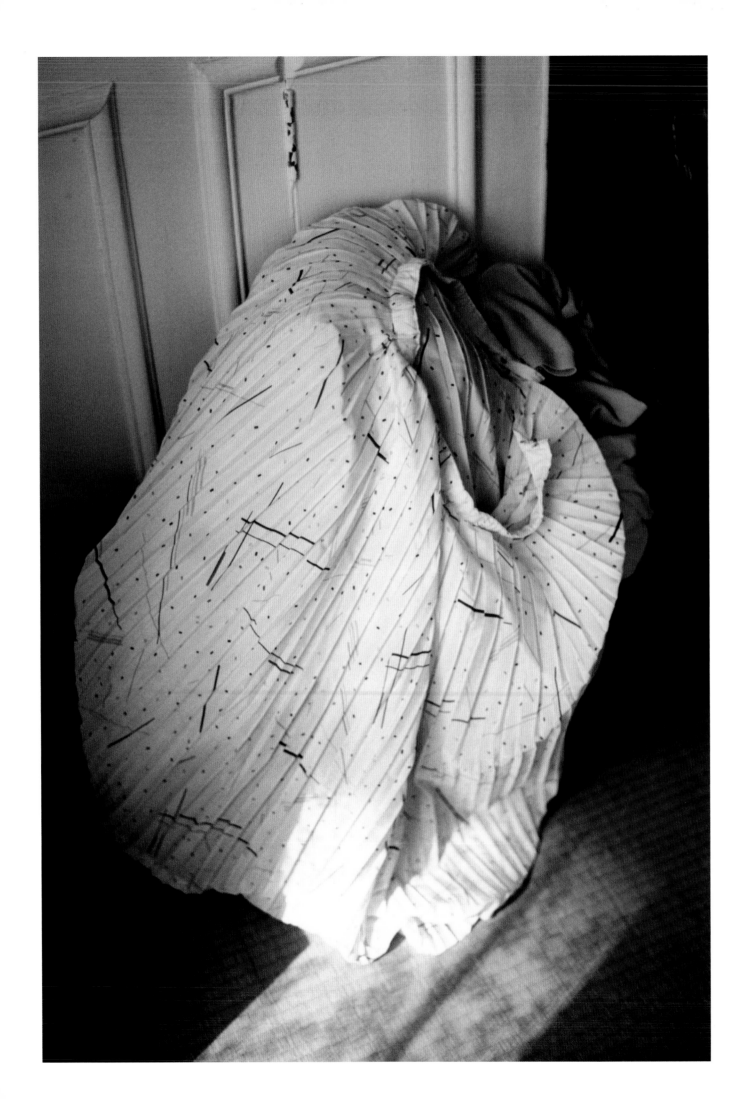

Man Running
2007 (previous page)

Skirt
2006 (left)

Hallway
2007 (right)

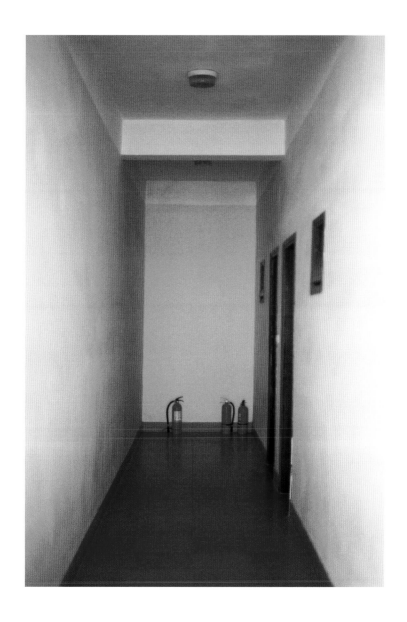

Flying Away
2007 (left)

Foggy Road
2007 (center)

Cemetery
2007 (right)

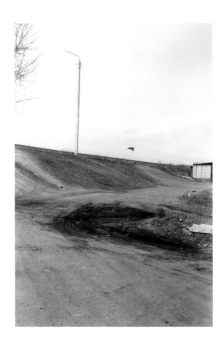

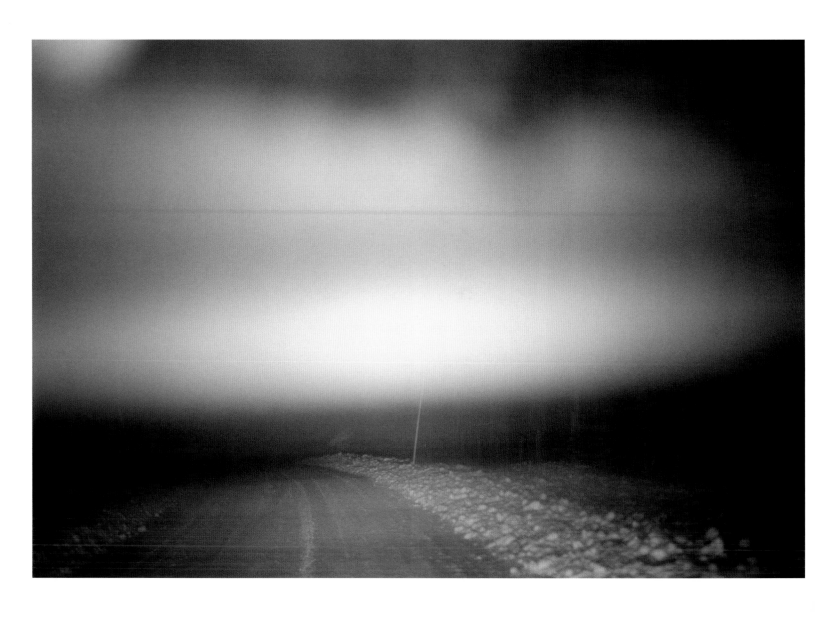

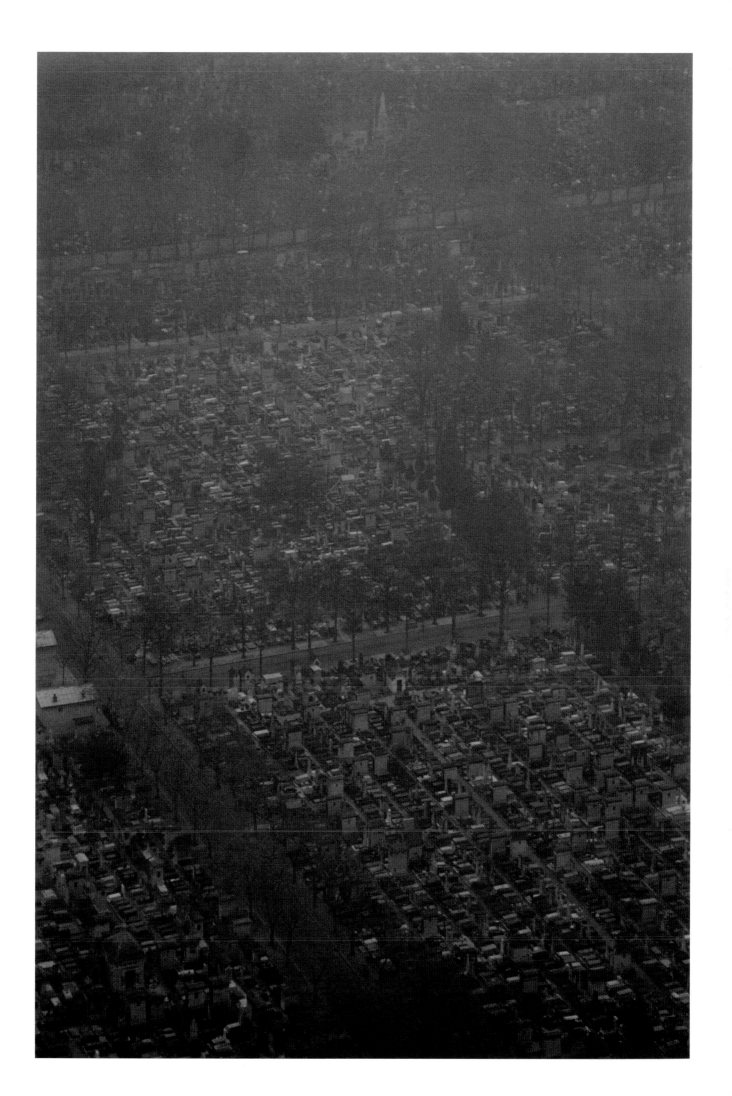

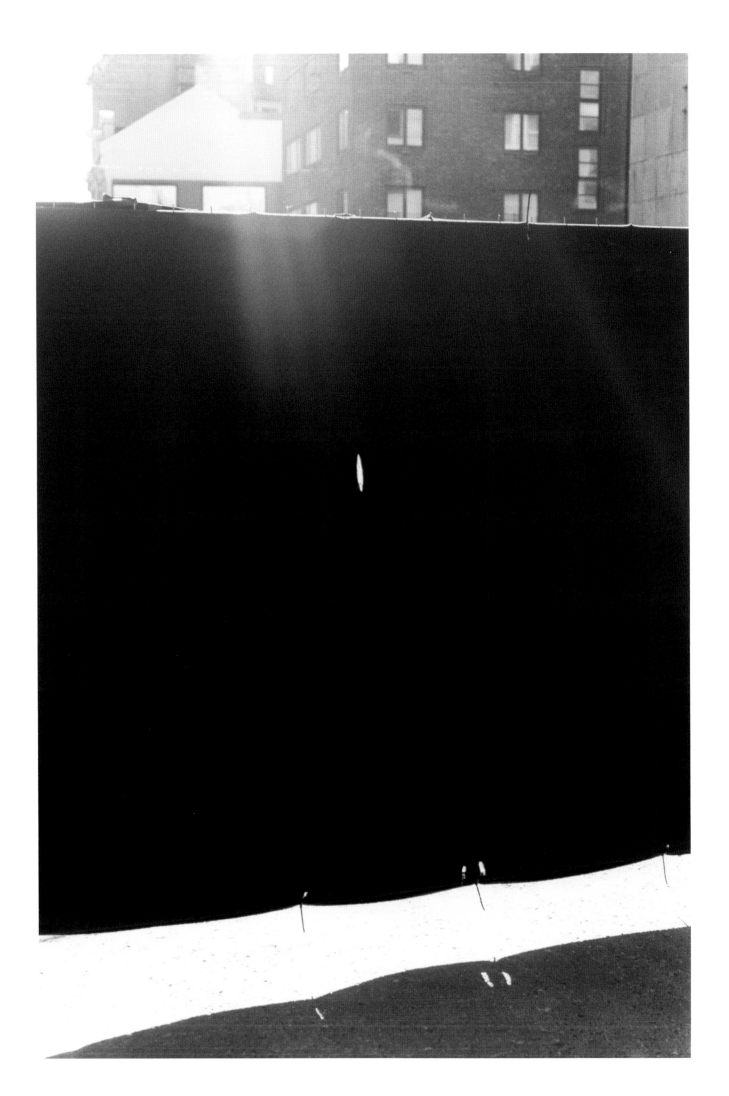

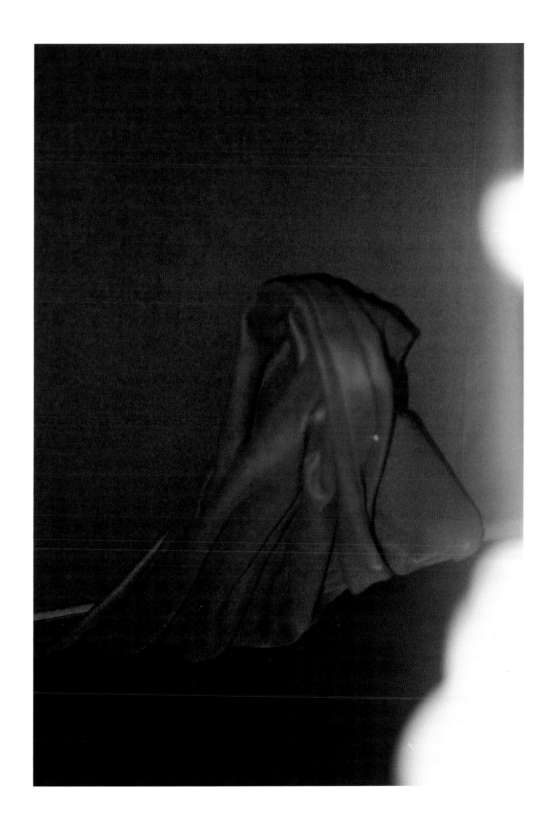

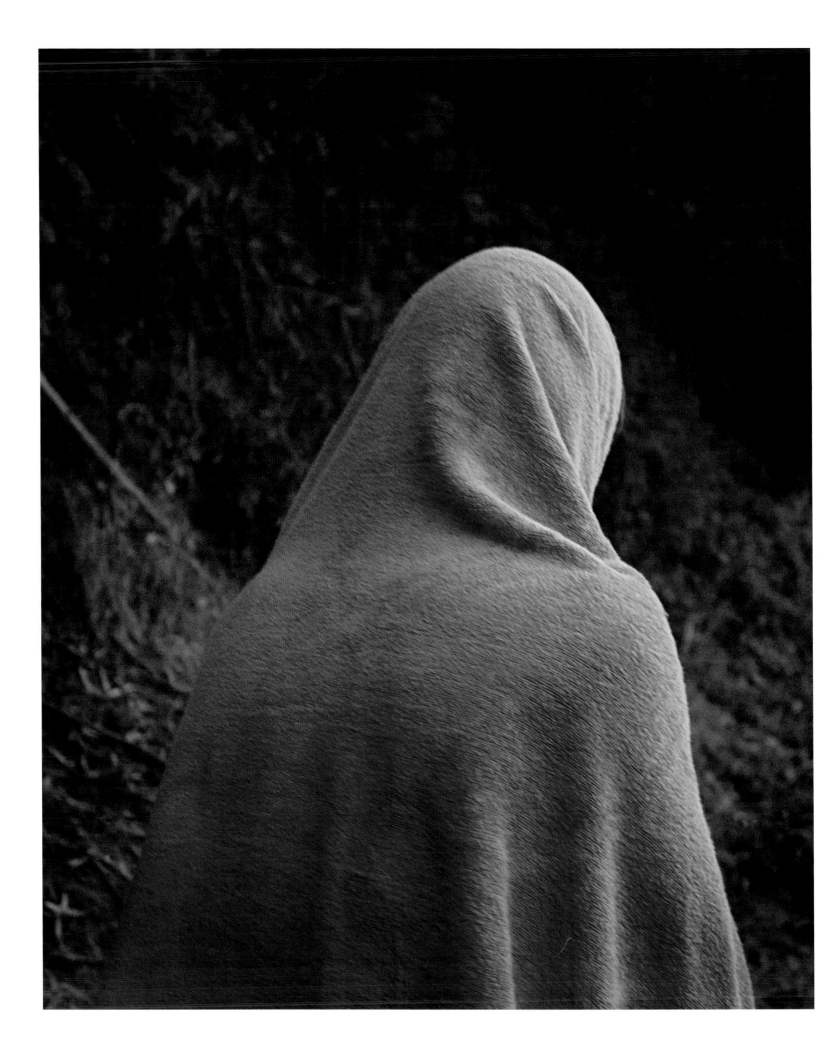

PAUL SCHIEK

Notable for what they do not reveal, Paul Schiek's photographs intrigue with their elemental simplicity. Born in Fond Du Lac, Wisconsin, he now resides in Oakland, California, where he has honed his reductive approach to photography. "I shoot as much as I can and reduce from there," he says. "I'm constantly removing information from the photos to try to find pure form and meaning." Schiek has also established a relationship with his fellow photographers through his notable independent imprint TBW books, which has published the work of Jim Goldberg, Marianne Mueller, Todd Hido, and Alec Soth, among others. Establishing that direct connection to a subject is important to Schiek, who says, "I never shoot something I don't know, including humans or landscape."

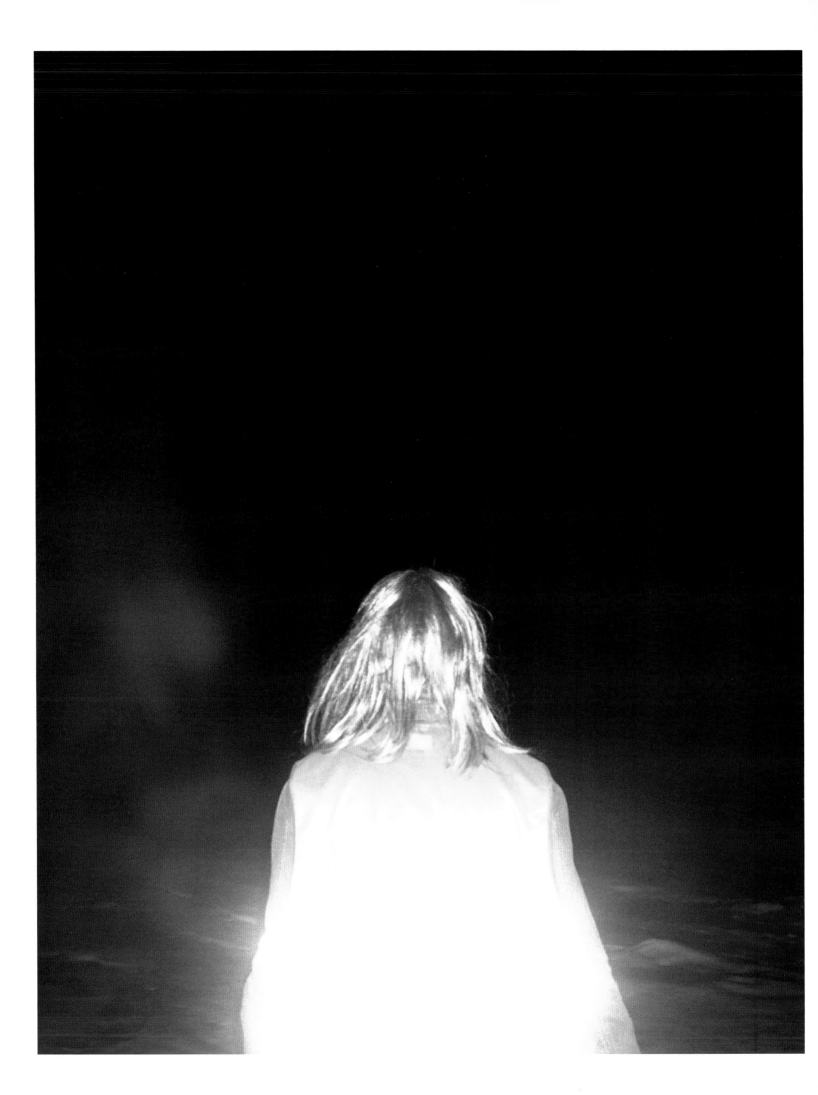

Untitled
2005 (previous page)

Keep Walking,
You're Almost There
2005 (left)

Untitled
2005 (right)

Untitled (Parrot)
2005 (left)

Self Portrait (As Total Goodness)
2006 (right)

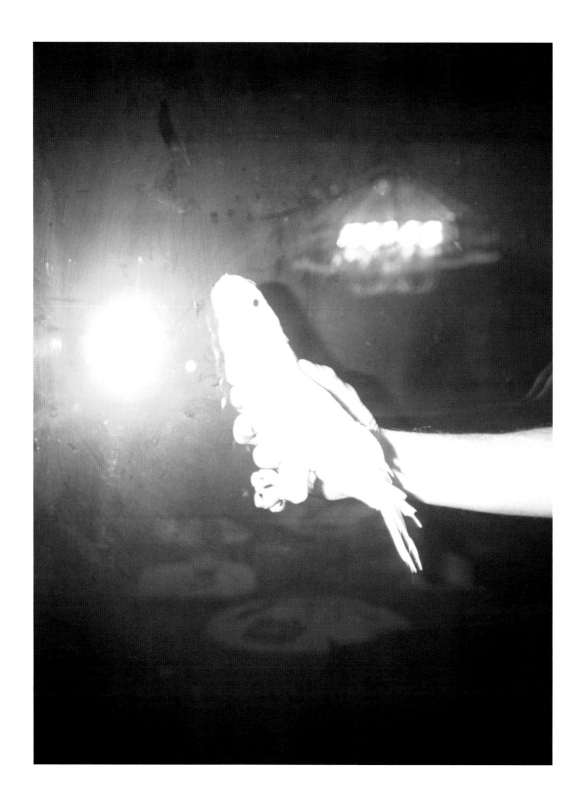

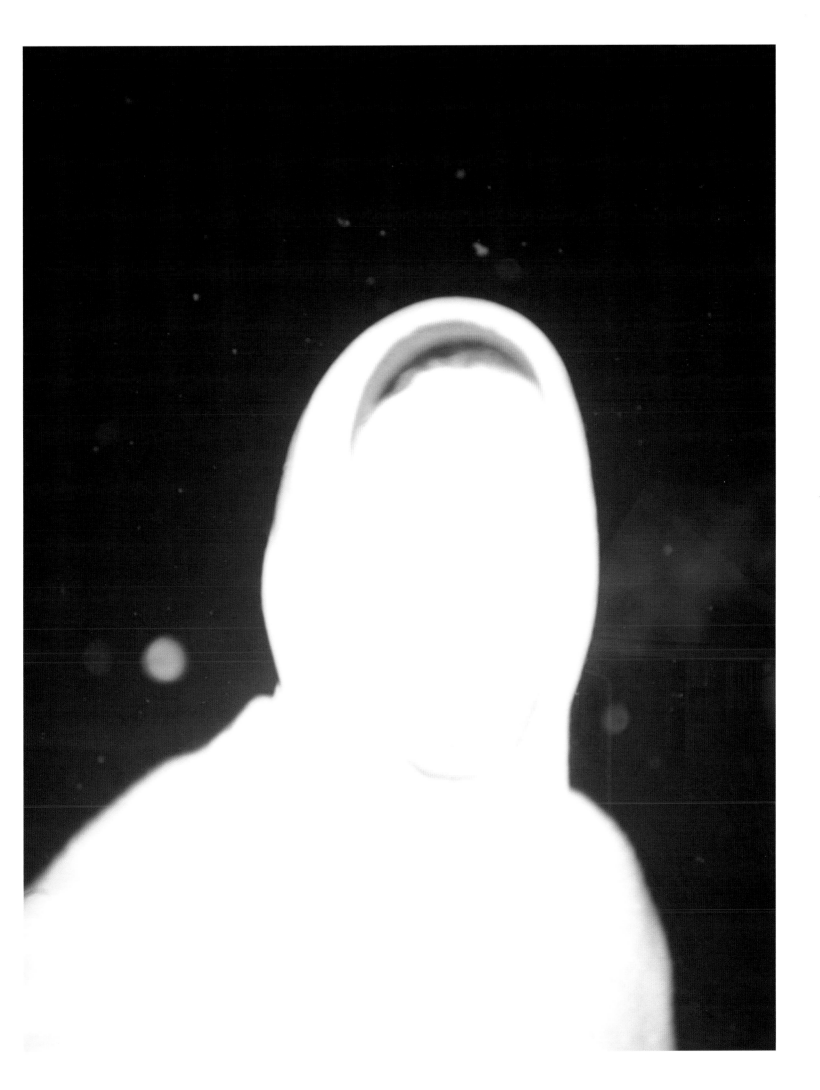

Untitled
2005

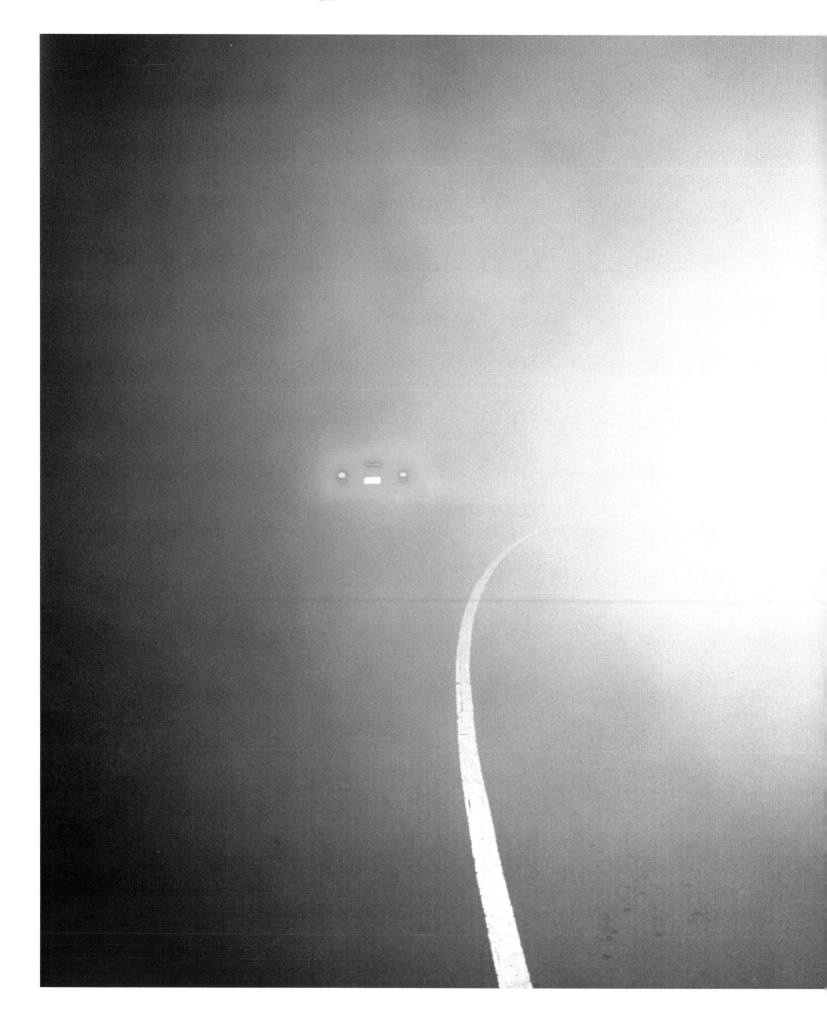

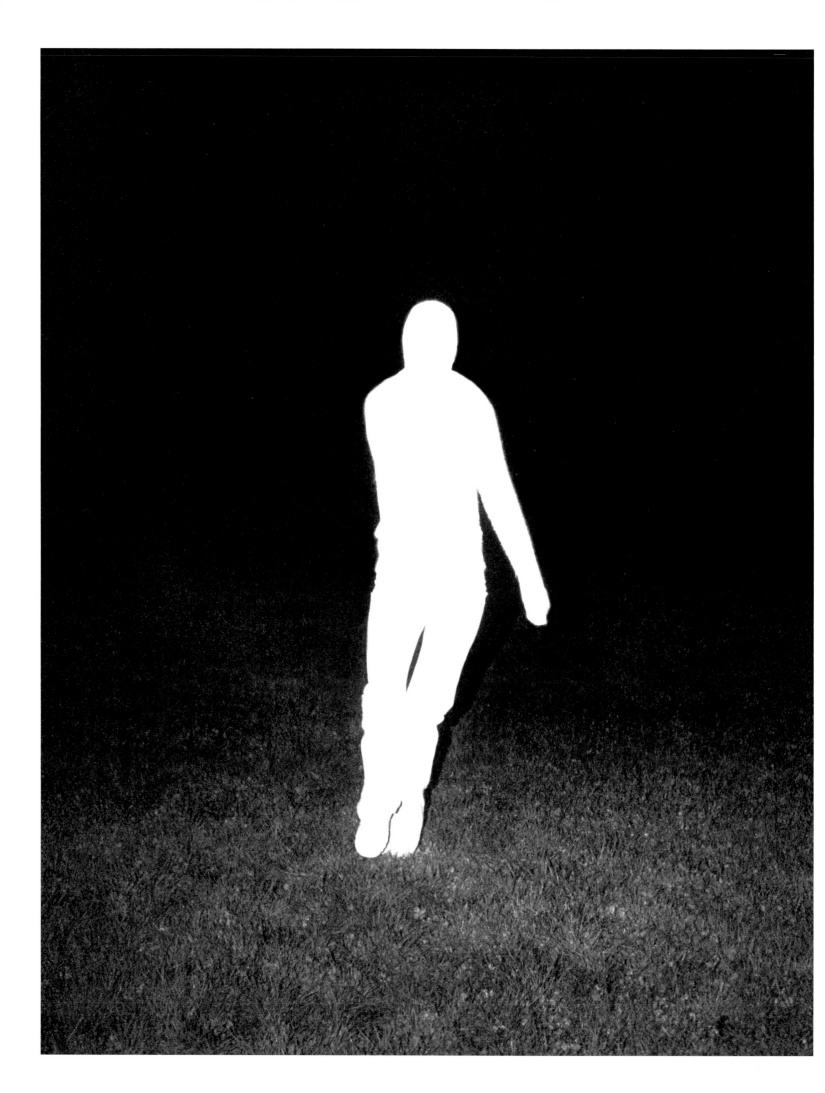

Untitled
2006 (left)

Untitled
2005 (right)

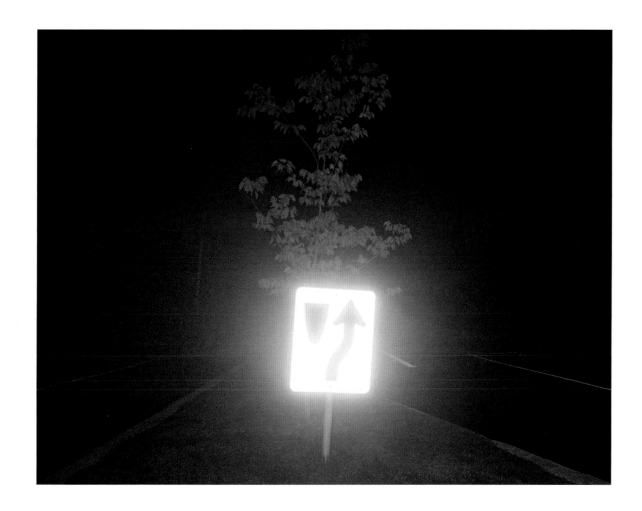

Untitled
2006

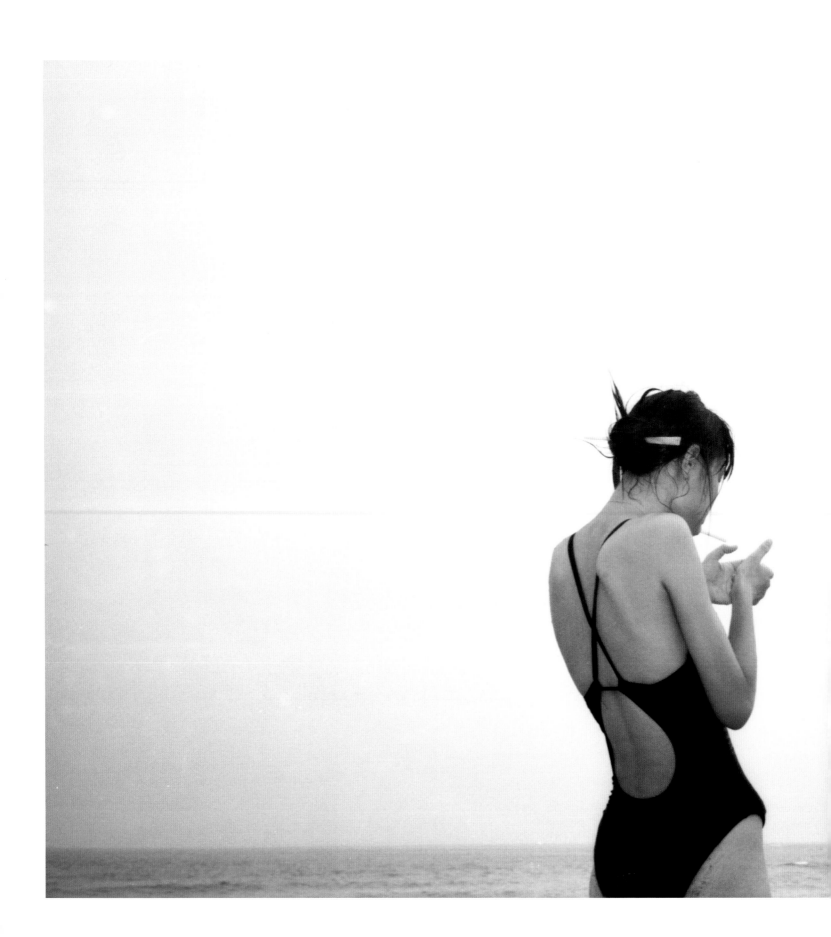

MADI JU

First recognized internationally for *My Little Dead Dick*—a diary project she posted on Flickr with her ex-boyfriend, fellow photographer Patrick Tsai—Madi Ju's personal photography is primarily focused on depictions of young women. "I always love to shoot girls and the small changes on their faces and their bodies," she says. Specifically, she documented her own relationship with Tsai (with a frankness that was at times unnerving) as well as the relationships of other young women in Beijing's emerging youth culture. The resulting images have a sweet, innocent lyricism drawn from Ju's desire to make the most of the everyday. "I shoot when I find that the scene around me is a little bit more like a movie than real life," she says. "I prefer to make people feel warm and happy, so I shoot when I feel that way about a scene. When it's not boring, but also when it's not fake." *My Little Dead Dick* was compiled into a book by the United States–based Nerve press, and Ju's work has been exhibited at museums and photography festivals in the U.S., France, Italy, and China.

Untitled
2006 (left)

Untitled
2005 (right)

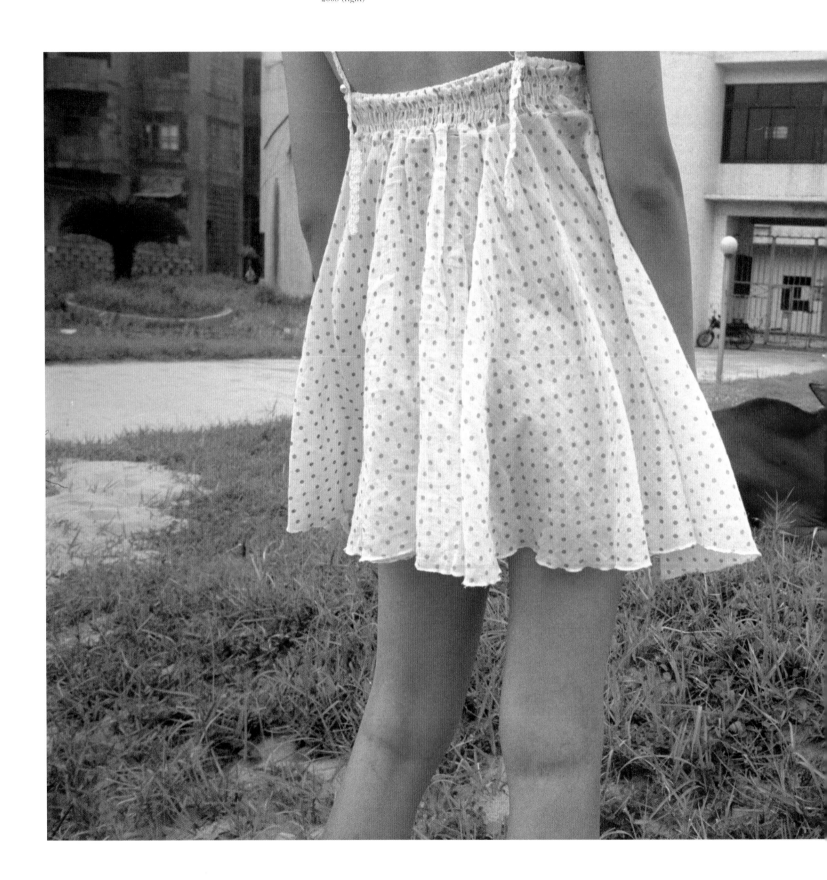

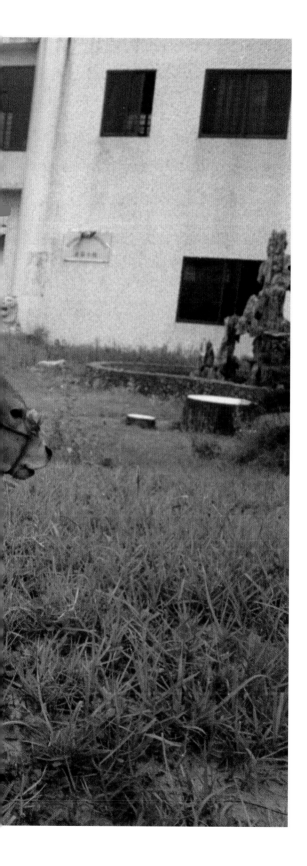

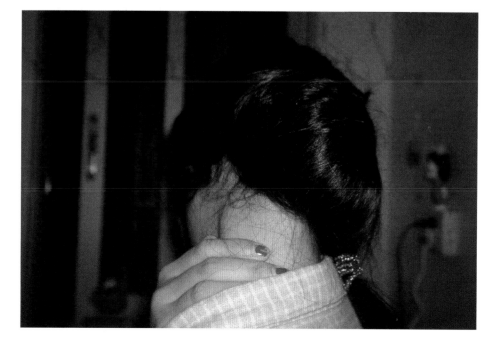

Untitled
2007 (left)

Untitled
2007 (right)

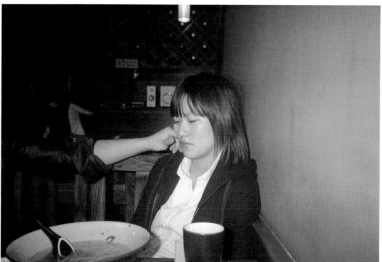

Untitled
2007 (left)

Untitled
2006 (right)

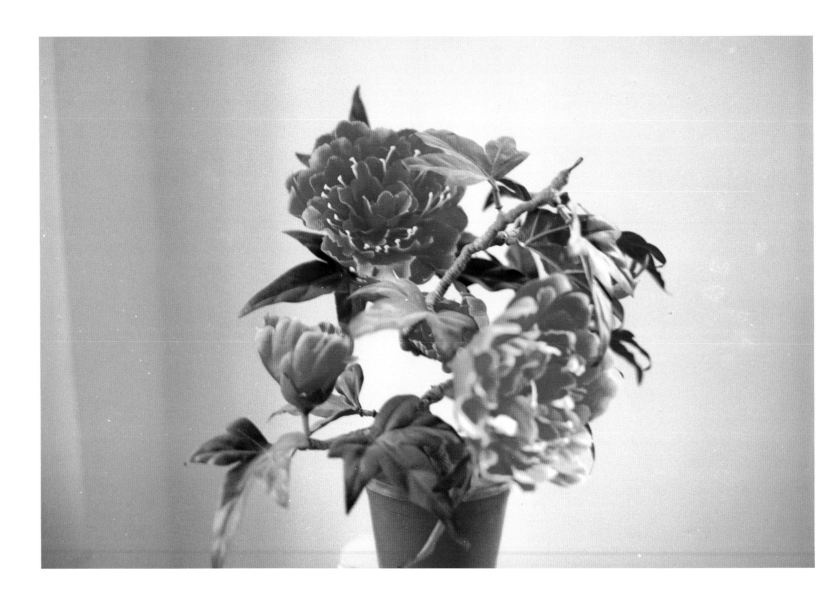

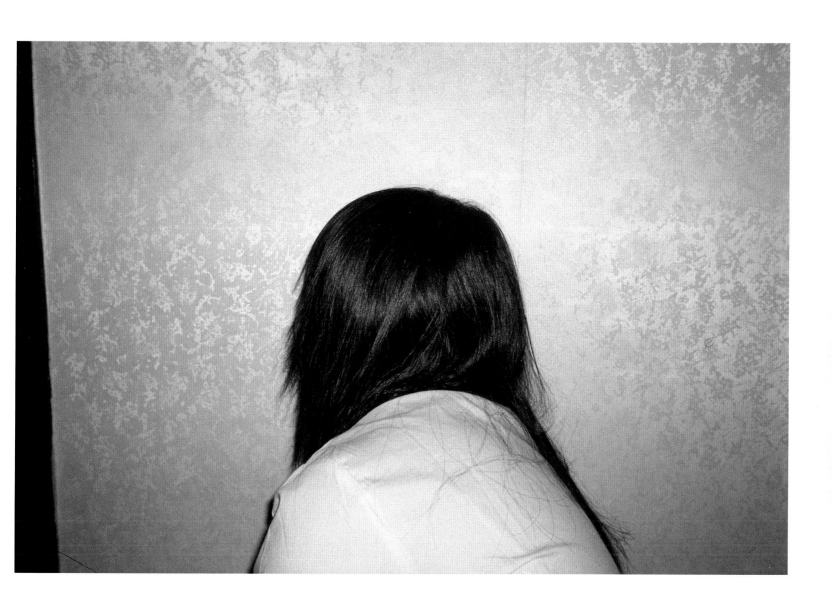

Untitled (Peggy, Red Plastic)
2007

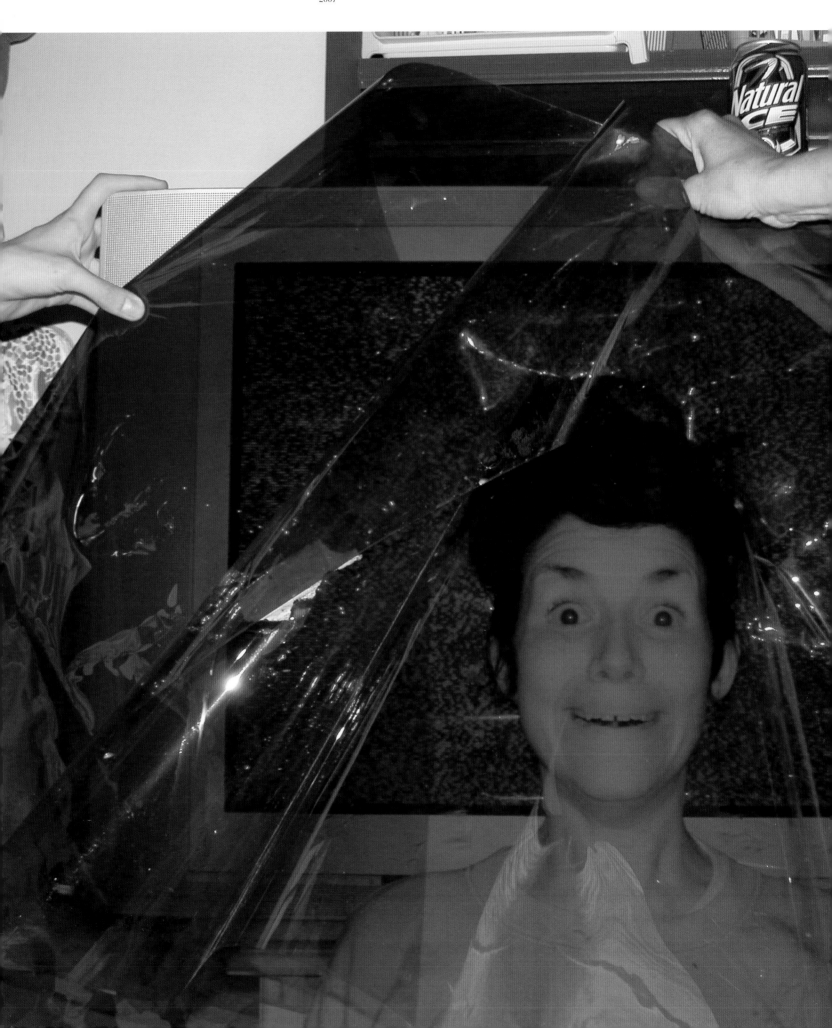

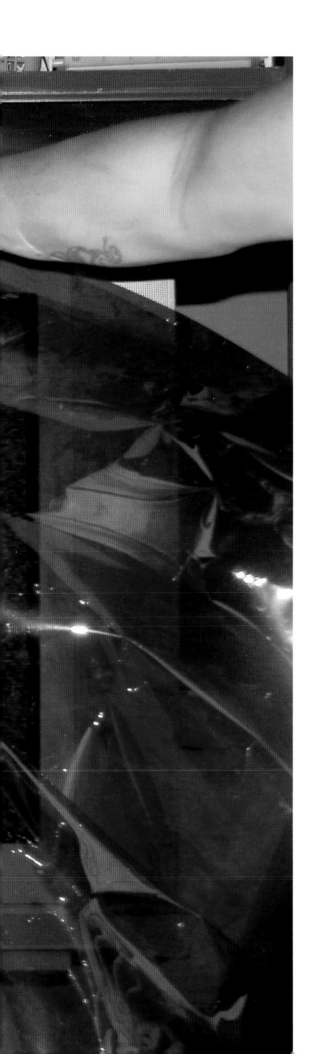

JAIMIE WARREN

"I would describe my photographs like farts—they are punchy, juicy, humorous, and potent…" Jaimie Warren says. She is joking, though she is also completely serious. She is seriously making not-serious art. "What's appealing to me is just trying to honestly capture my environment," she says, while also "keeping the wholesome appeal of everyday interactions—keeping it fun and real, but cropping the perspective in an interesting way when it is seen as actual physical documentation." This documentation has been seen in galleries and museums (such as Aperture and Deitch Projects) in the U.S., Europe, and Asia. It has also been seen as a series of live performances and on television as the public access program *Whoop Dee Doo*, which Warren broadcasts in her hometown of Kansas City, Missouri. Regardless of venue or medium, Warren's aesthetic remains deliberately cheeky and almost crass. "When I look at these images one after another, with each new image I see I automatically make a fart sound in my head. A juicy, quick one… Not a gassy, hollow, long one."

Untitled (God Cloud)
2006 (left)

Untitled (Sour Face Girl)
2006 (right)

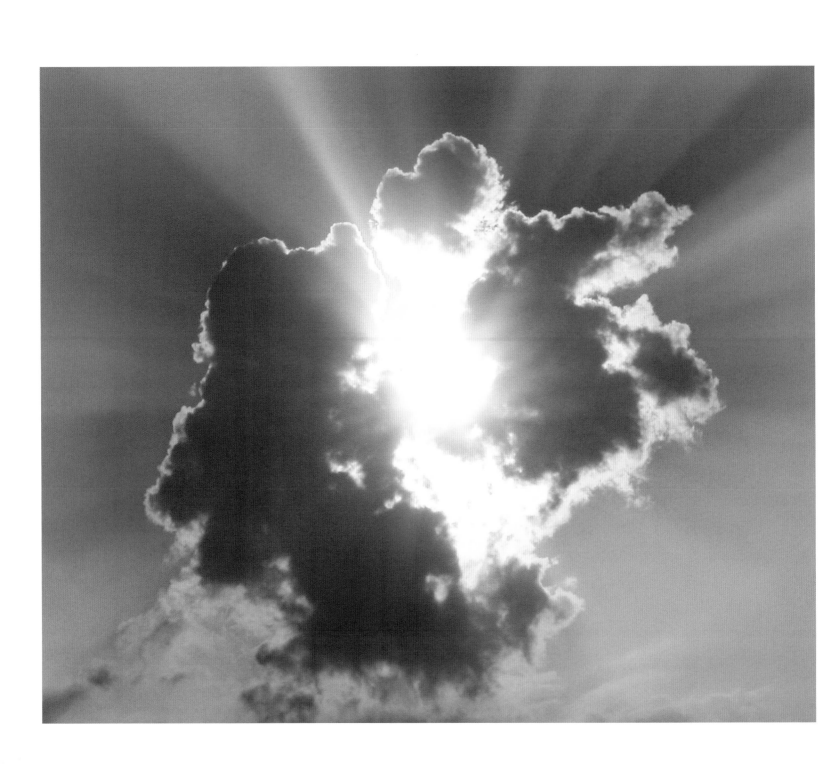

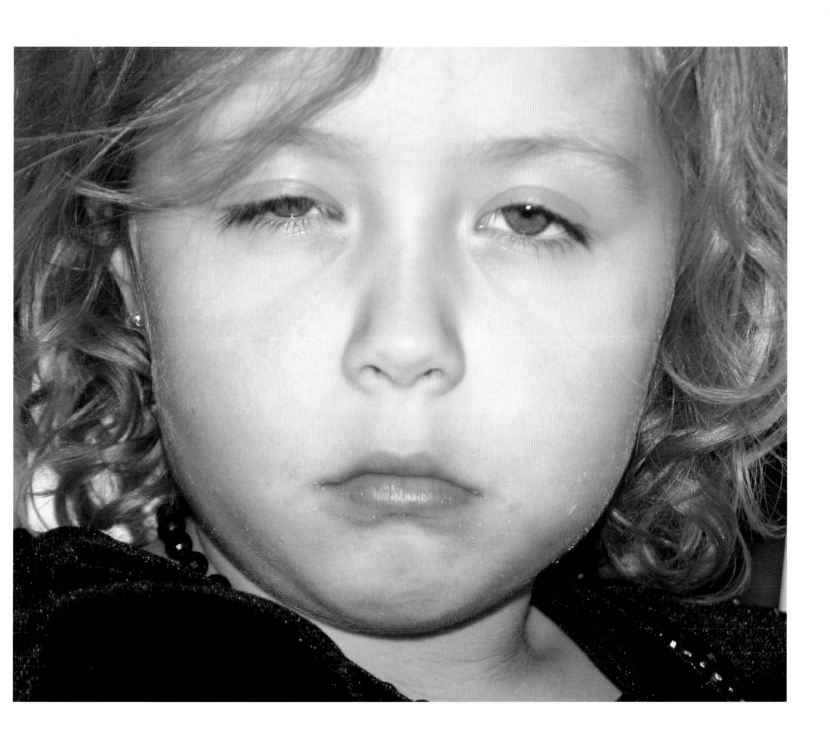

Untitled (Digging for Presents)
2006 (left)

Untitled (Tokyo Garbage)
2007 (right)

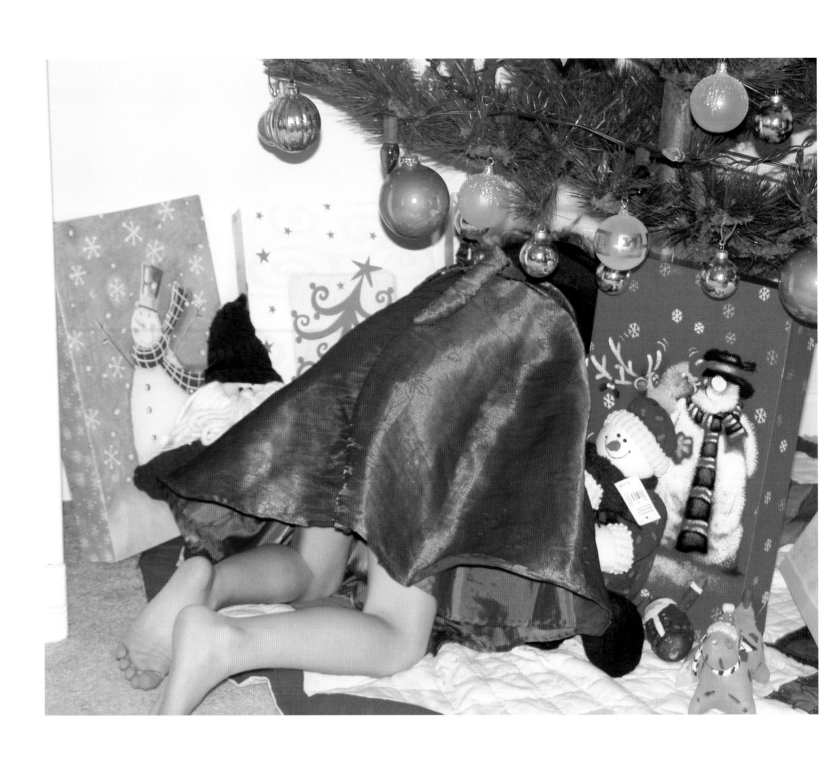

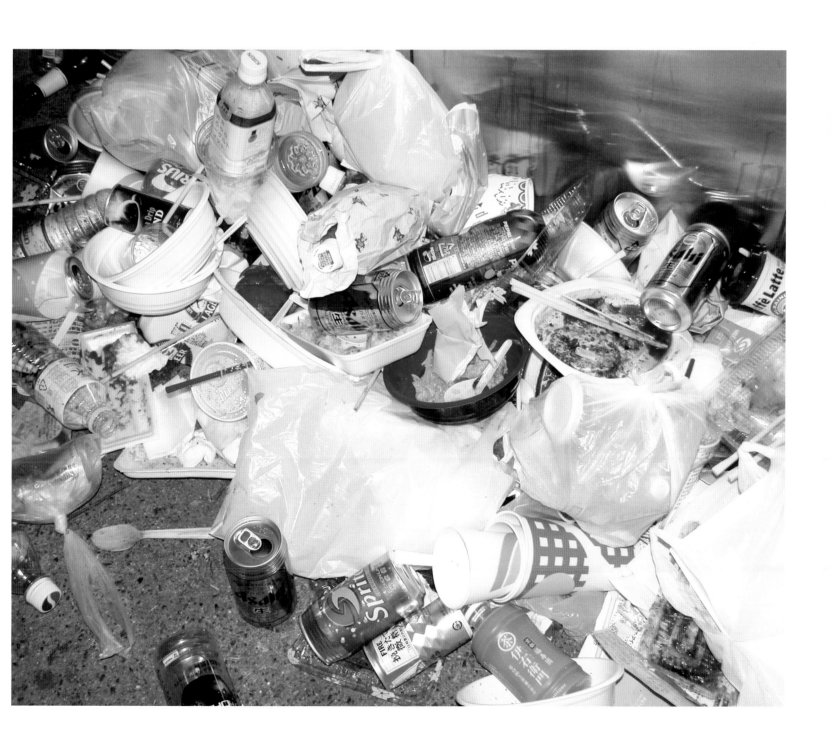

Untitled (Alex/Peggy, Smoosh)
2007 (left)

Untitled (Jaimie, Chili)
2008 (top)

Untitled (White Flowers)
2006 (bottom)

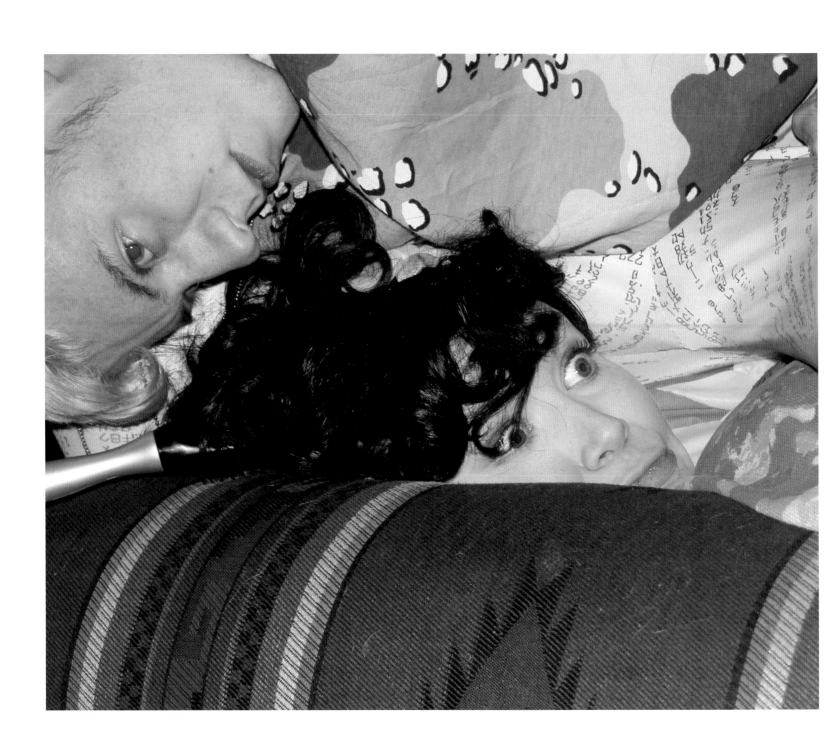

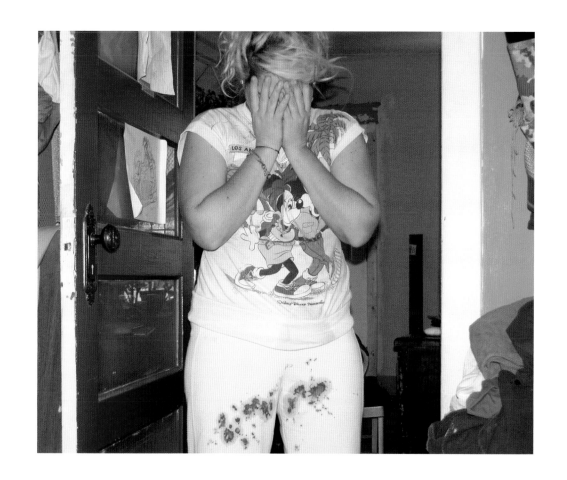

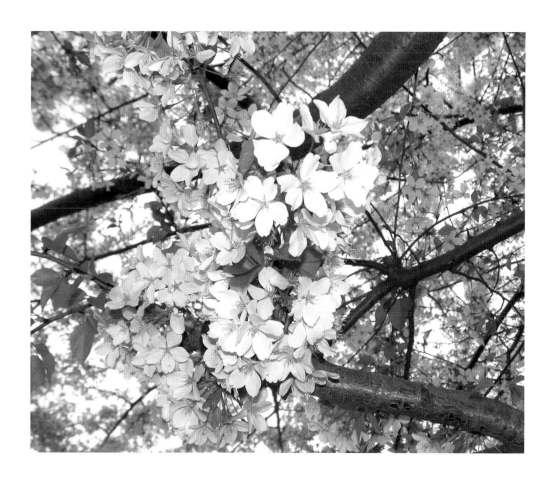

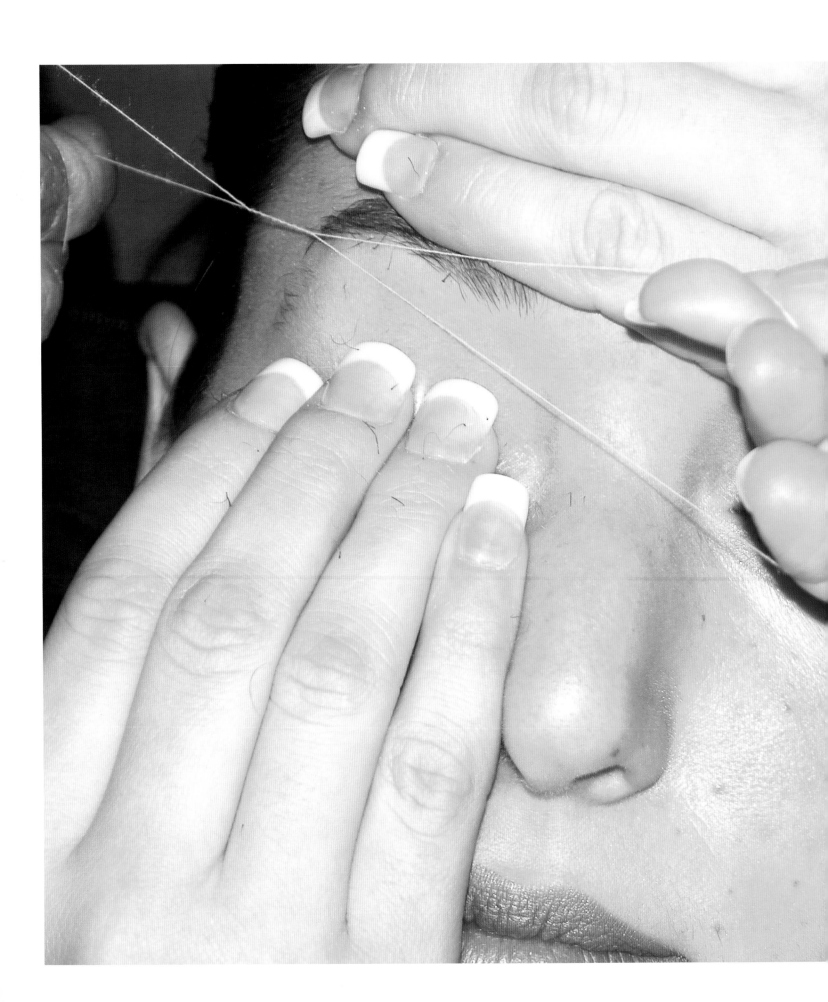

Black Stump
2008

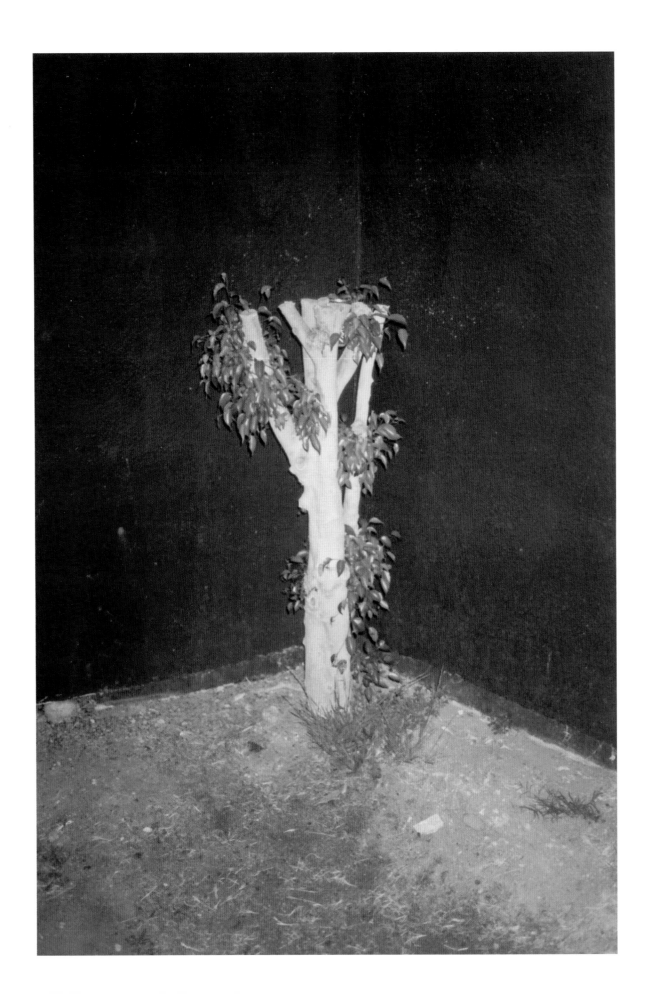

THOMAS JEPPE

Thomas Jeppe is a photographer, painter, curator, publisher, and surfer. Born in Perth, Australia, he is part of a small, yet remarkably prolific creative community in Melbourne. Jeppe's belief is that photography, in contrast to painting, should not be treated as precious, and that its singular appeal as an art form comes from the photographer's ability to produce a never ending series of images. "I've had periods where I shot 15 rolls a day," he recalls, "though now I'm thankful that I don't feel the need to have a camera with me all of the time." That attitude is appropriate for someone who publishes books, photo edits a magazine, and sits on the curatorial board of two galleries, in addition to having his own work published and exhibited internationally. Perhaps the ultimate truth is that the camera serves as a coping mechanism for Jeppe's over-saturated existence: "In some ways, I feel that the photos I take allow me to *forget*; a visual experience takes place that is so haunting—albeit often in a positive way—that I can only handle its existence once it is mediated through the camera."

Blind Noose
2008 (top)

Arm with Plant
2007 (bottom)

Spruce Noose 4
2008 (right)

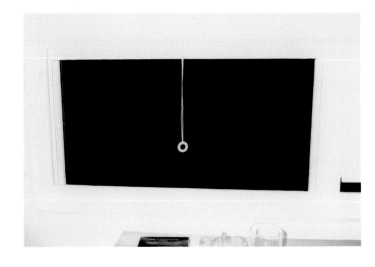

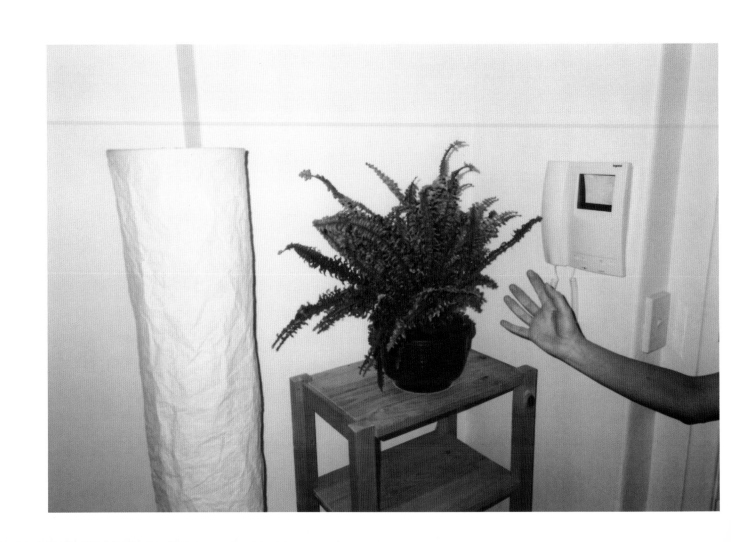

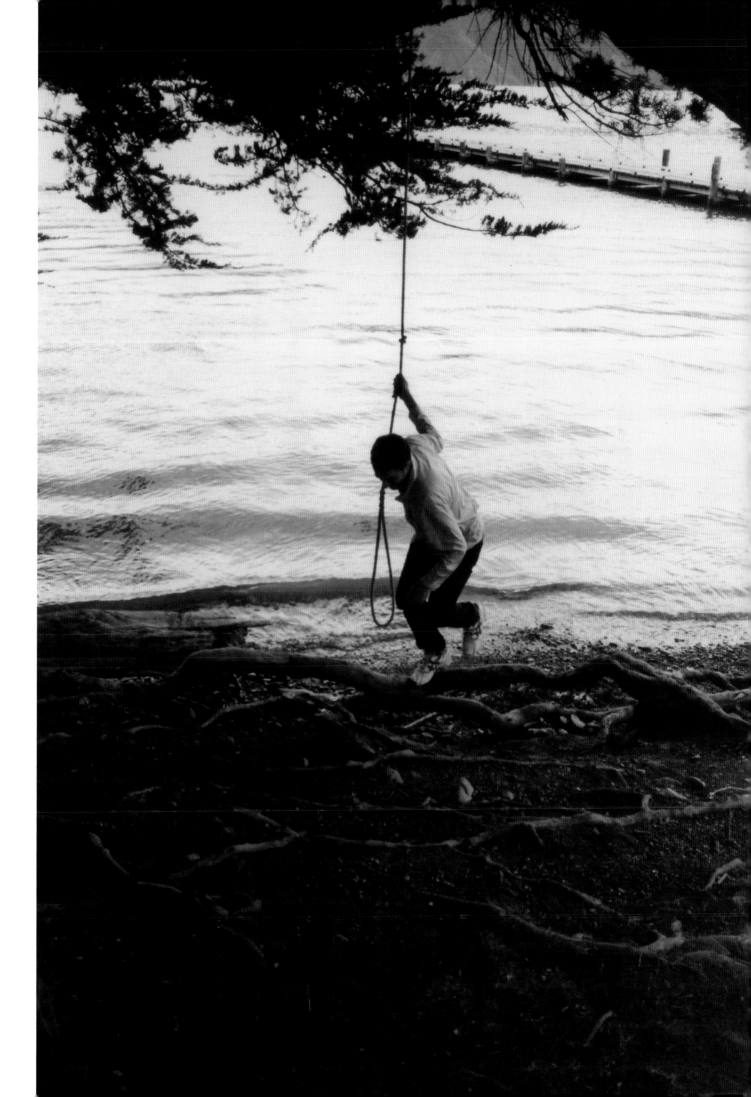

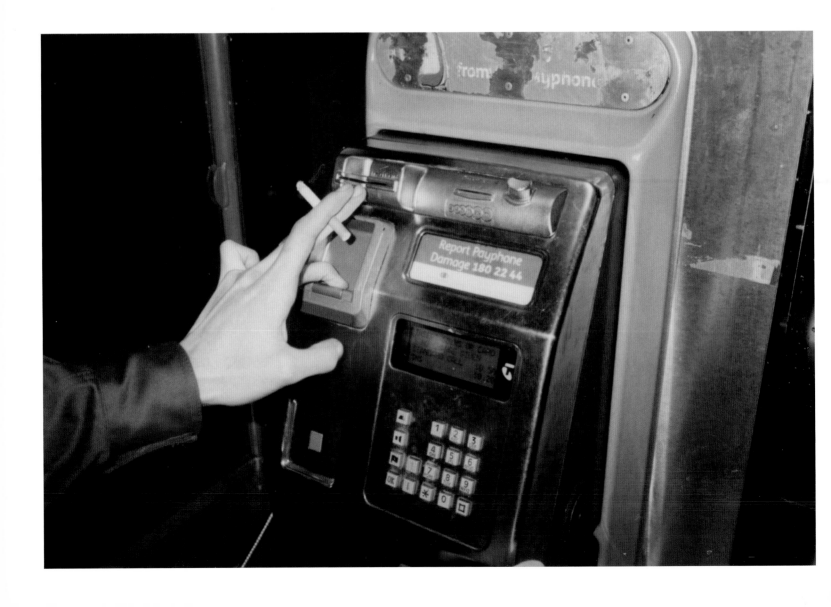

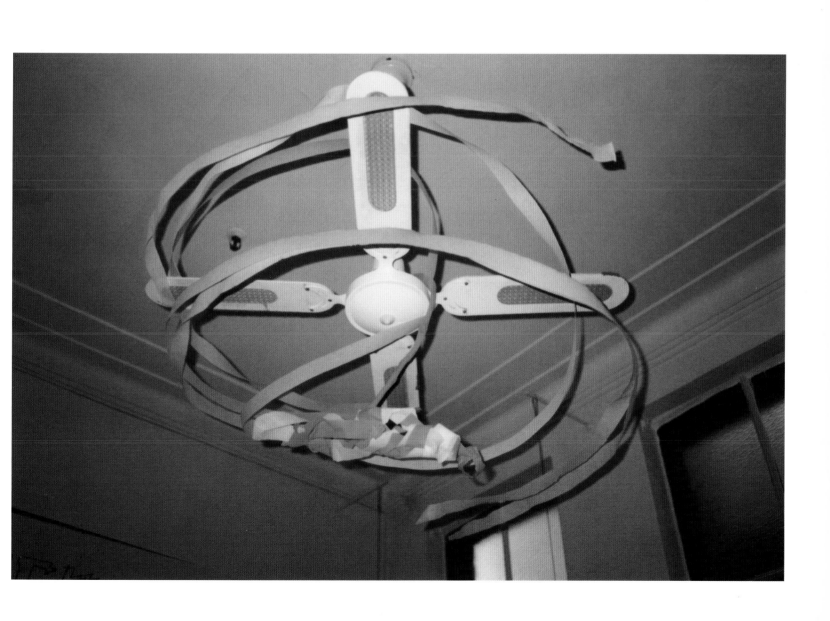

202

Naked Groom
2006 (left)

Radiant Parking
2008 (top)

Shower Scene 1
2008 (bottom)

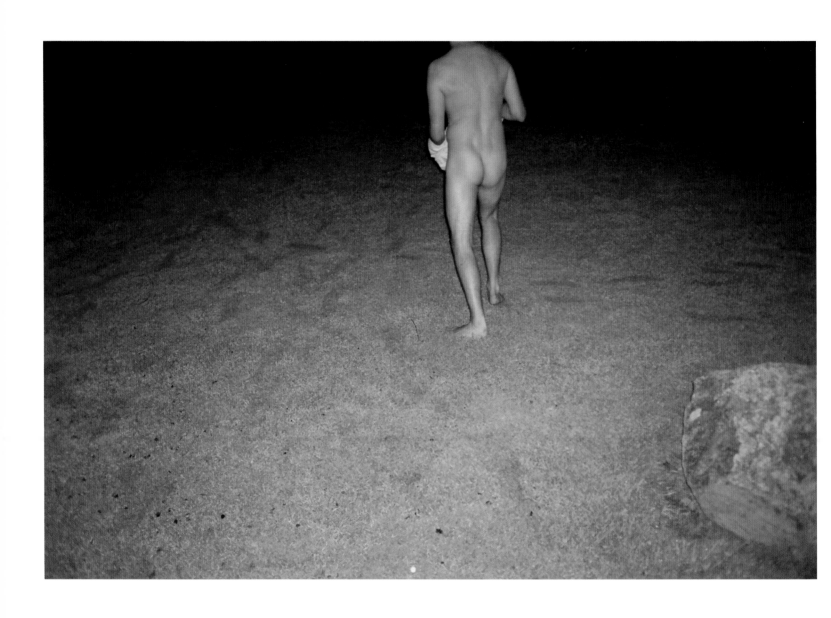

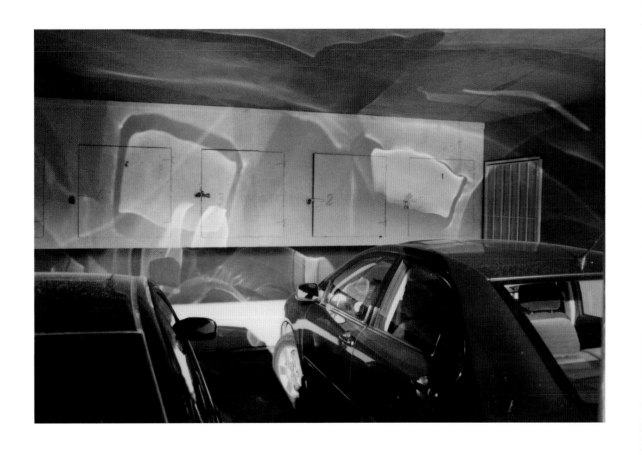

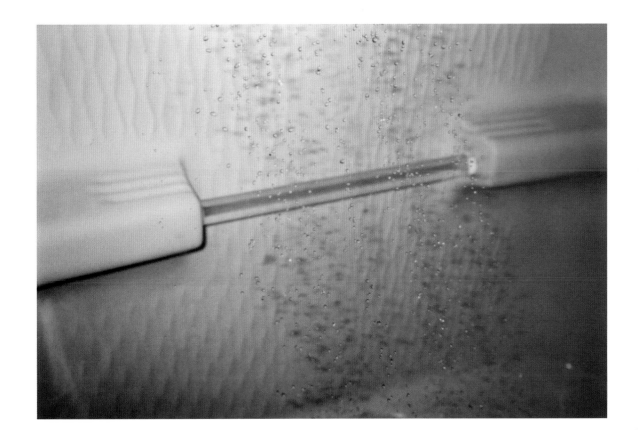

American Can
2008 (left)

Portal 1
2008 (top)

Pool Cover
2007 (right)

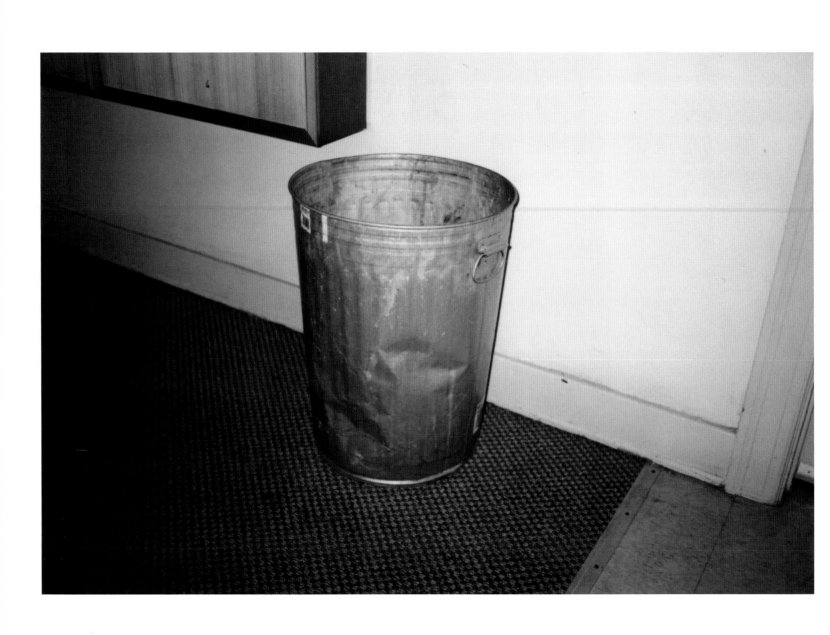

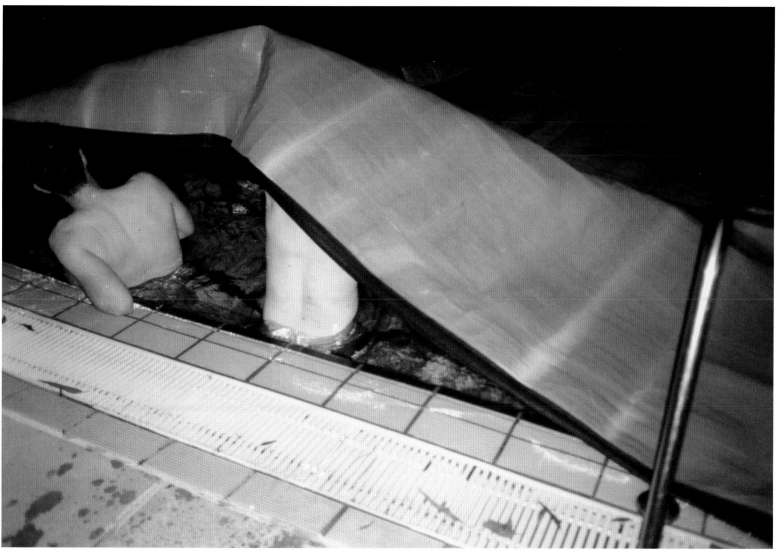

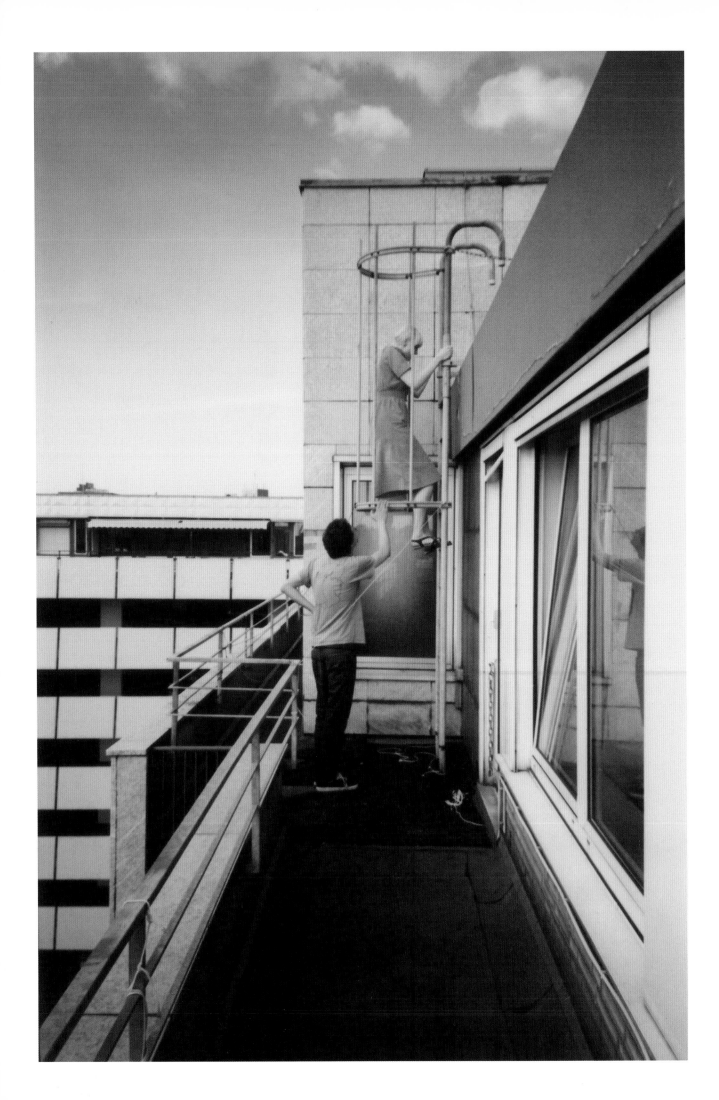

First published in the United States
of America in 2009 by
Rizzoli International Publications, Inc.
300 Park Avenue South
New York, NY 10010
rizzoliusa.com

2009 2010 2011 2012/ 10 9 8 7 6 5 4 3 2 1

Printed in China

Editors: Ken Miller &
Julie Schumacher
Design: Jiminie Ha
Production: Kaija Markoe

ISBN-13: 978-0-8478-3193-7
Library of Congress Catalog
Control Number: 2009920760

Special thanks to:
Ken Miller would like to thank all of the
photographers in SHOOT, not only for their
participation, but for their generous guidance
and support. He would also like to thank Jesse
Ashlock, Cynthia Leung, Marcelo Gomes,
Michael Nevin, Brannie Jones, Noah Sheldon,
Mirabelle Marden, Adam Glickman, Jamie
McPhee, Victoria Sounthavong, Tomoko Oka-
moto, Thuy Pham and Miho Aoki, Matthew
Eberhart, Shu Hung, Betty Kim, Kate Sennert,
Noah Shelley, Sue Barber, Tim Petersen, Alex
Wagner, Dmitri Siegel, Ed Looram, Neville
Wakefield, Dashwood Books, and especially
Julie Schumacher for her editorial patience.

Julie Schumacher would like to thank Amoreen
Armetta, Henry Casey, Lauren Cecil, Charles
Miers, Ellen Nidy, and Anthony Petrillose.

Jiminie Ha would like to thank Rebecca
Giminez and Pete Deevakul.

Penny Martin thanks Jason Evans and
Camilla Palestra.